Sheds

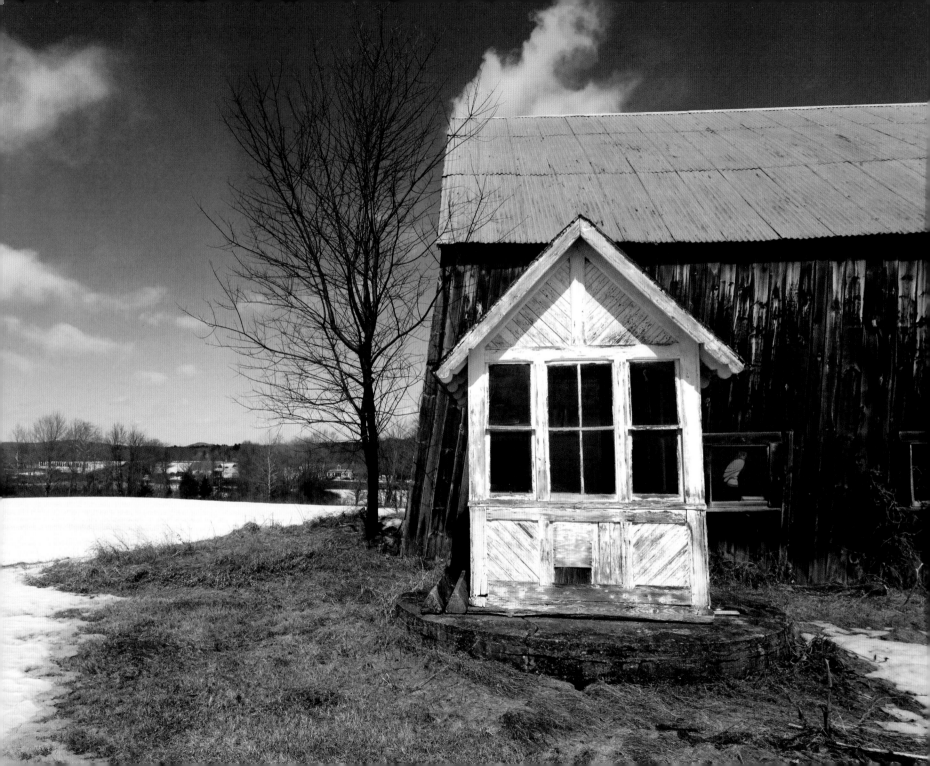

Sheds

HOWARD MANSFIELD

Photography by Joanna Eldredge Morrissey

BAUHAN PUBLISHING
Peterborough, New Hampshire
2016

Text ©2016 Howard Mansfield
Photographs ©2016 Joanna Eldredge Morrissey
ISBN: 9780872331860

Library of Congress Cataloging-in-Publication Data
Names: Mansfield, Howard, author. | Morrissey, Joanna Eldredge, illustrator.
Title: Sheds / Howard Mansfield ; Photographs by Joanna Eldredge Morrissey.
Description: Peterborough, NH : Bauhan Publishing, 2016.
Identifiers: LCCN 2015049929 | ISBN 9780872331860 (pbk./gatefold : alk. paper)
Subjects: LCSH: Sheds--United States. | Sheds--United States--Pictorial works.
Classification: LCC NA8301 .M36 2016 | DDC 728/.9220973--dc23
LC record available at http://lccn.loc.gov/2015049929

The quotes from "The Chainsaw Dance," *Judevine* ©1999 by David Budbill,
are from Chelsea Green Publishing, www.chelseagreen.com, and are used with permission.

Book design and photo editing by Henry James
Typeset in Lapture Display with Chronos Pro titles
Printed by Versa Press

To contact Howard: www.howardmansfield.com
To contact Joanna: jo.eldredge@me.com

BAUHAN
PUBLISHING LLC
PO BOX 117 PETERBOROUGH NEW HAMPSHIRE 03458
WWW.BAUHANPUBLISHING.COM
603-567-4430

Once again, and always, for Dr. B. A. Millmoss.
Howard

To my talented and beautiful daughters, Brianna and Lauren—women of true, kind hearts—for whom I have the deepest respect.
Joanna

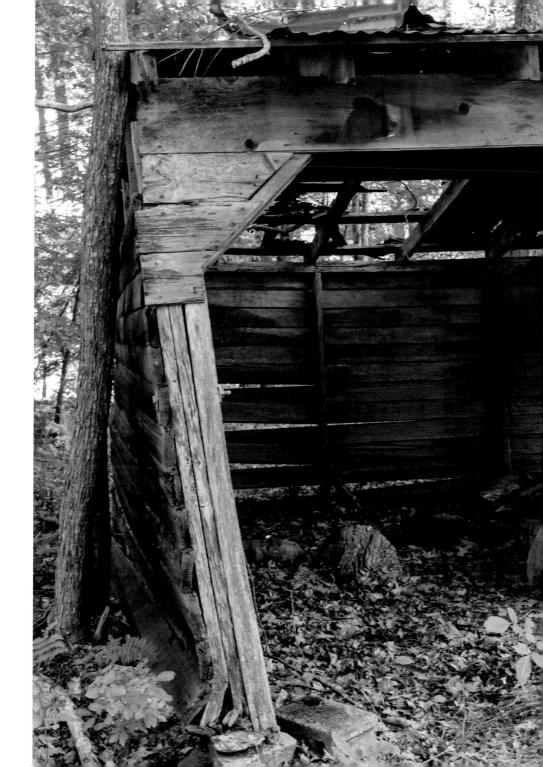

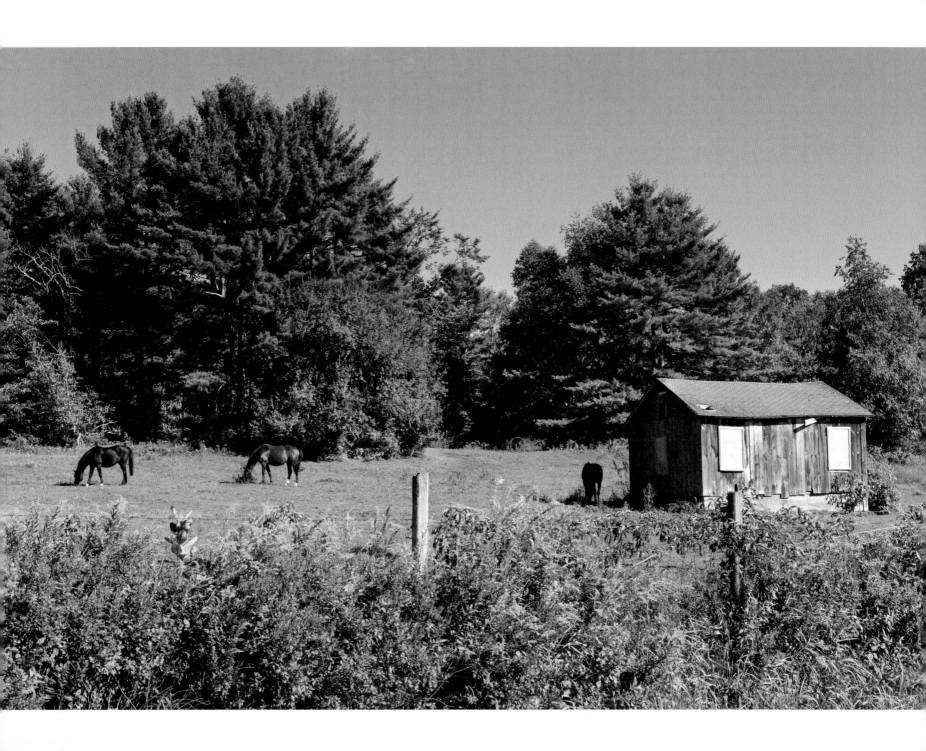

CONTENTS

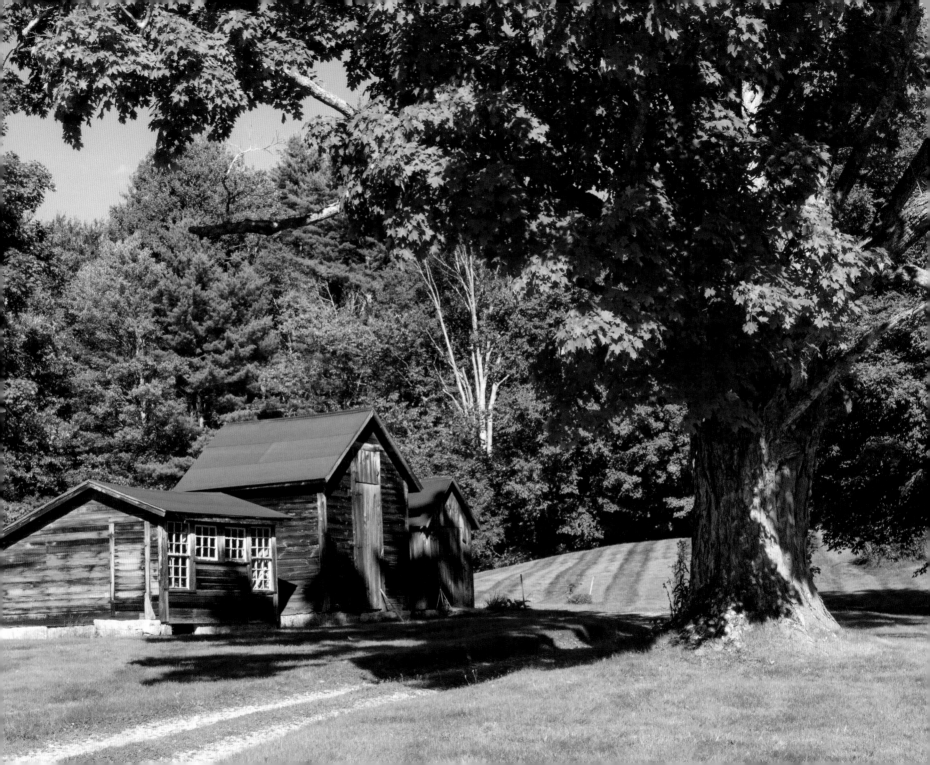

PREFACE

In a small town near me, there are a couple of streets that lived and died with the railroad. It was a place of tracks, loading docks, sheds, and mills. When the trains stopped running, this part of town was like an actor without any lines. For years it drifted. A former railroad freight station was used by a family-run department store to sell rug remnants; a cinder block warehouse became that store's furniture showroom. A beer joint opened in a transient rooming house, a place whose history remains mostly untold. After the family department store closed, the area fell further: empty buildings, peeling paint, and different shades of patched paving.

Today this part of town thrives. There's an art gallery, up-market antique shops, and restaurants. The new gallery and stores look great, which is surprising if you know the history of the buildings. Behind the twinkling white lights and the tasteful signs, these buildings are sheds. They were built for storage, for trade. No one designed them to be looked at. No architect stood before a zoning board with those made-to-please renderings in pastel colors that exaggerate the green space, the amount of parking, and the happiness of the days to come. These railroad depot buildings were built as tools for a job. The life of commerce moved through these sheds and when that commerce changed, they were easily adapted for new uses. Sheds are malleable. They are undistinguished, demure to the point of invisibility, an overlooked testament of plain-speaking utility.

New Englanders are, above all, practical. Even if you arrive with fancy notions, the weather will swiftly veto the unfit roof and wall. The first white settlers were, of necessity and religion, quick to get right to the point. The New England meetinghouse is a shed. Compared to churches, they were stark: no altar, stained glass, paintings, or spire. They were usually unheated and unpainted. They were not much more than barns. Put windows and pews in a

barn, you have an early meetinghouse. (The same is true of early houses—they are sheds with windows and chimneys.) For the faithful, the worship mattered, not the church. Sheds are

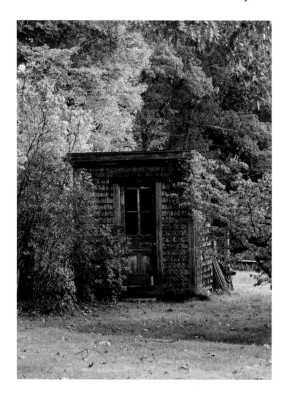

vessels of time. We fuss over the architectural details that decorate the store, house, barn, meetinghouse, but we should look more closely at the life that flows through them.

It's the simple that's adaptable, that thrives from generation to generation.

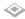

I began looking at sheds when I was trying to puzzle out what's lacking in our houses. In a previous book, *Dwelling in Possibility*, I asked, "What qualities are missing in our homes, and how can we regain them?" We know within seconds upon entering a new house if we feel at home. We know when a place makes us feel more alive. This is the mystery that holds my attention—some houses have life—are home, are dwellings—and others don't. Dwelling is an old-fashioned word that we've misplaced.

When we live heart and soul, we dwell. When we belong to a place, we dwell. Possession, they say, is nine-tenths of the law, but it is also what too many houses and towns lack. We are not possessed by our home places. This lost quality of dwelling—the soul of buildings—haunts most of our houses and our landscape.

By looking at sheds we can find some of the qualities that animate the most welcoming homes. We can begin to see our way clear of the current obsession with ever larger houses. Cable TV home shows are united in preaching that bigger is best, that gutting older houses to make way for glinting granite and stainless steel is the way to happiness. But what if the truth is otherwise? What if less really is more? Humble wooden buildings offer a way out of this trap. Think of sheds as the anti-McMansions, as the permission slip freeing you from expensive home demo/reno projects. Sheds are buildings where utility and beauty are one: woodsheds and barns, boathouses and bob houses, covered bridges and summer cabins. Sheds, in addition to holding old tools and broken chairs, hold a few hints about living well.

Howard Mansfield
July 2016

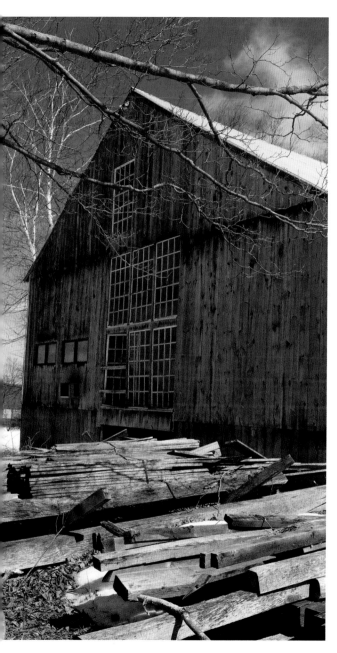

INTRODUCTION

Where I live, we really have only one kind of building, old and new, big and small: the shed. From woodsheds to barns, to houses, meetinghouses, and covered bridges, they are all sheds. New England has never gotten much beyond the shed and we're the better for it. In fact, it's what tourists respond to, though they certainly won't say, "We've come to see the sheds." But they love covered bridges, and the way that the houses lining the common seem like the little brothers of the bigger meetinghouse, or the way the connected sheds and barns trailing behind a house stand there like a third-grade class lined up for its photo.

Sheds are utilitarian. Sheds contain small things—wood and tools—and big: summers, winters, solitude, festivity. The smallest sheds can be liberating: a bob house on a frozen lake, a summer cabin. They can shelter dreams.

Sheds are reticent. They stand back; they're demure, easily adaptable. They let life flow on through.

A shed is the shortest line between need and shelter. It's a trip from A to B. It's often built of found materials; it's built with a distilled practicality.

The best sheds house this contradiction: they are built according to accepted rules and thus they are free.

Here's a small tour, near and far, of sheds.

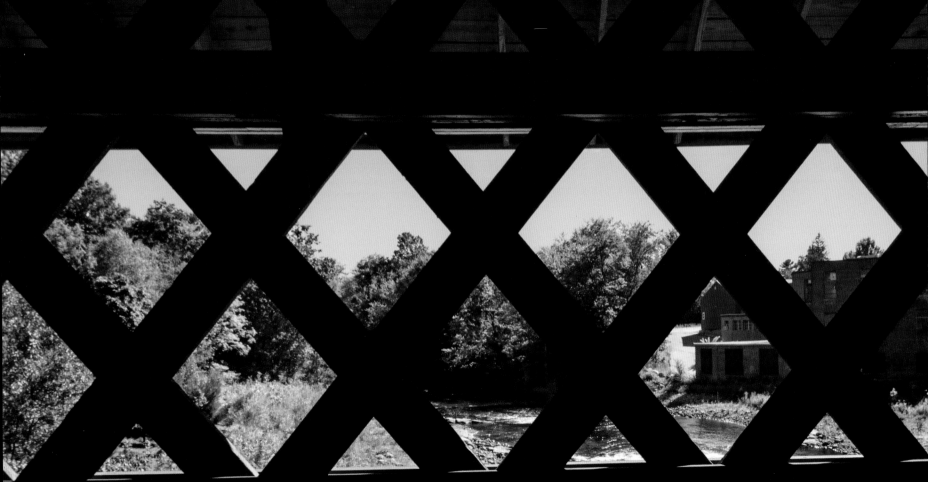

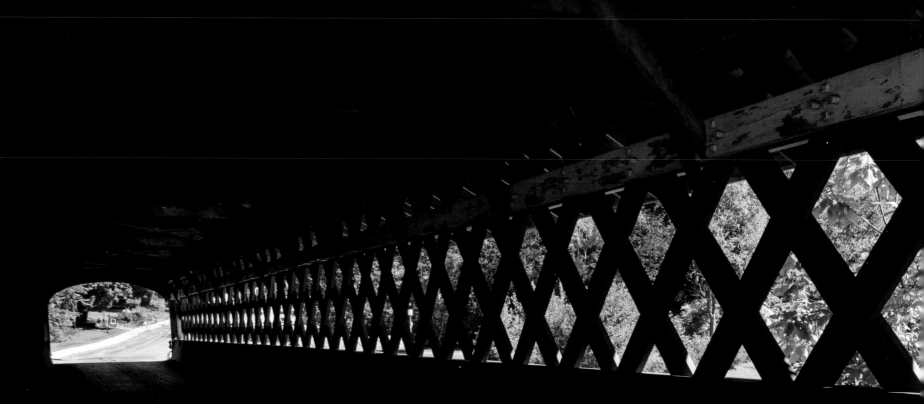

COVERED BRIDGES

Covered bridges are the stars. These sheds spanning the water are beloved for the beautiful pictures they make.

Devoted "bridgers"—as enthusiasts are known—talk about the "bygone horse-and-buggy days": "prancing hoofbeats" on the wooden boards, "the fragrance of the aging wood," kids swimming under the bridge or fishing off the bridge, young swains stealing a kiss with their "best girl," and the ghosts that might be seen in the terrifying dark on moonless nights. Bridgers keep the nostalgia mills turning.

But the strongest appeal of covered bridges, I think, lies in the surprising feeling of shelter they arouse in people. Passing into the bridge's shadows, a traveler is enclosed and suspended, and in many bridges, open to the water— looking through the trusses or windows,

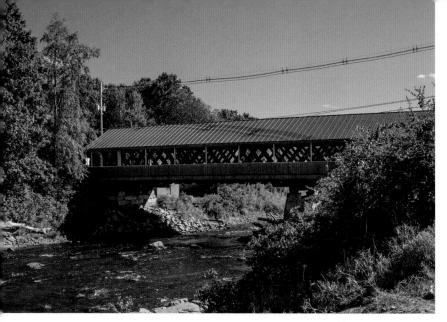

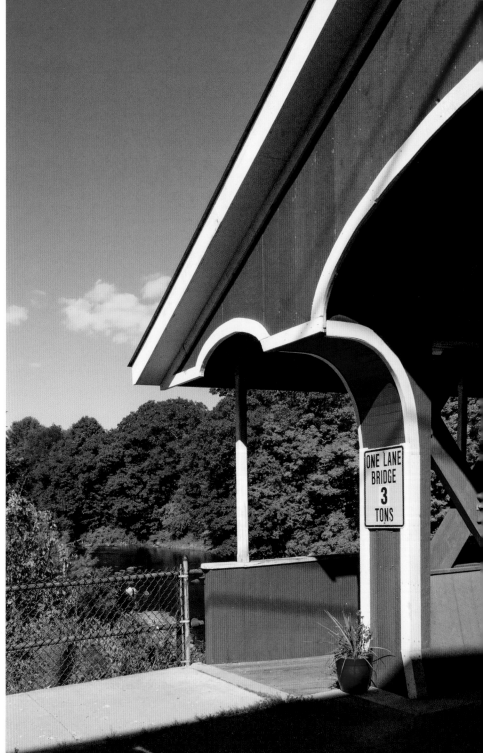

or down through the boards of the roadway. This sudden enclosure and suspension reawakens the senses.

Covered bridges are like tree houses in that way—you're high up, hidden, and have a view. For a moment you are hiding out. The English geographer Jay Appleton says that people are drawn to shelters that offer "prospect and refuge." Evolving as hunter-gatherers, humans naturally sought out places where they could see without being seen. Passing through a covered bridge offers a quick taste of our old affinities. The bridgers' stories are tales of refuge.

But covered bridges weren't built to star on calendars. They weren't built to

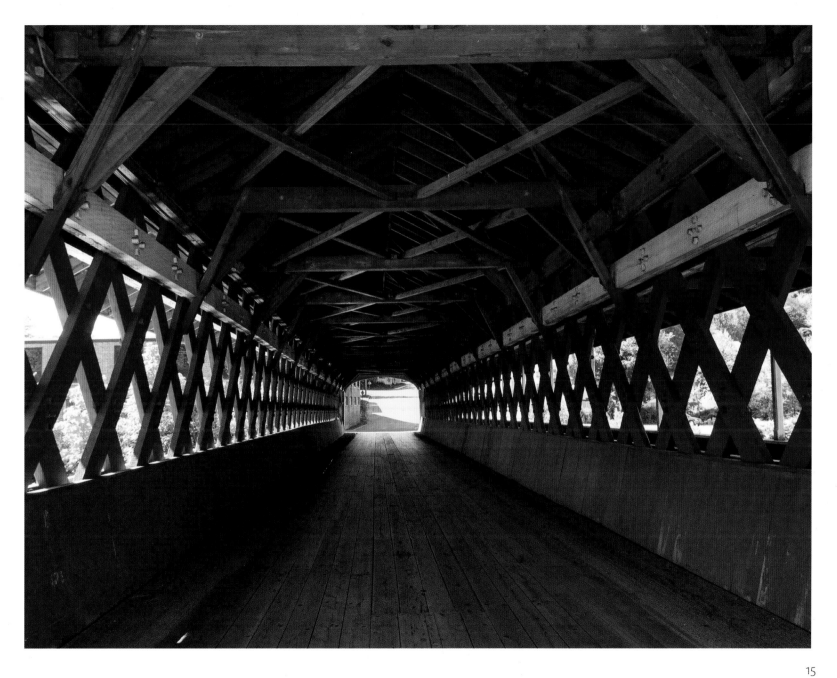

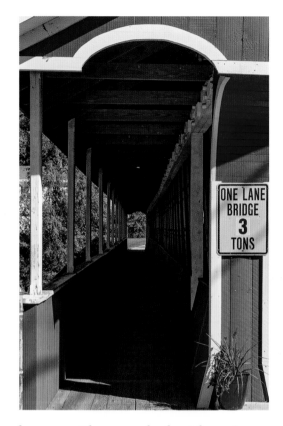

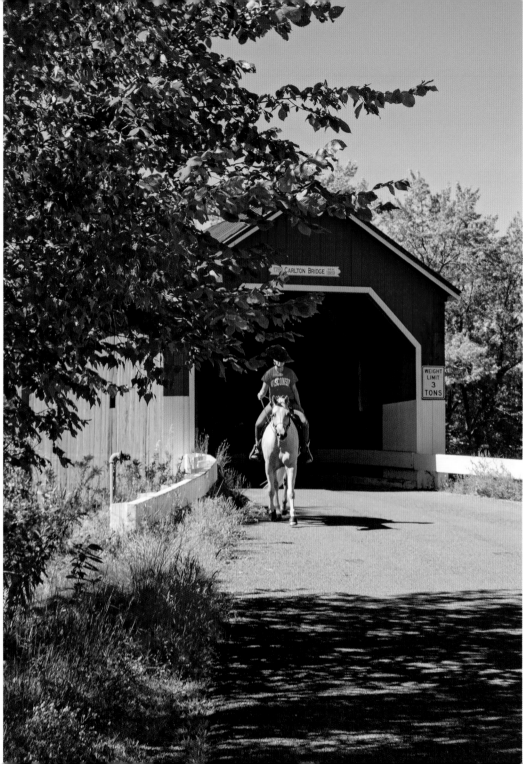

be pretty. They were built with roofs to protect the bridge's support, the trusses you see on the side scissoring by. Twenty different truss designs, most of them patented, were used in the nineteenth century. Philadelphia built the country's first covered bridge in 1805 at the insistence of a local judge who said, correctly, that the bridge would last much longer if its trusswork were protected from the

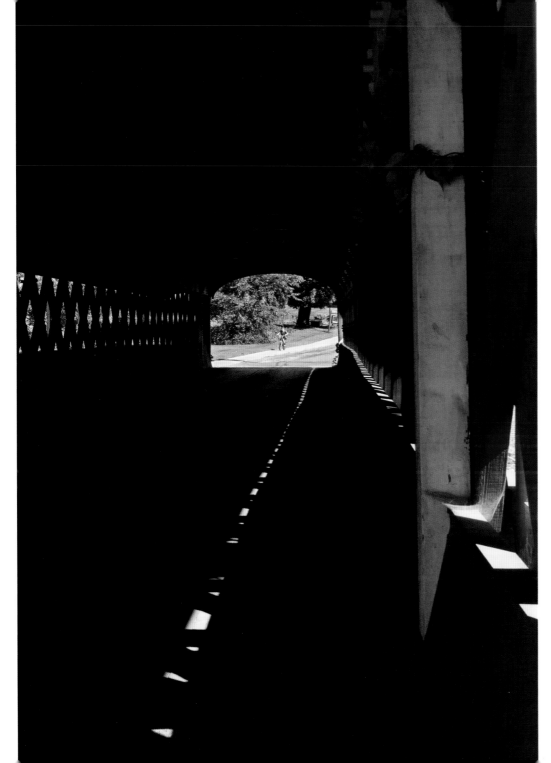

weather. This innovation was quickly adopted across the country with great success. Bridges that once had to be replaced frequently now could serve for a century—or more, in the case of several bridges. Across the country, about 850 covered bridges survive, due in part to the vigilance of the bridgers. These calendar stars are sheds for trusses.

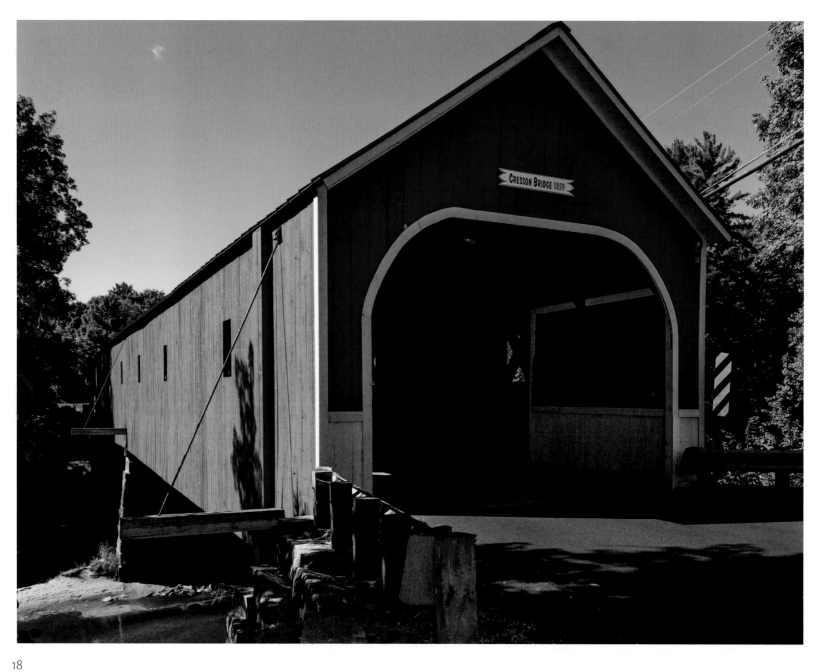

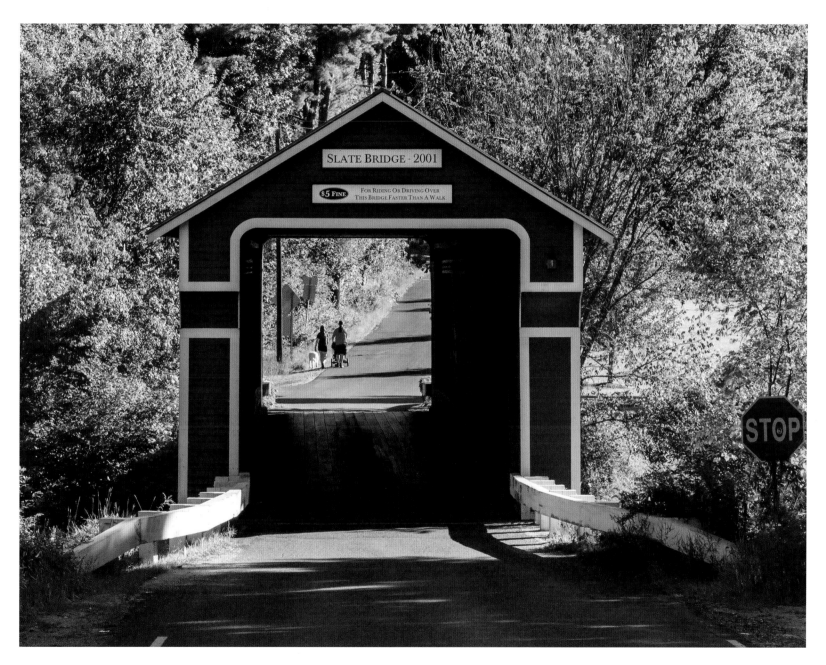

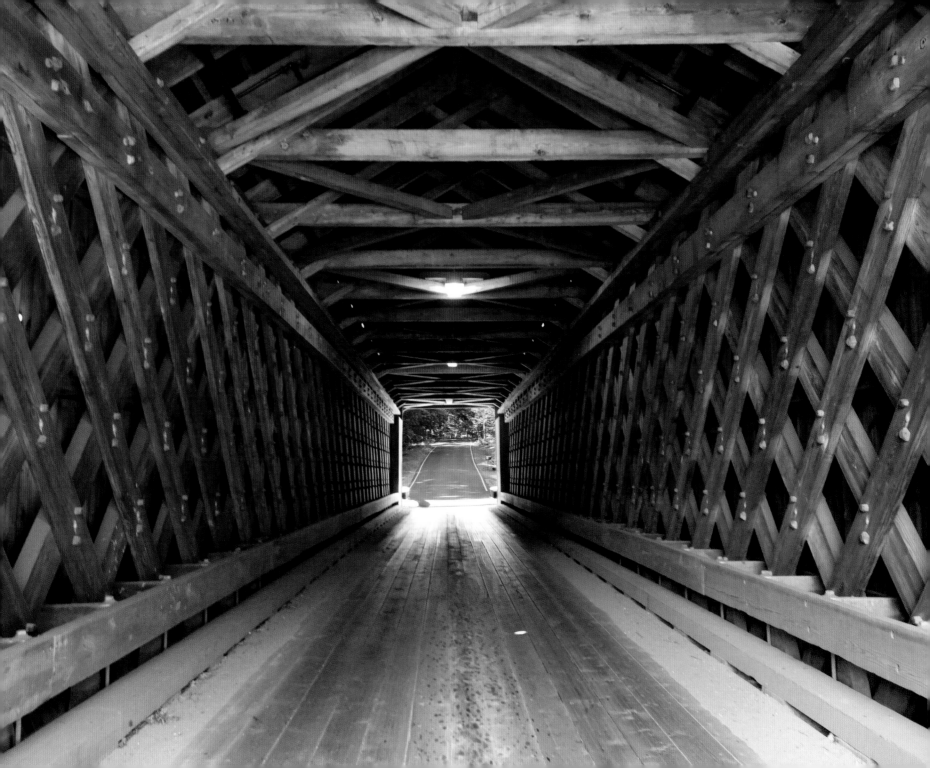

BARNS

On our old barn there's a big rusty pulley hanging under the eaves on a back corner with a big rusty hook below, big blocks on three of the corners that were once useful, the outline of one or more vanished sheds on the rear wall, and, on one side, cut boards showing where the house once joined the barn, before the barn was dragged off to rest beyond the house.

A barn is a tool. It's like a big workbench bearing the marks of many projects: saw bites, clamping dents, drilled holes, paint drips, and burns. The workbench takes on a topography, a work history.

Our old barn has a similar topography. It's been changed many times and, like most barns, openly shows the signs of wear and change. Houses tend to hide their changes under clapboards, plaster, and paint, but a barn is all bones. It's right out in the open. And actually, the degree of openness, or shelter, is one of the qualities that changes over time as the barn's occupation changes.

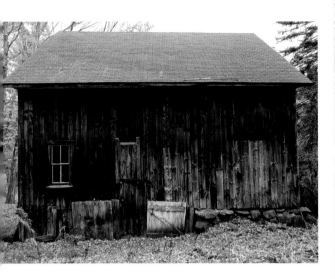

This small barn has about a dozen doors. On the front, under the gable, are two closed hay doors. We enter through a big red sliding door, which has, in the center, a small door that was added later. We never use the small door. The right side has two small, square doors, now closed. One is under the eaves, and the other, perhaps newer, is on the second floor. On the ground floor are two big sliding doors, entrances for our pig pen, our chicken coop, and the cool, dark, dirt-floored space—a former "manure basement"—where we store hay, feed, and a "library" of old fencing: chicken and turkey wire, metal poles, wooden pallets. Upstairs, the right side has one

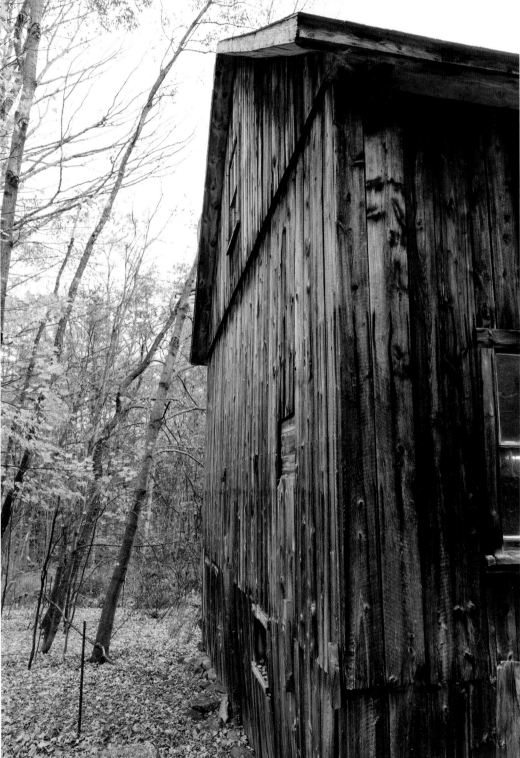

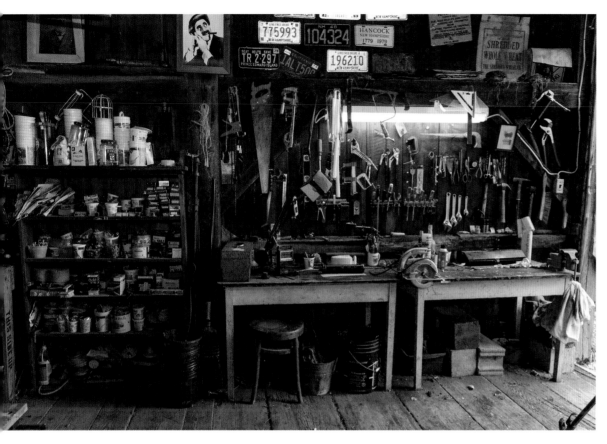
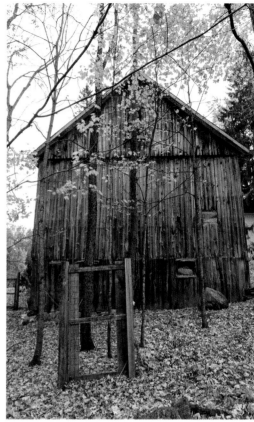

old window, and an open window-space with loose fitting boards for a cover. Touching the ground are either two more hatches or maybe just patches near the rock foundation. There are two more square doors on the back, one likely added to pitch out manure.

Barns are really best thought of as a semi-shelter, more like a lean-to, open to the weather and the bats, birds, squirrels, mice, rats, and cats who come and go.

Inside, toward the back, the old floorboards have been worn by hooves into smooth hills and valleys, and a long-gone horse has chewed ("cribbed") a beam. There are old heavy hooks, rings, and generations of nails stuck into the timber frame. I can always find a place to hang up a tool, or to hoist a riding lawnmower with a come-along. The timber frame itself is steadfast. The joists and floor of the hayloft are gone. Part of the second floor was added later, framed in with weathered lumber from another shed or house. Our old barn has passed through many hands and hoofs, claws, and paws.

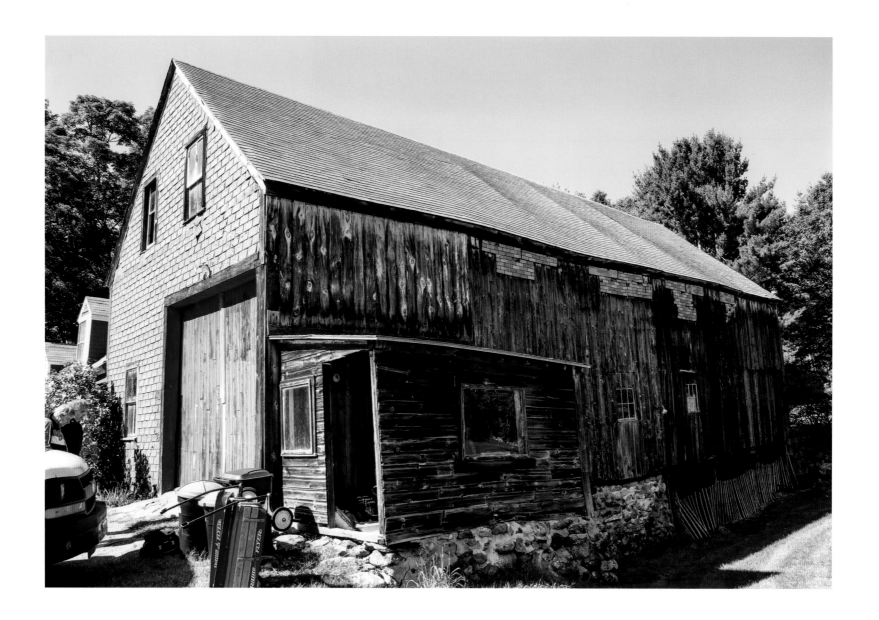

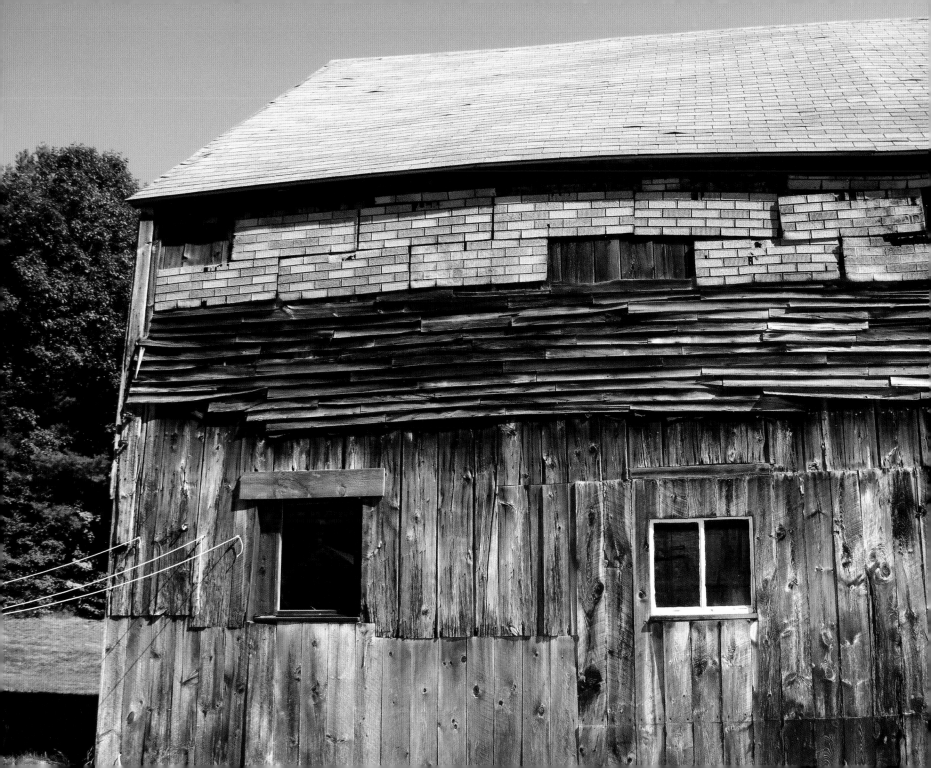

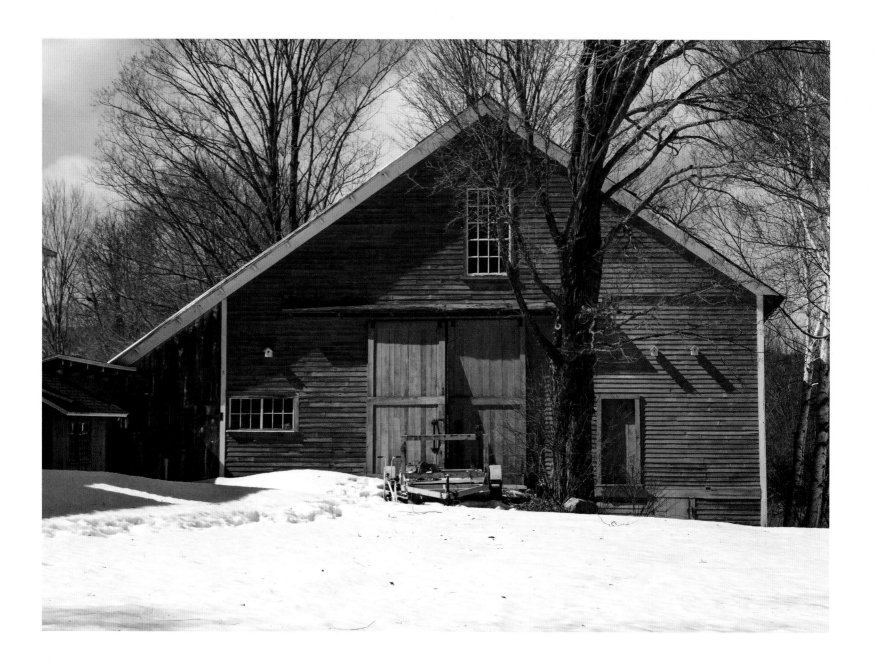

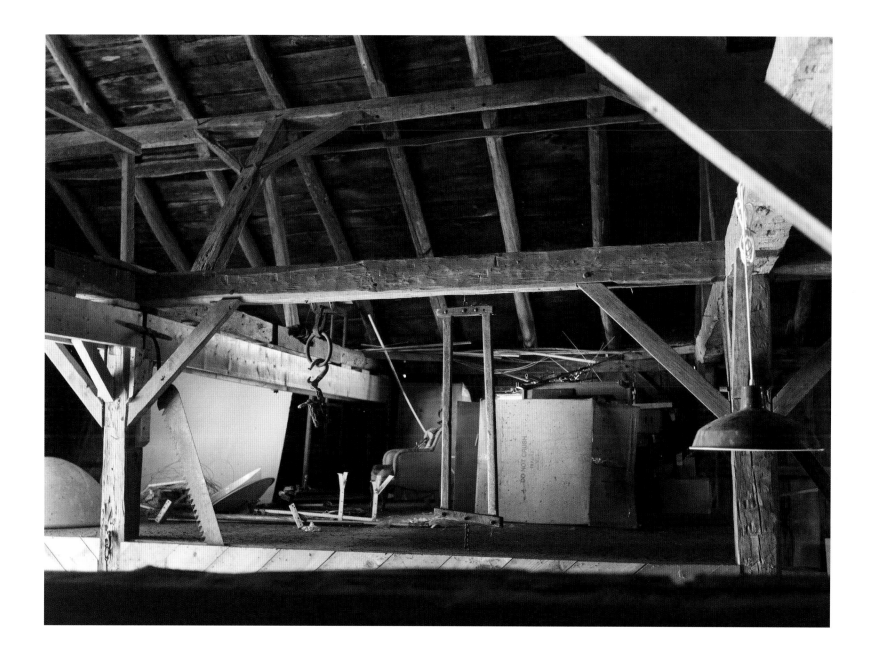

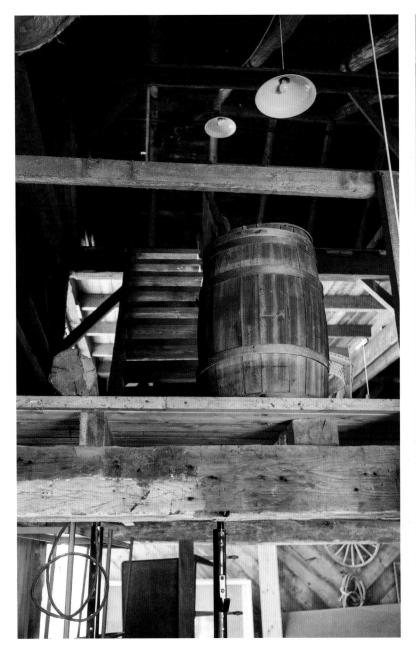

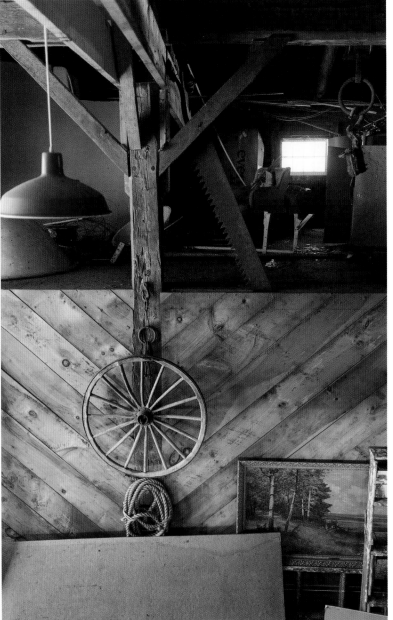

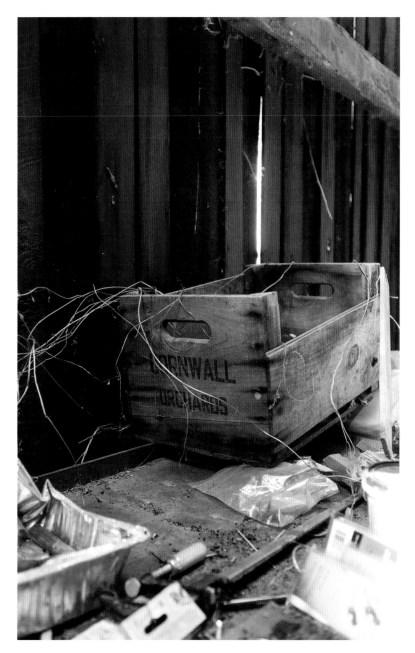
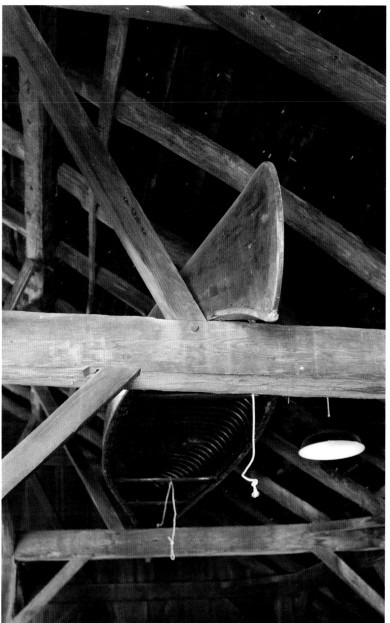

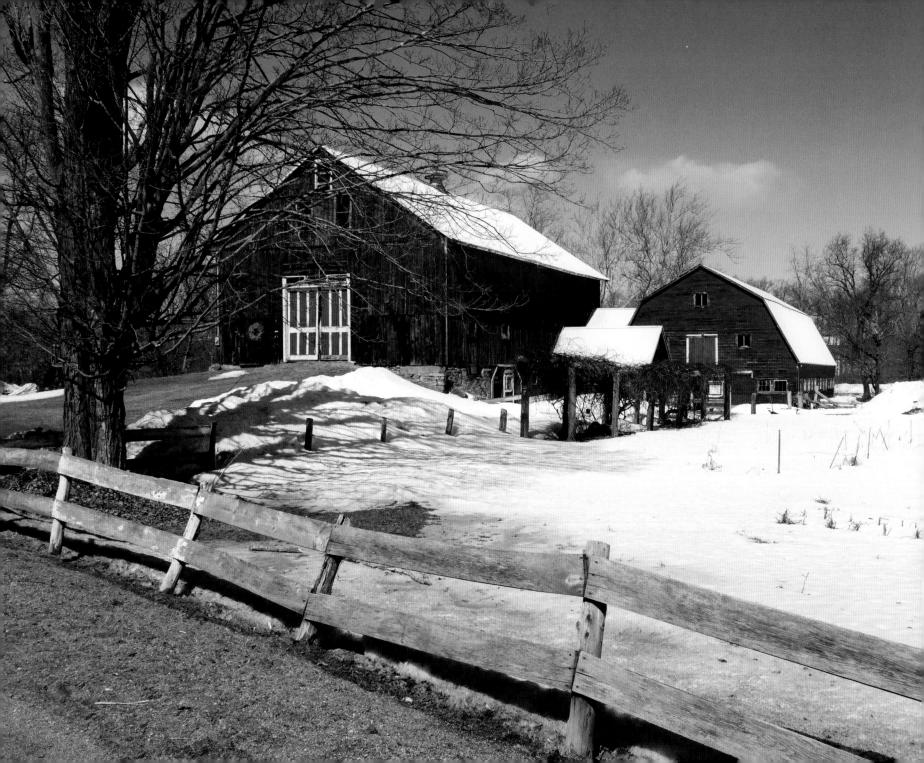

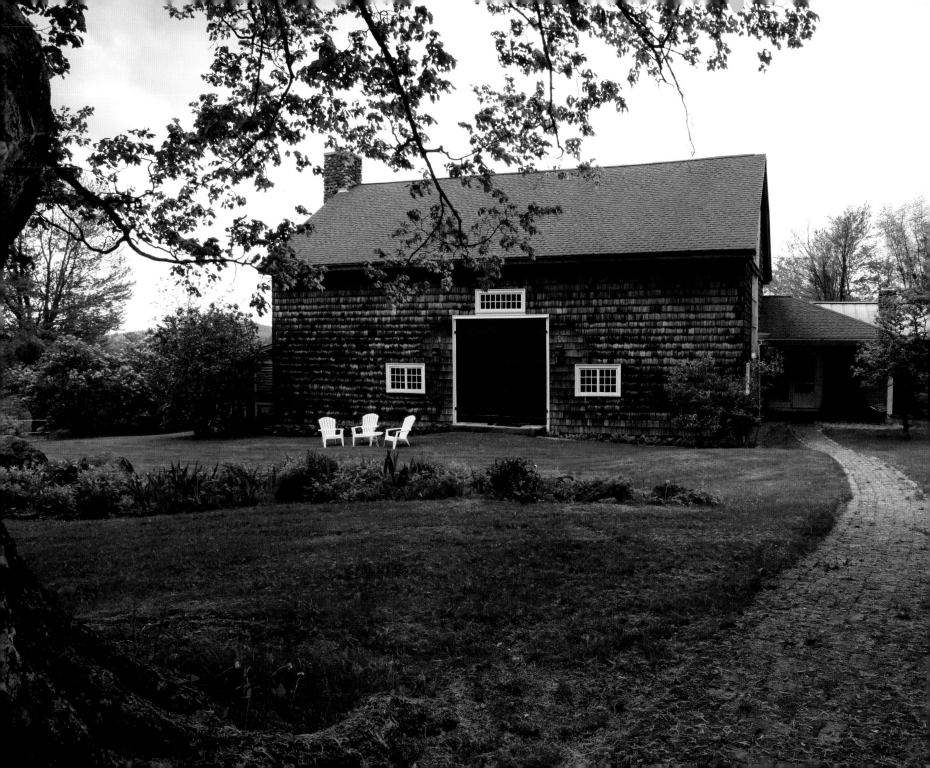

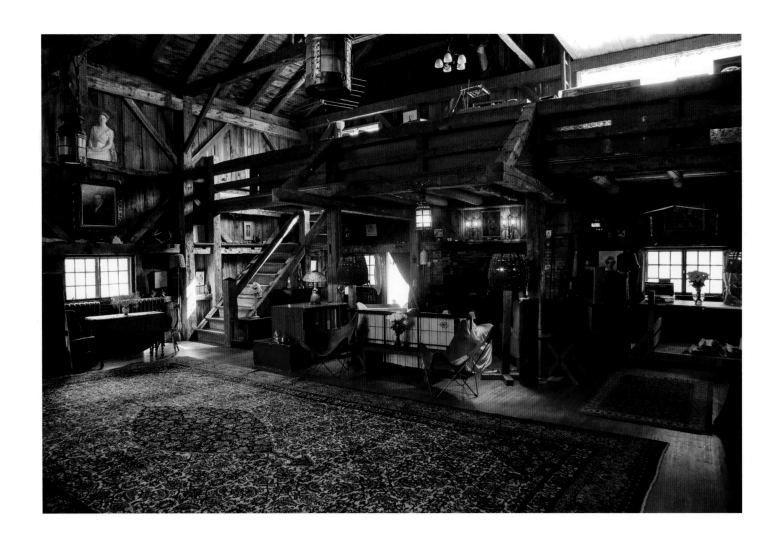

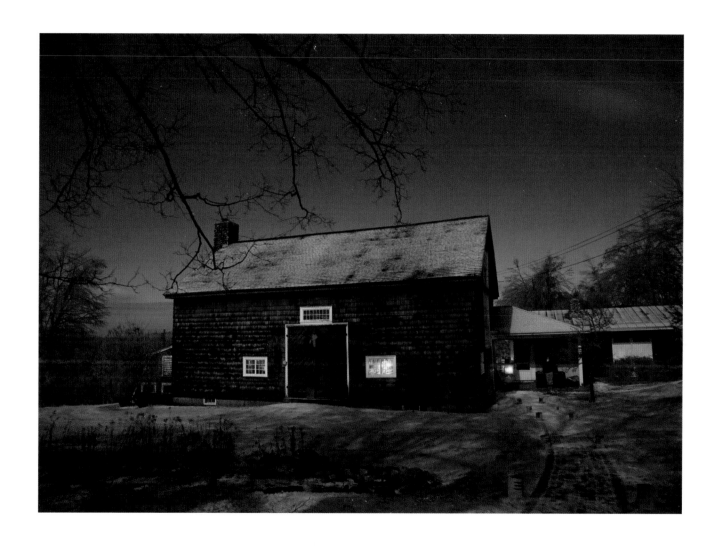

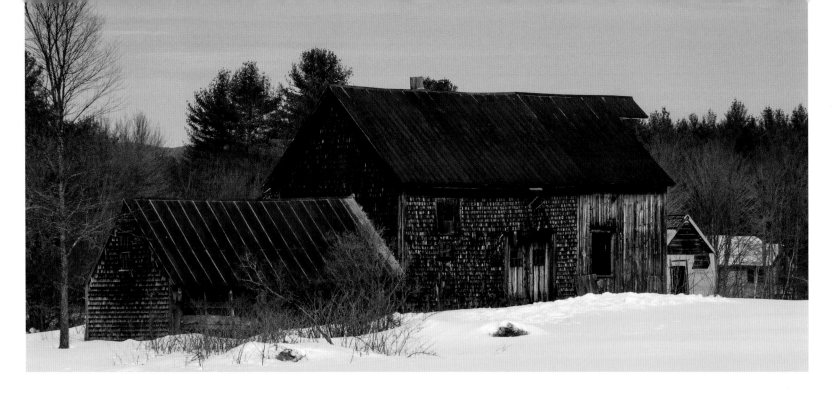

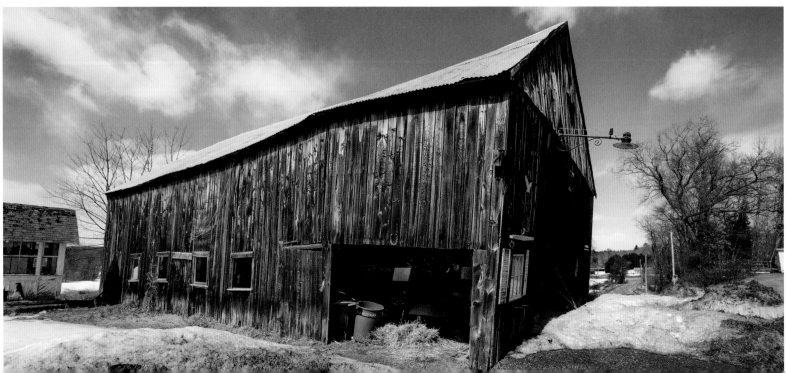

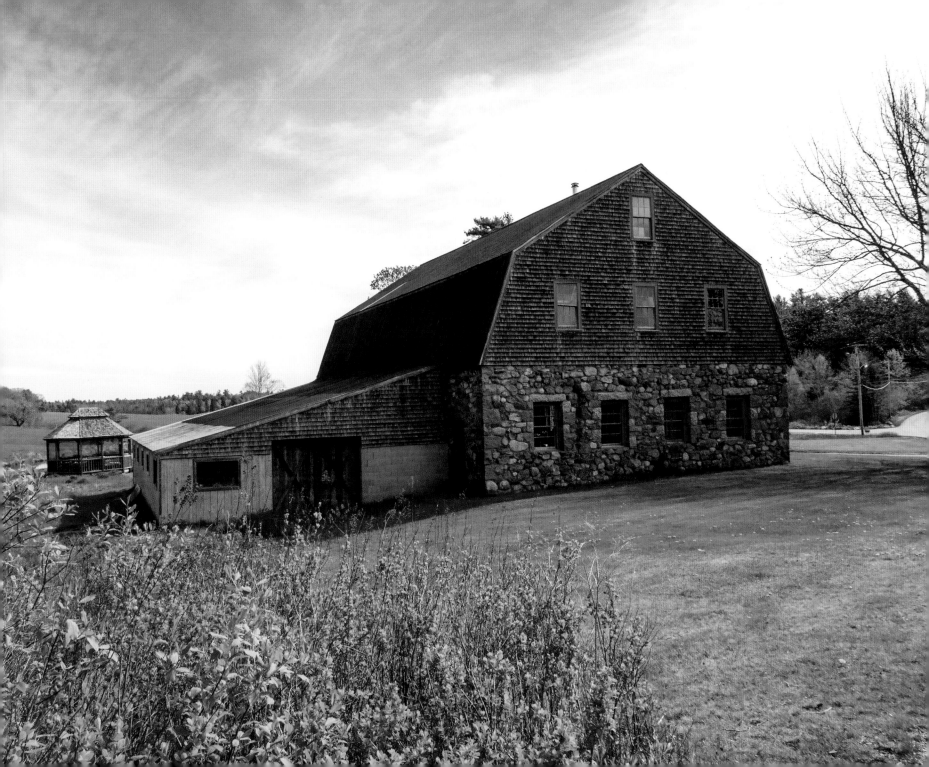

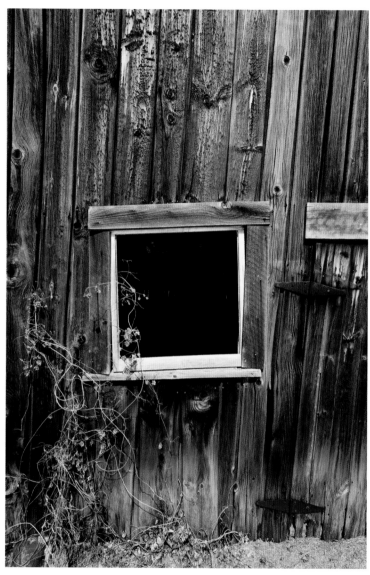

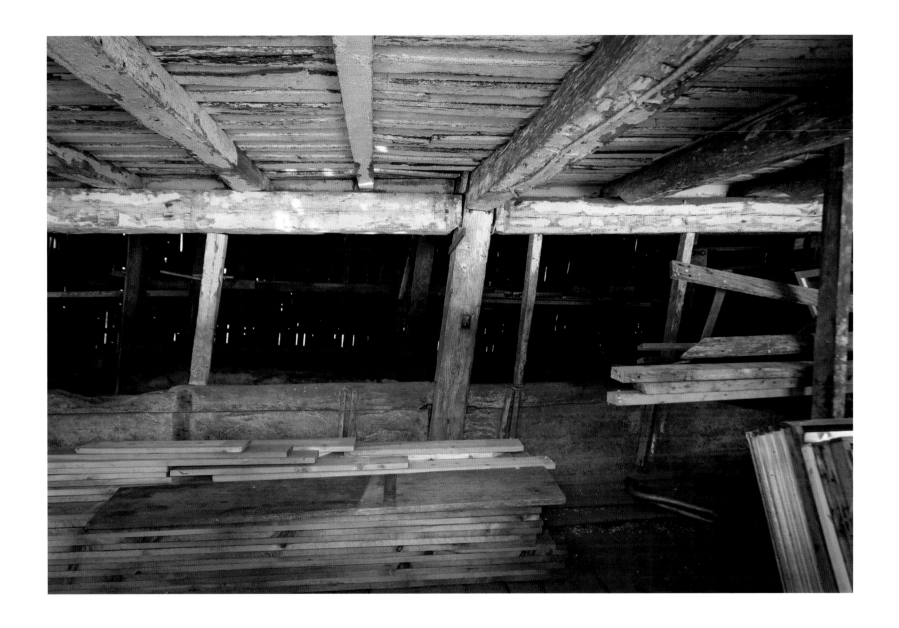

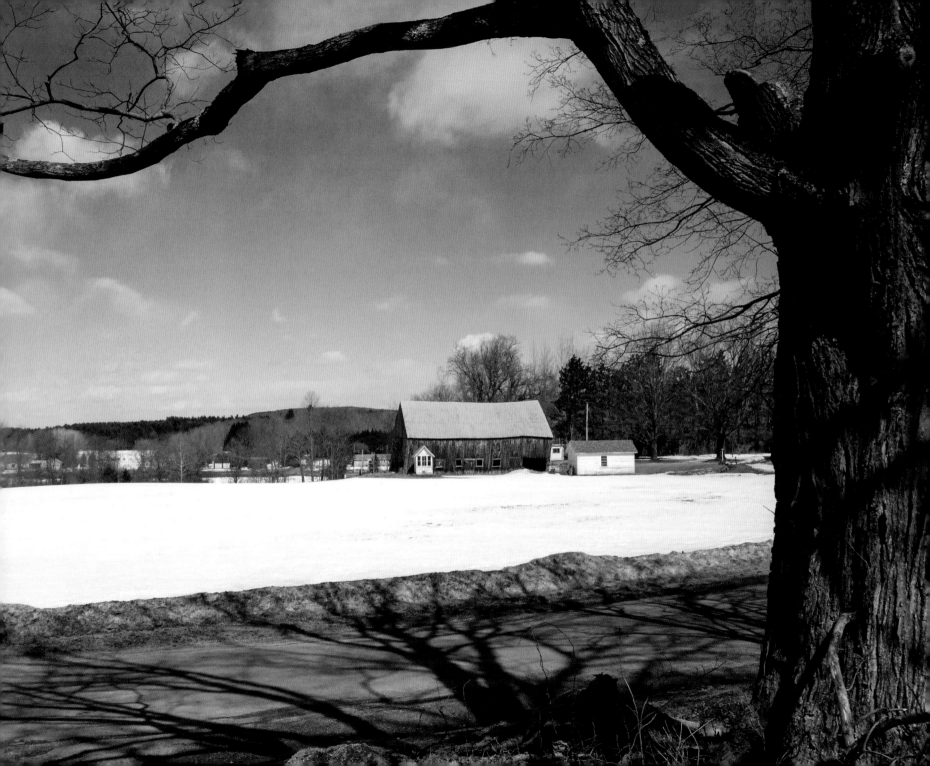

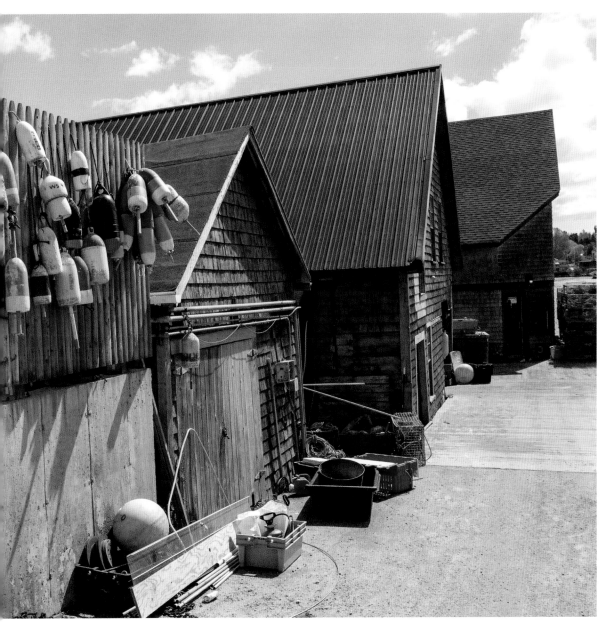

WORK SHEDS

Tilting is a small Newfoundland town of sheds, or "stores" as they are called. There are wood stores, grub stores (for bulk food), general stores (for all-purpose tools and supplies), stages (built out over the harbor to store boat gear and clean fish), twine stores (for mending nets), flakes (wooden platforms for drying fish), slide storage (for horse-drawn sleds), carpentry shops, coal houses, outhouses, garages, milk houses, hen houses, pig pounds, stables, and cabbage houses (old rowing punts, turned upside down and covered with earth).

Quite a few of these sheds are "launched just as boats are launched"— moved from place to place once one owner is done with them. Some sheds are pieces of houses that have calved like a glacier; an old "back kitchen" will be launched to continue life as an out-building elsewhere. In this way sheds— ephemeral, a built tool—have nine lives, a surprising resiliency.

Houses, too, may be "launched." The houses are tough but loose-jointed, growing with the family, adding back-kitchens, bedrooms, back porches, washhouses. Built of trees felled on the island, the houses are tight enough to withstand wind-driven rain and the salt air. They don't mar the land with a foundation or a basement. They sit on "shores"—posts like those used to support docks. When a house is sold, the land stays in the family, and the house is launched, pulled across the ice, or floated across the harbor. Horses once did the pulling, and before that a team of seventy-five to eighty men. Today a tractor is used. (A house once went through the ice. They dug a channel and pulled it out. The house was in fine shape, only the wallpaper "spoiled.")

If you drove through Tilting without an introduction (after the fifty-minute ferry crossing from the mainland and a forty-five minute drive across Fogo Island), it might strike you as a stark, treeless place with angular, boxy houses bobbing on a rocky landscape, jouncing up against each other. But in his fine book about the town, architect Robert Mellin teaches us to see Tilting's rough beauty.

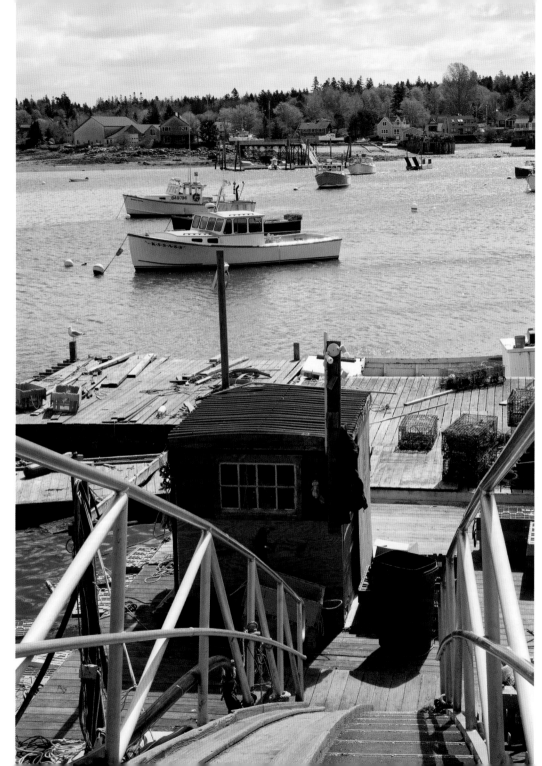

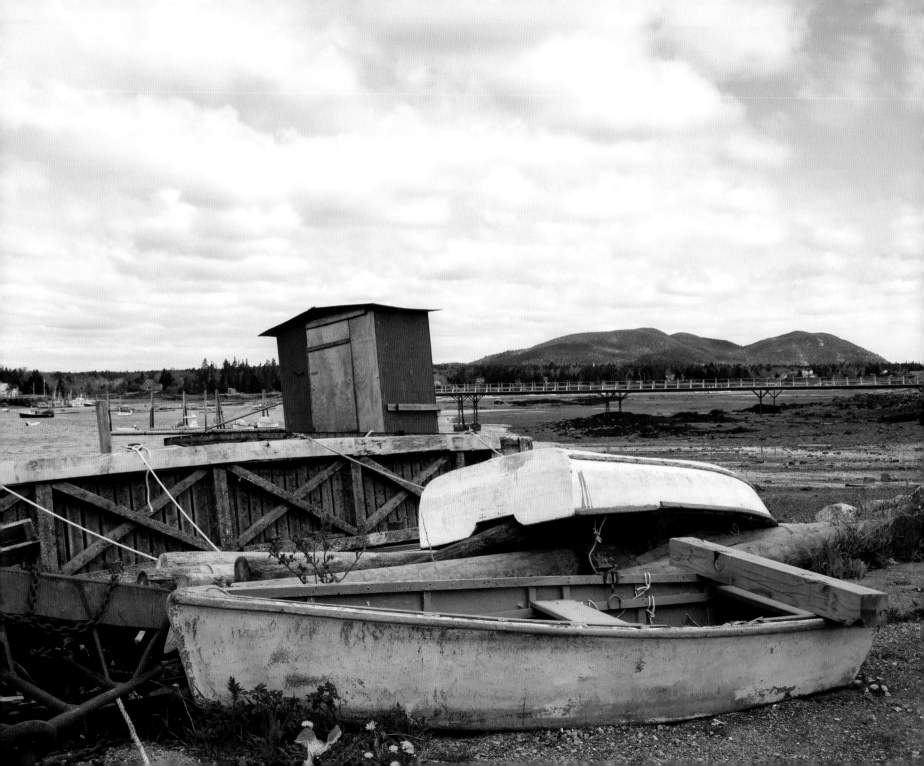

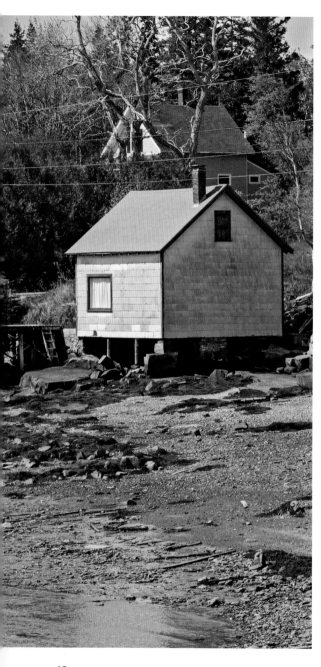

The town took its name from the splitting and salting of fish, or from the sheds set up to do that, the "tilts . . . temporary wooden structures, constructed with vertical log walls and log roofs covered by birch rinds and sods." So Tilting is a town that may be named for a temporary shed.

Mellin has visited and measured every house in the small town of 350. (He also bought one.) The population is down by a third since the collapse of the cod fishery, due to overfishing by large offshore draggers. Ashore, Tilting folks were once busy hunting, berry picking, and hauling fresh water until it was connected to a public water supply in 2001. In winter, woodcutting used to be a full-time job, the men working in small groups to "slide haul" wood across the island on horse-pulled sleds. "Tilting's traditional way of life was in balance with its available resources," Mellin wrote. It's still a hardworking place. Tilting "never stops working. If they are not fishing or farming, they are making repairs or trying to get ready for the long winter ahead. Tilting's outbuildings are a testament to the diverse and difficult work of the community."

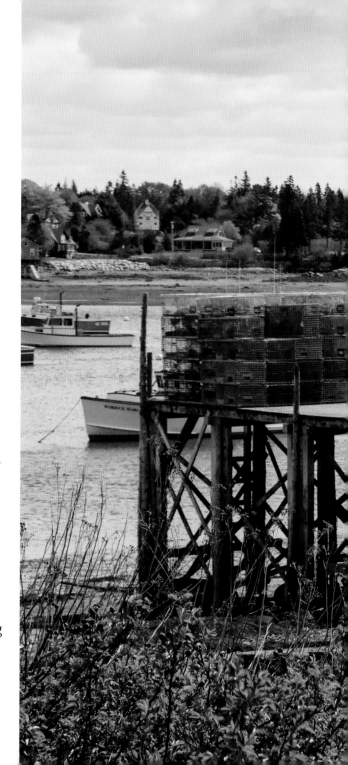

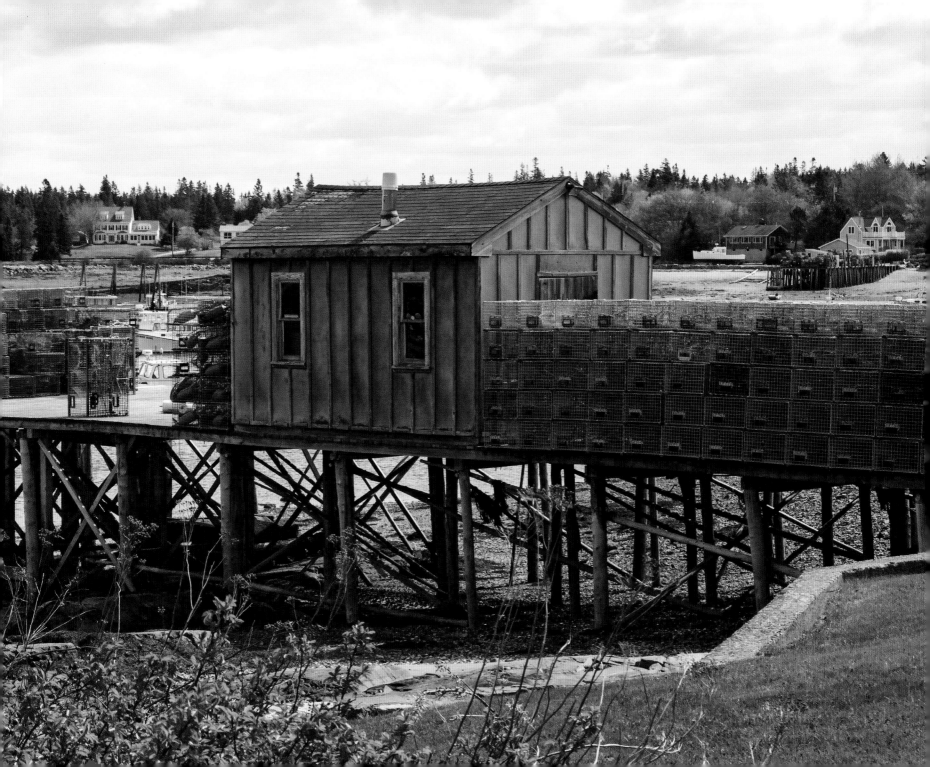

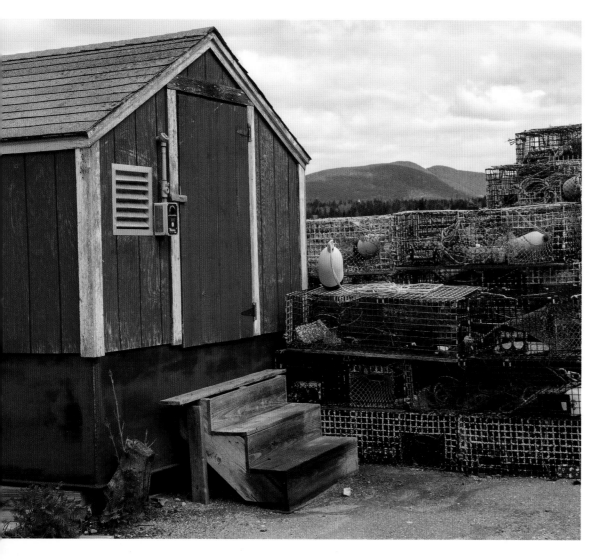

Once a shed is set in motion, it, too, never stops working. "Gilbert Dwyer's twine loft was originally a house built by John Ellsworth around 1872. Before it became a twine loft, it was a store and then a cod liver oil factory. It was also used for pit-sawing lumber and for building boats; Phonse and Joe Dwyer built twenty-five boats in it. The building was moved three times, and its roof was cut down from a gable roof to a flat roof."

The brightly painted houses and sheds are "a formal architecture of resistance," but also "a fragile architecture that ultimately acknowledges that circumstances change, families get larger and then smaller, people move around or they move away, but life still goes on." Mellin has identified an important mixture—the temporary and permanent, the soft and hard qualities that animate shelter.

In the many sheds "there are contrasts of light and dark, closed and open, dry and humid, quiet and noise. The fishing shed with its open floor of spaced beams, or longers, is open to the air and the sound of the water below, producing a slight feeling of exposure or vulnerability. The stage offers variations in light—the daylight of the open flake or bridge, to the dark stage interior with

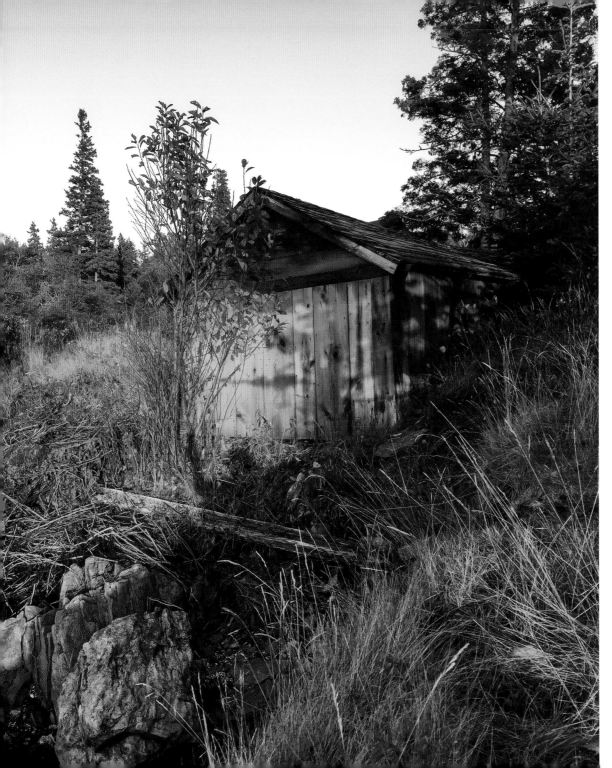

its small windows, to the brightness of the stage head with light reflecting off the water. The stable is enclosed, dark, soft with hay, and muffled in sound. The root cellar is dark, humid, cool, and silent. You have to feel your way around in the dark. The twine-mending loft and carpentry shop is bright, dry, and warm, and the crackle of softwood burning in the makeshift oil barrel stove provides the background to the sound of conversation and work. In each outbuilding, what you notice first and what predominates in memory is the smell of fish, hay, earth, twine, or wood."

None of these buildings have what we would consider a proper foundation. "It is this aspect of Tilting's construction that's remarkably fragile: houses, outbuildings, stages, and flakes constructed with wood foundations that carefully supported and balanced the superstructure over rugged, irregular terrain, and left no traces."

A shed is more fragile than, say, a cathedral or a big box store, but because of its fragility it may outlive both. Fragility may equal flexibility. This is the chief distinction of the shed: it is flexible. It can be rebuilt, moved, taken apart, reassembled, restored, renewed. Sheds are workshops for life.

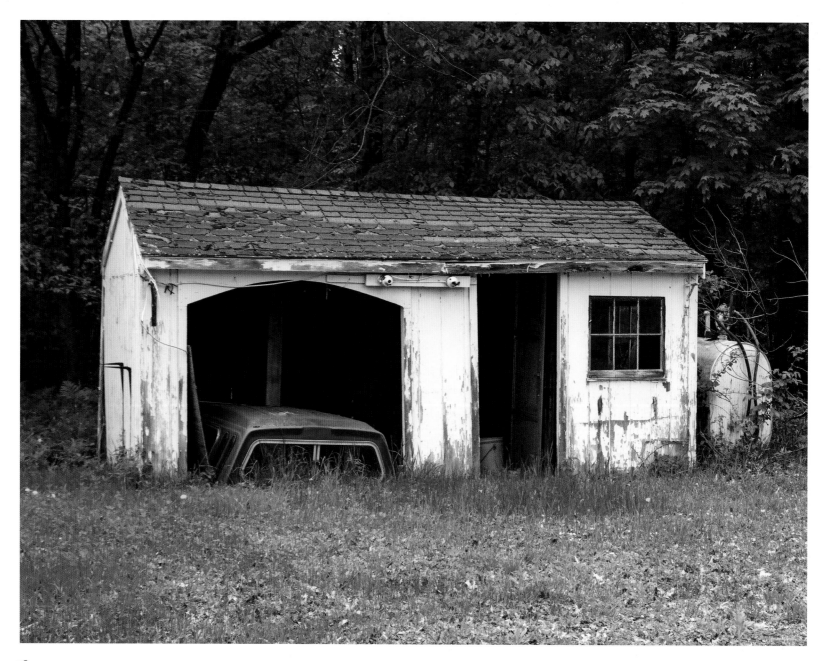

46

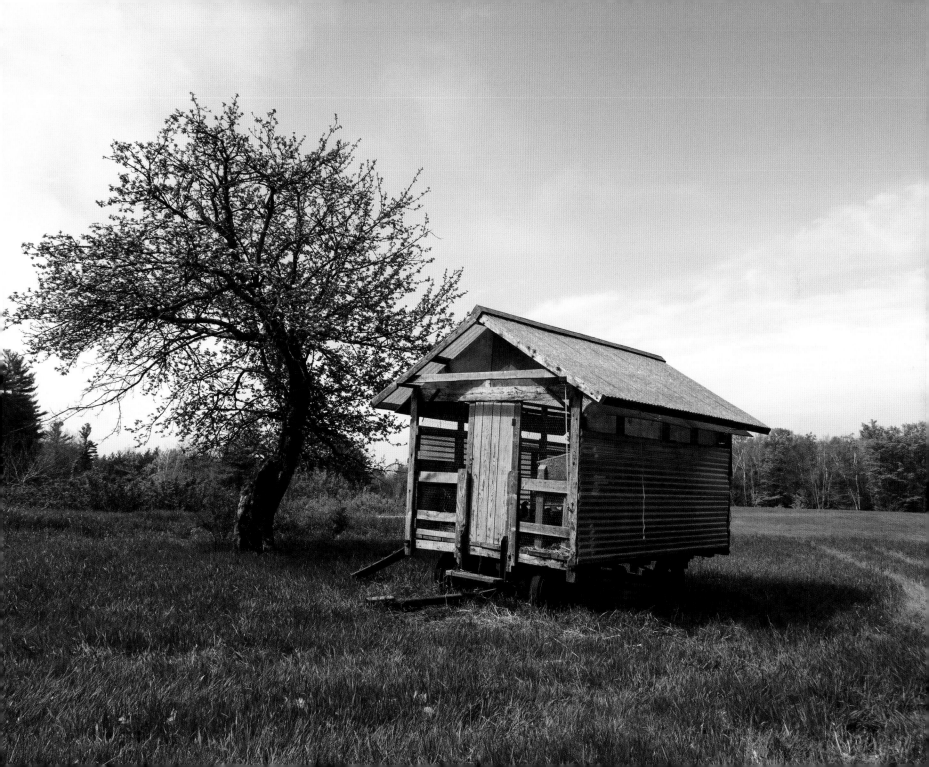

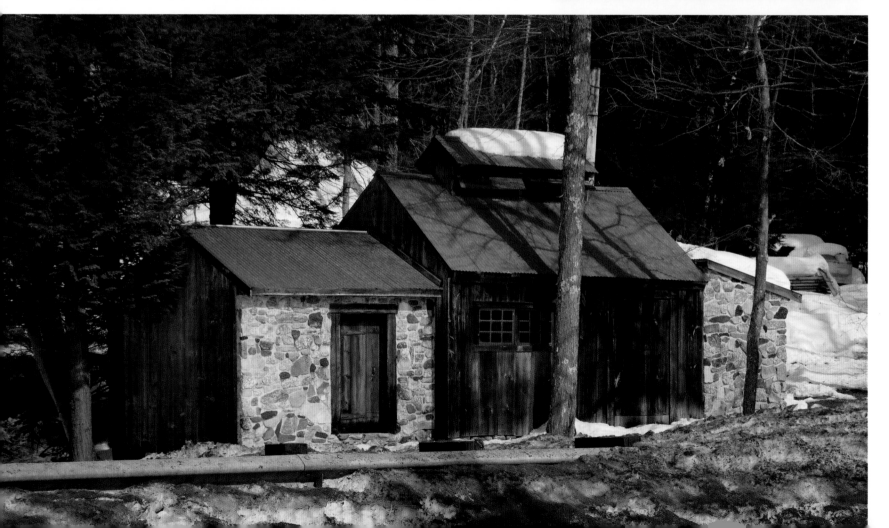

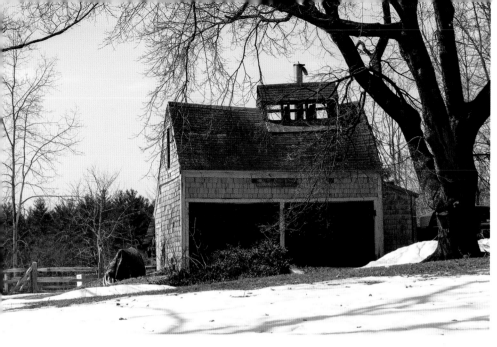

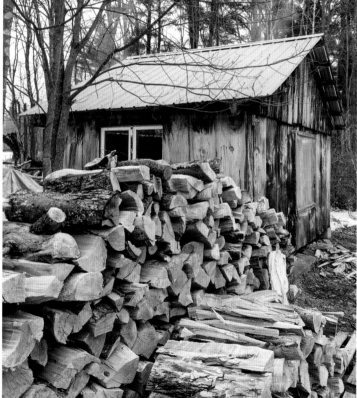

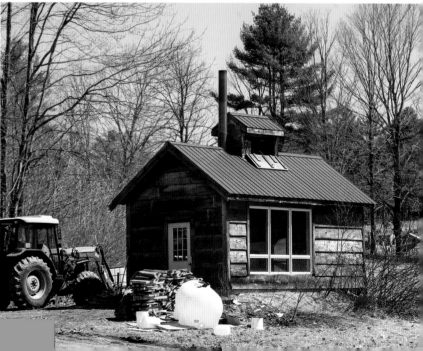

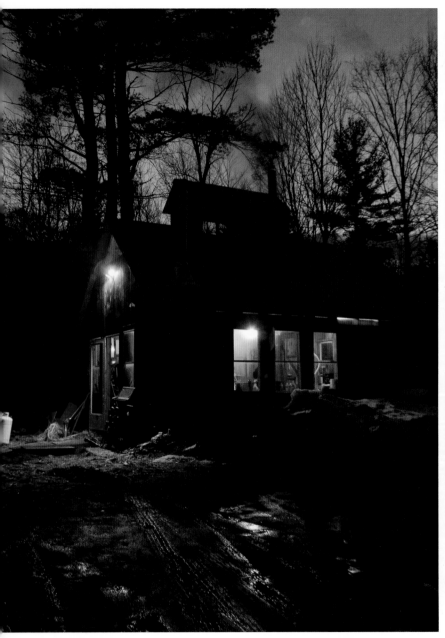
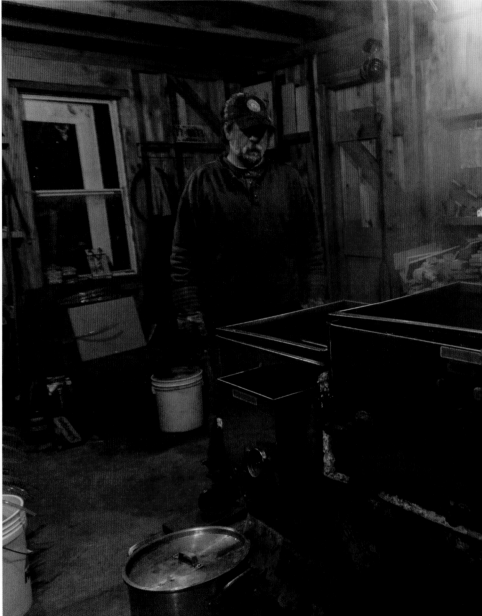

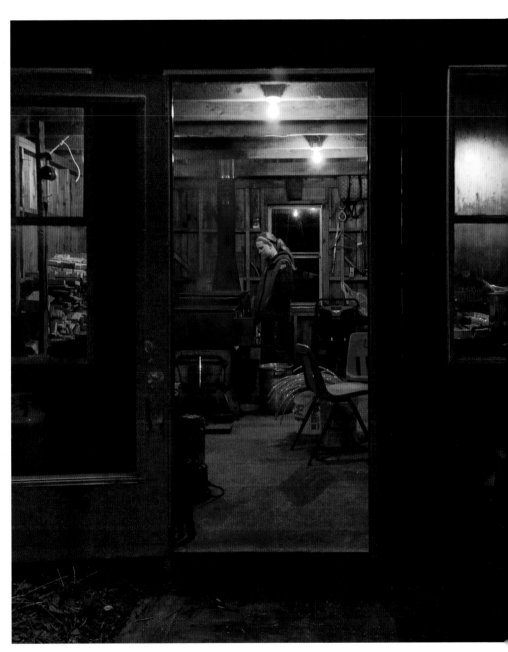

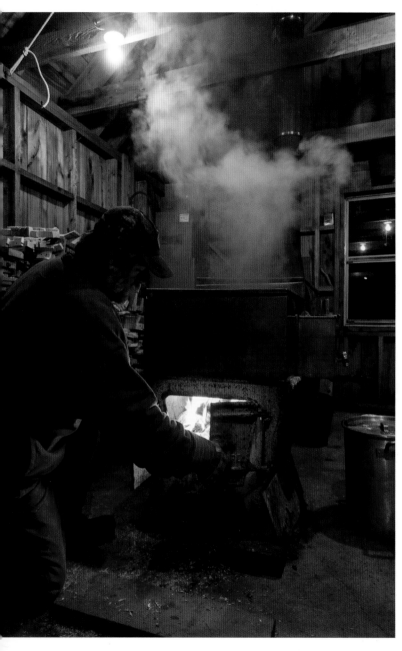

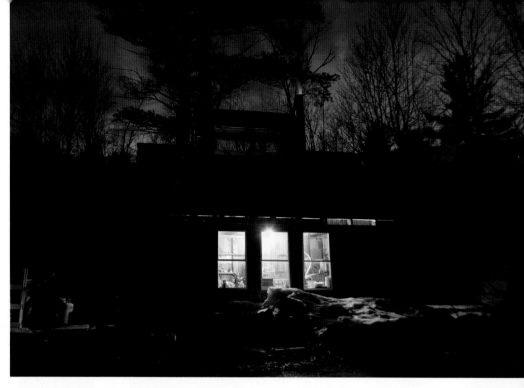

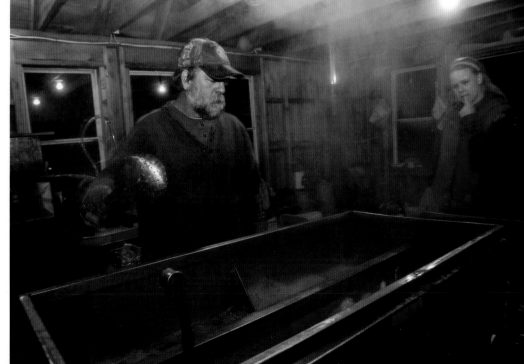

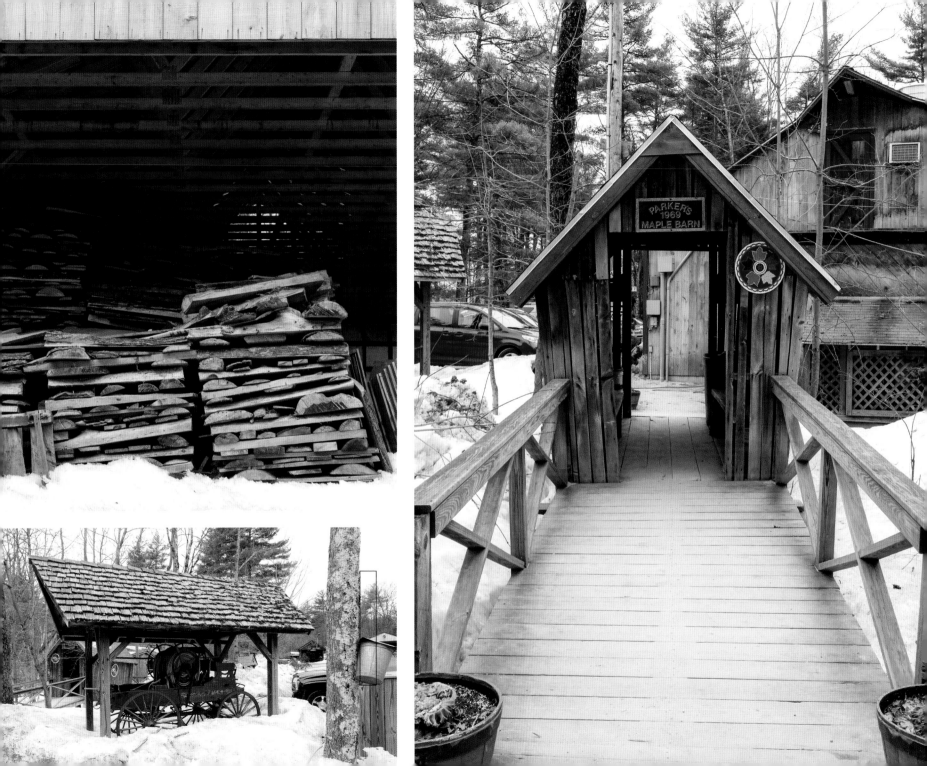

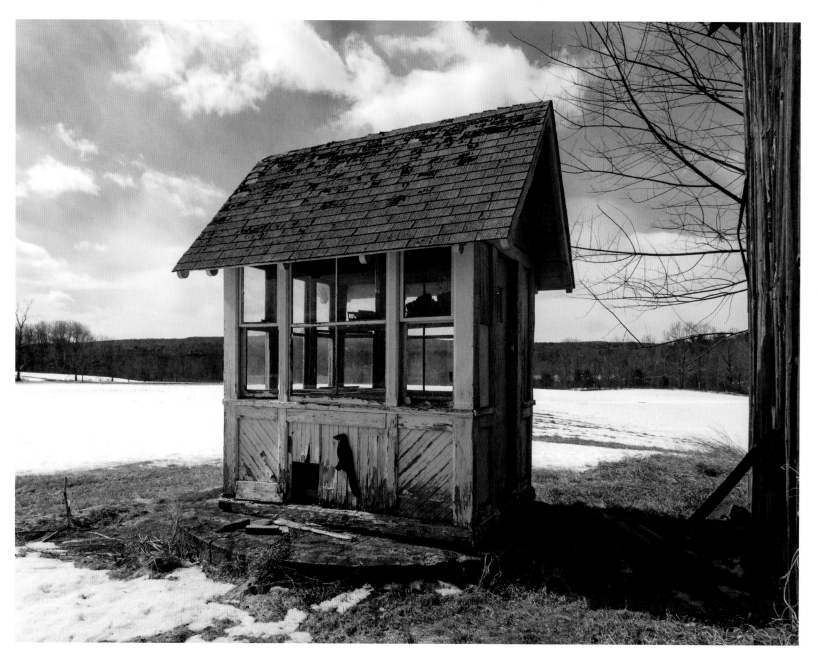

54

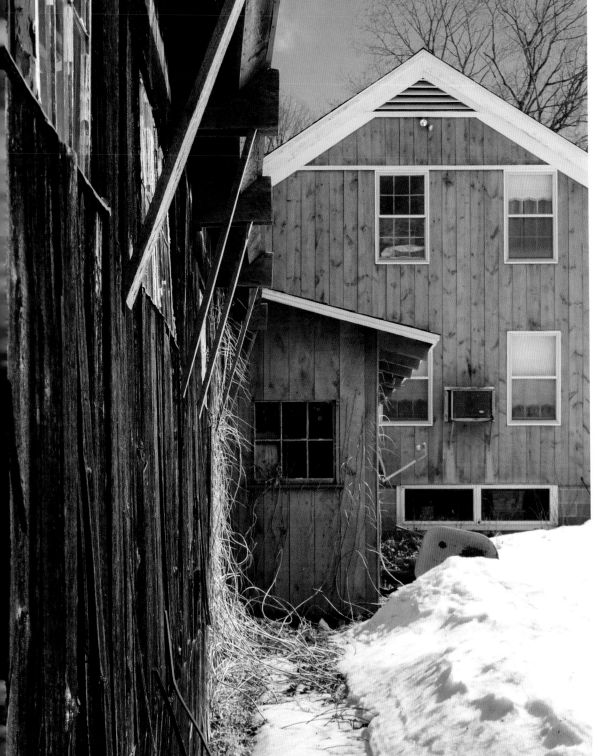

CONNECTED FARM SHEDS

In the spring of 1850, Tobias Walker, a Maine farmer, used forty oxen to pull his large woodshed from behind his house to the barnyard. Later that year he took down two old barns to replace them with one larger barn. Many of his neighbors were busy with similar projects. Northern New England, a tough place to farm, was losing out to bigger farms out west. Farmers like Walker responded by moving their sheds and barns, lining them up, and joining them to their houses. They were looking to modernize, to make their farms more efficient. And they were looking for a touch of grace, detailing their barns with the same elegant restraint as their houses. When Walker's new barn was finished three years later, he painted the clapboards white with red and yellow

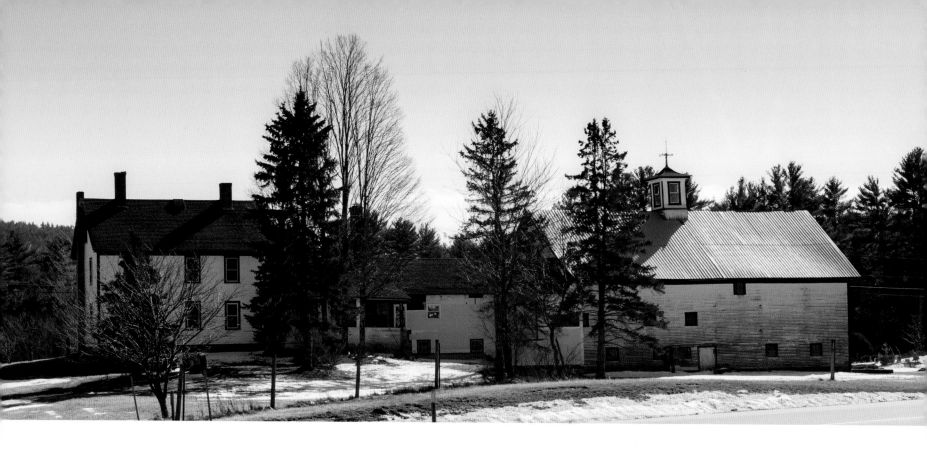

trim. He had let his old barns blacken in the weather. "Improvement is now the order of the day; improved stock, improved buildings, improved implements, improved orchards, gardens, mowing, pastures, improved everything," one Maine farmer reported to his state's agricultural board in 1858.

The unique connected farm sheds, a sign of progressive agricultural reform, became a "conspicuous and remarkable aspect of the New England countryside," said architect Thomas C. Hubka in his study of the form. A children's verse from the nineteenth century captured the new setup: "Big house, little house, back house, barn." Some old-timers could even recall the games they played to this rhyme. The connected farm buildings flourished for almost a hundred years, as common and as nameless as a stray cat. The childhood refrain is the only known

regional description. "This is surprising to a visitor from outside New England because elsewhere the connected farm building organization is extremely unusual," said Hubka.

The "big house" was the family's home; the "little house" included the kitchen, which was the hub of daily life, the summer kitchen, and a small woodshed (to feed the stove); the "back house," which connected to the barn, was a workshop and storage space for tools and a wagon. The privy was usually in the corner of the back house, closest to the barn. The little house and back house were called "the ell" because they formed the longer part of an L-shape with the big house. The connected sheds were lined up to shelter a work yard—the dooryard—from the north or west winter winds. The dooryard and the barnyard usually faced south or east.

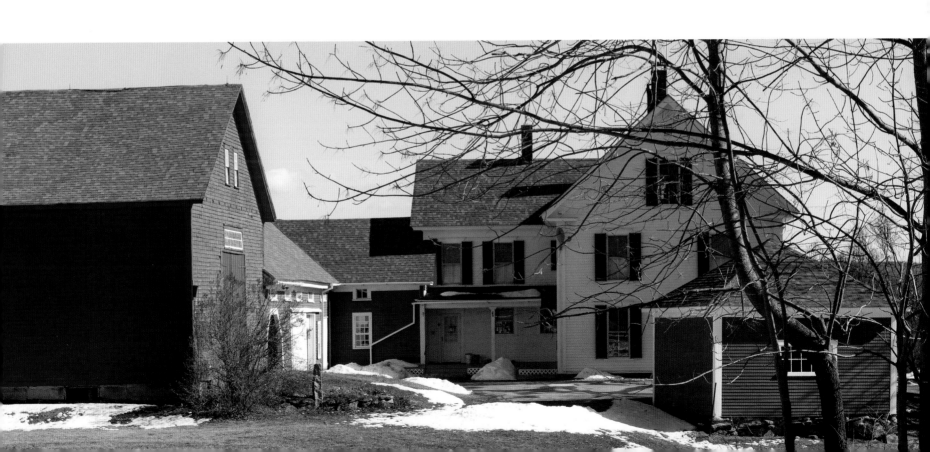

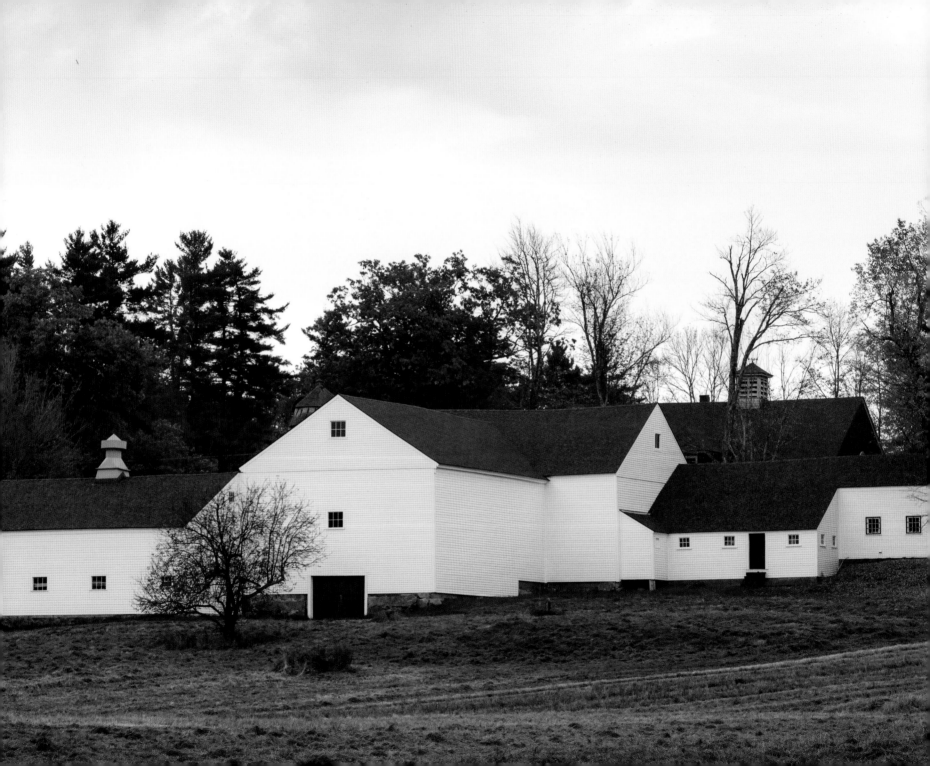

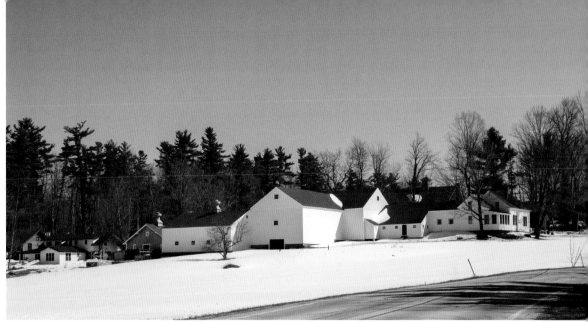

(There were, as well, at least a half-dozen outbuildings on most farms, housing cows, pigs, sheep, chickens; crops like corn, hops, apples, a root cellar; a sugarhouse to boil maple sap; a well house, and an icehouse, among others.)

Connecting the houses with the barn was a way to bring order to the endless work required to raise several crops and small livestock; cut firewood; repair tools, fences, and the house; cook, wash, and sew. "The task of describing work on the farm is staggering simply because it includes almost everything that everyone did, all the time," said Hubka.

The farmers worked hard, improved their farms time and again, followed the latest advice from their state agricultural agents, the Grange, and the farming periodicals. It was a brave, century-long battle, but they lost. "Today even a casual observer is struck by the dynamic force of these rhythmic, unified compositions. It took an undaunted collective will to improve the farm and to conduct such an optimistic building experiment in the face of a stiff struggle just to continue farming," said Hubka. "The dogged persistence of their labor and the grandeur of their dreams are still evident in the design of their farmsteads."

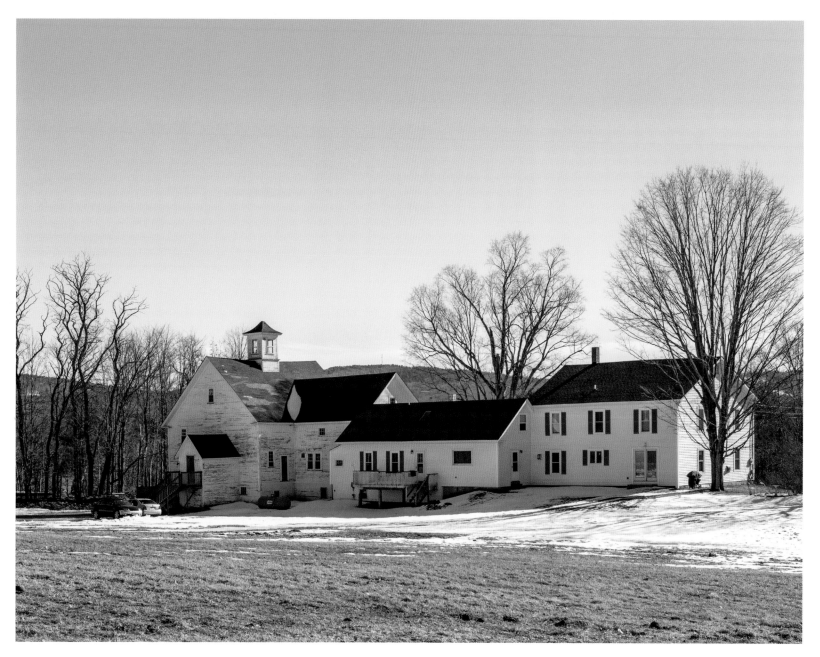

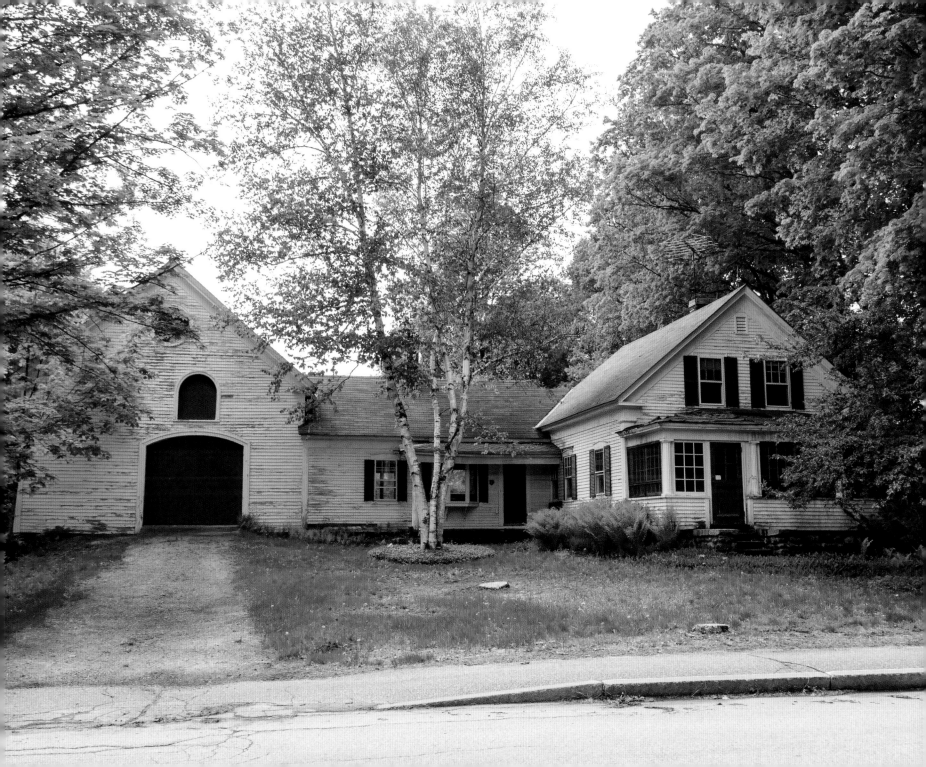

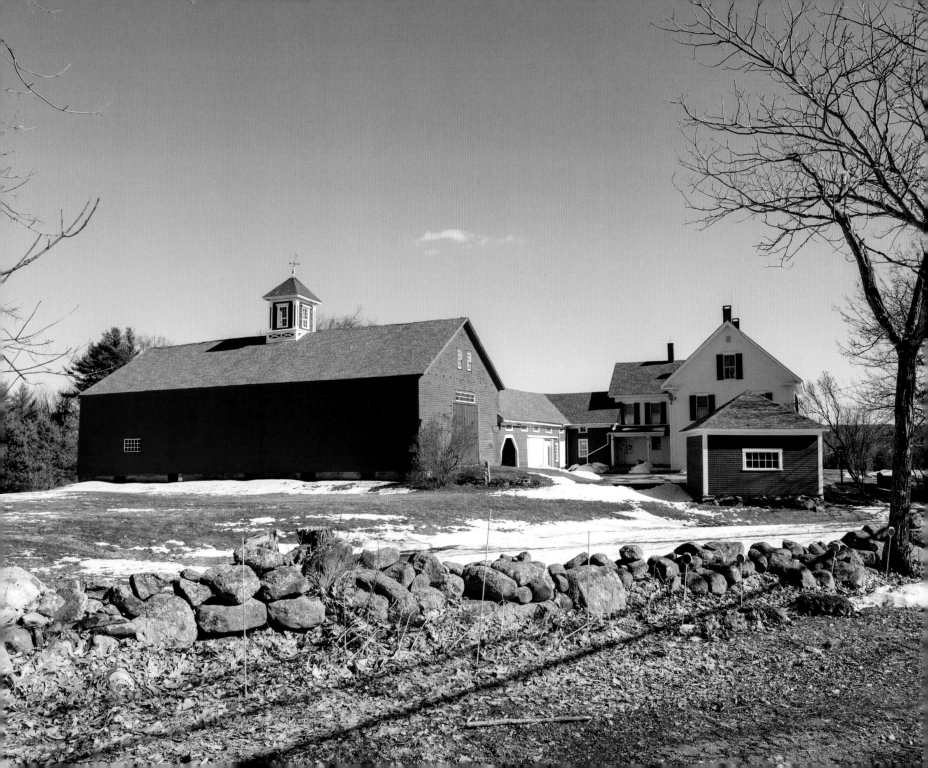

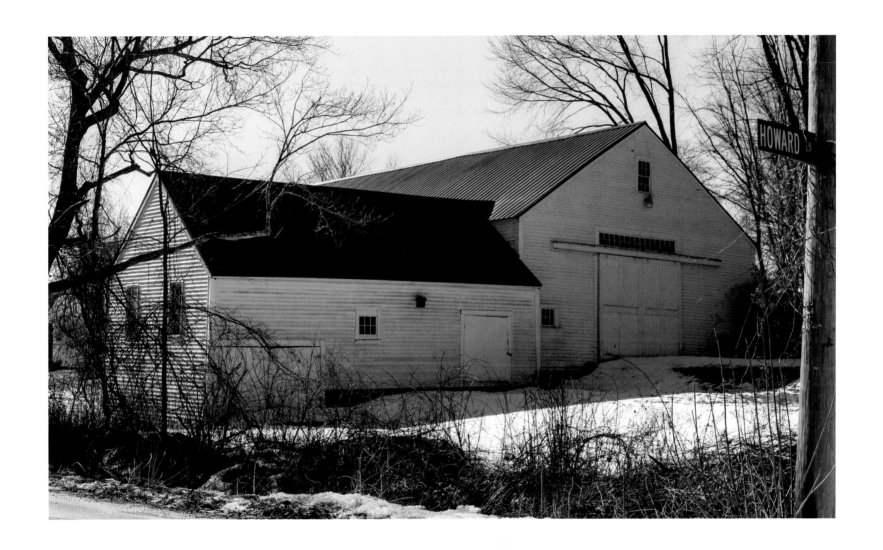

ANTI-SHED I

Electricity killed the work shed; it was no longer needed. The small retinue of sheds around the farmhouse vanished. "Gone were the smokehouse, the block-house, outdoor privy, the open well with rope and bucket, the cistern and gutter system to catch rainwater on the roof and the rain barrels under the corner eaves of the house," wrote historian D. Clayton Brown. "In many instances the garden disappeared as refrigeration enabled housewives to store fruit and vegetables." Yards were tidied up. With washing machines replacing hard days of scrubbing on a washboard, "backyards were no longer cluttered with kettles and ashes from last week's laundry."

Zoning ordinances finished the job, outlawing backyard chickens and pigs and even, sometimes, laundry drying on the line.

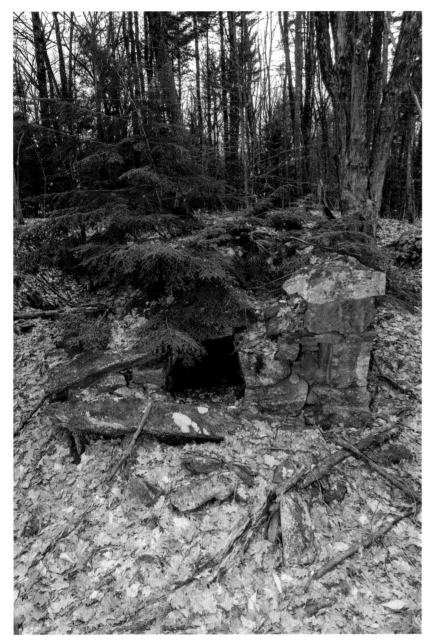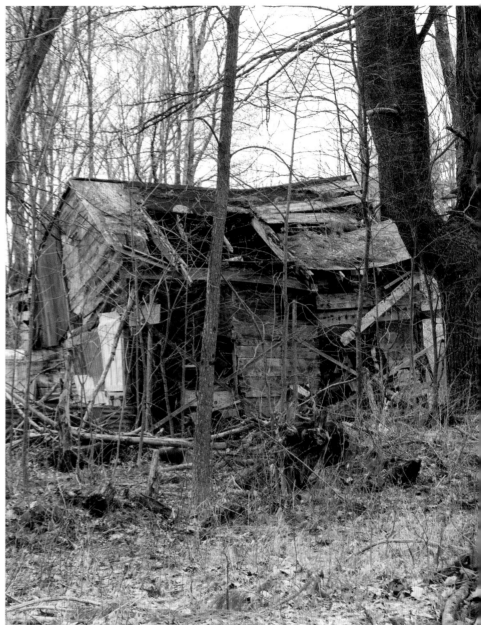

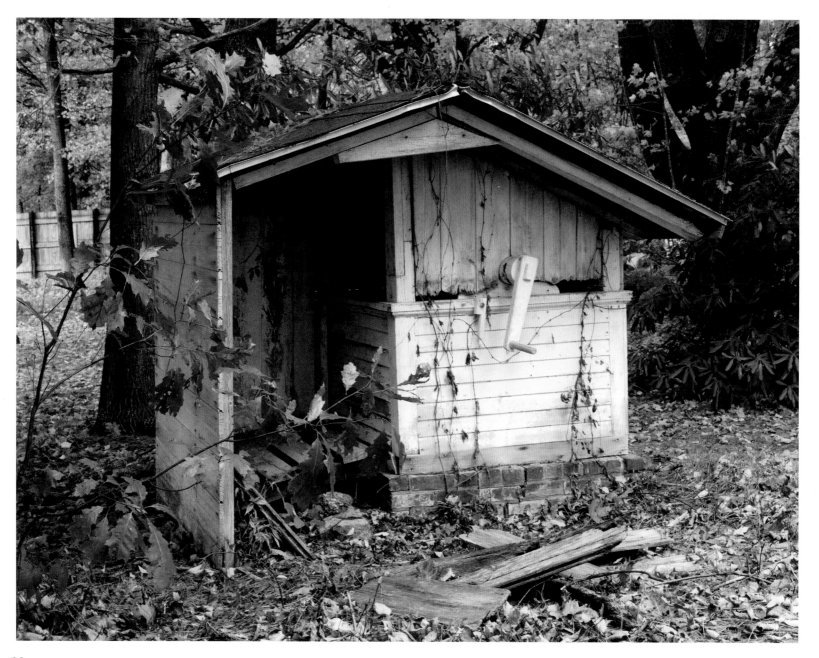

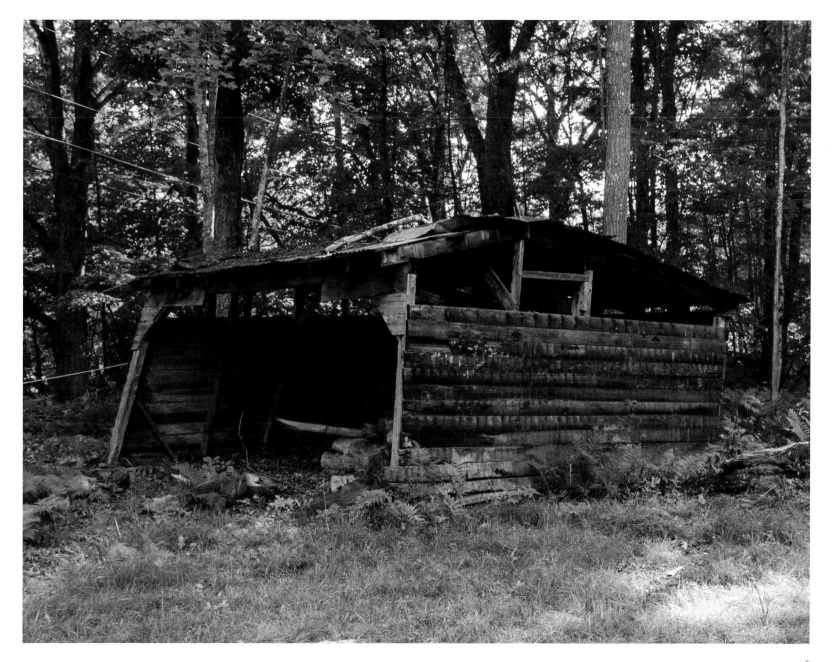

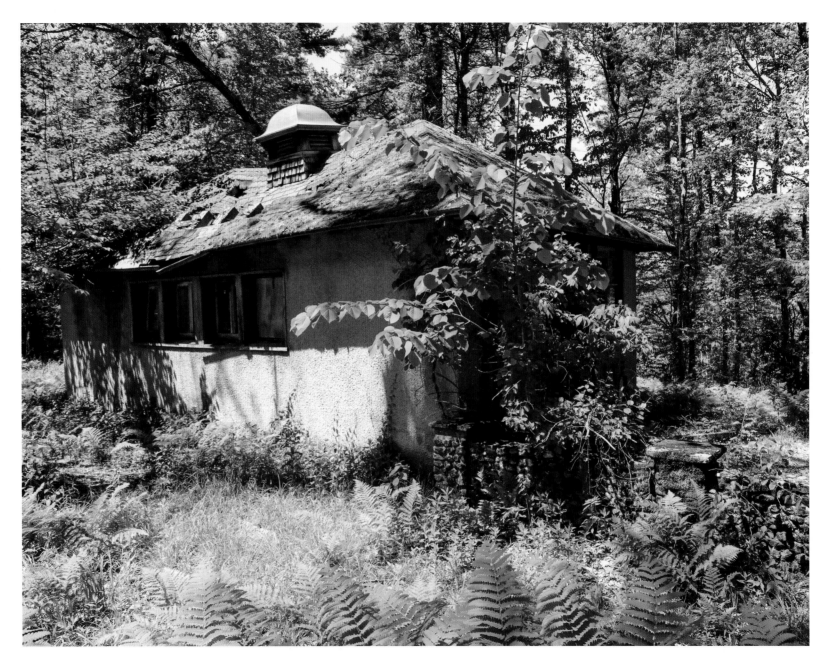

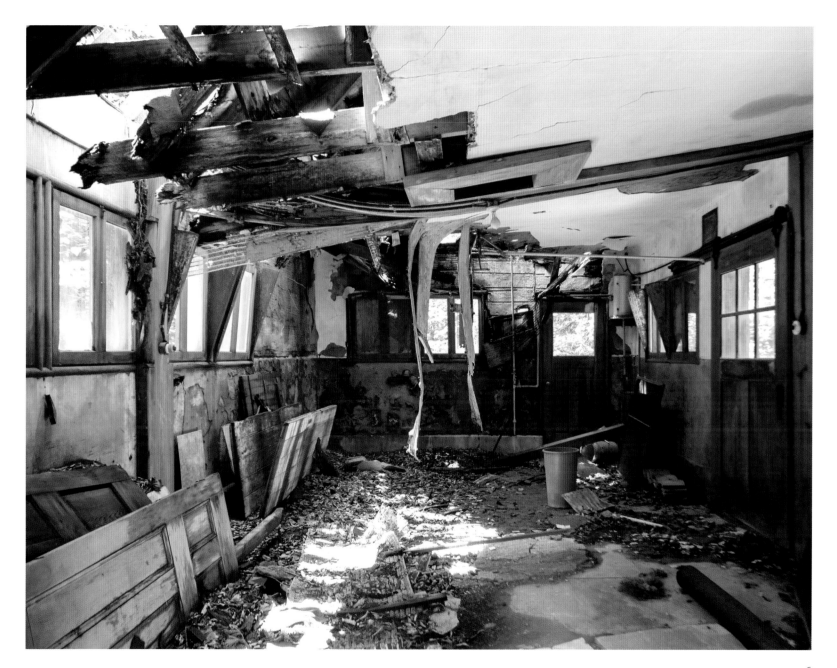

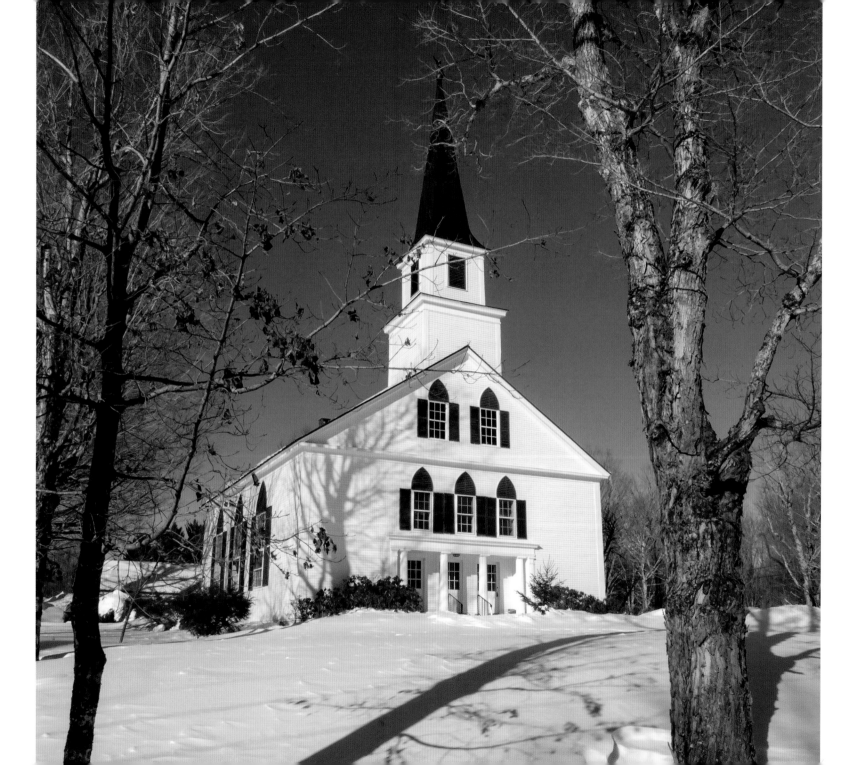

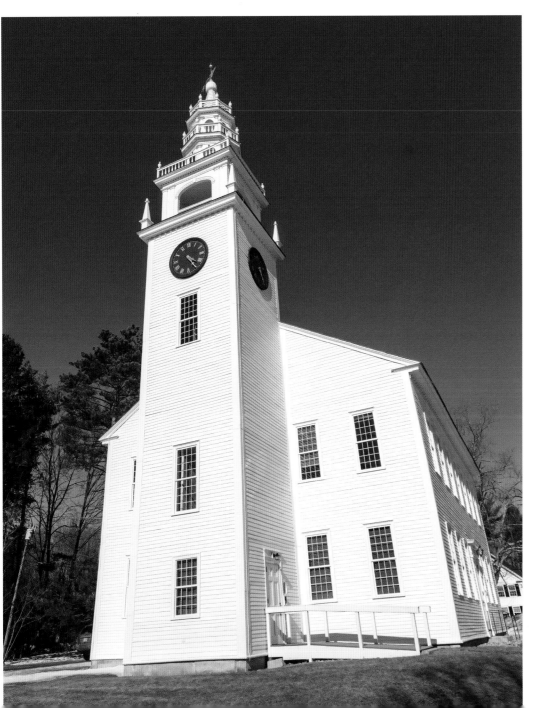

WORSHIP SHEDS

Meetinghouses were not sacred places. The Puritans wanted nothing to do with the pomp and theater of other denominations. They had simple requirements: a room, a pulpit, and a table. They built plain, large houses for worship in early New England. Meetinghouses were anti-churches—they had no spire, tower, bell, clock, stained glass, statues, frescoes, or altar. They were oriented in an un-churchlike direction: the front door was on the long side (not the narrow gable end). They were just minimal shelters for prayer. (Quite minimal. They had no lighting and no heat. "Bread was frozen at the Lord's Table," noted Samuel Sewall in January 1716.)

These Sabbath Day tools were roughly treated. They were moved, burned, and discarded; they were converted to ugly churches or useful barns. (The Third Meetinghouse in Hatfield, Massachusetts, later served as a tobacco barn.) Thousands were built; few survive. Of the 337 "first period" meetinghouses built between 1622 and 1770, only 15 are left, or about 4 percent. Of the 1,156 built later in the "second period" (between 1699 and 1820), just about 190 remain, roughly 16 percent. The last 603 meetinghouses built, in the short "third period" (1790-1830), fared better, with more than half still standing. In the early periods, the least likely structure to be left standing after fifty years was the meetinghouse, said historian Peter Benes, who provides the count. Fashions in faith brought changes; towers and spires were added, buildings were rotated to a more churchly position, entrances and pulpits were moved, pews and furnishings grew ornate. Today they are venerated as symbols of continuity and repose, great white ships of faith, but the meetinghouse remains a barn with a spire.

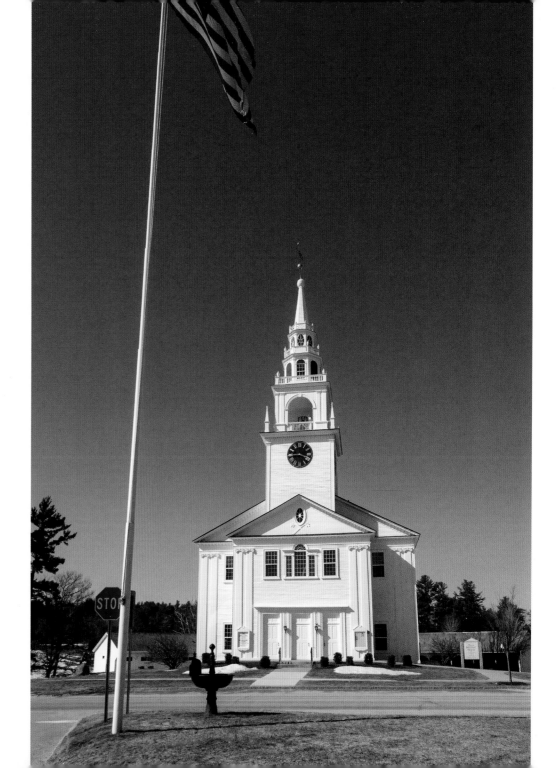

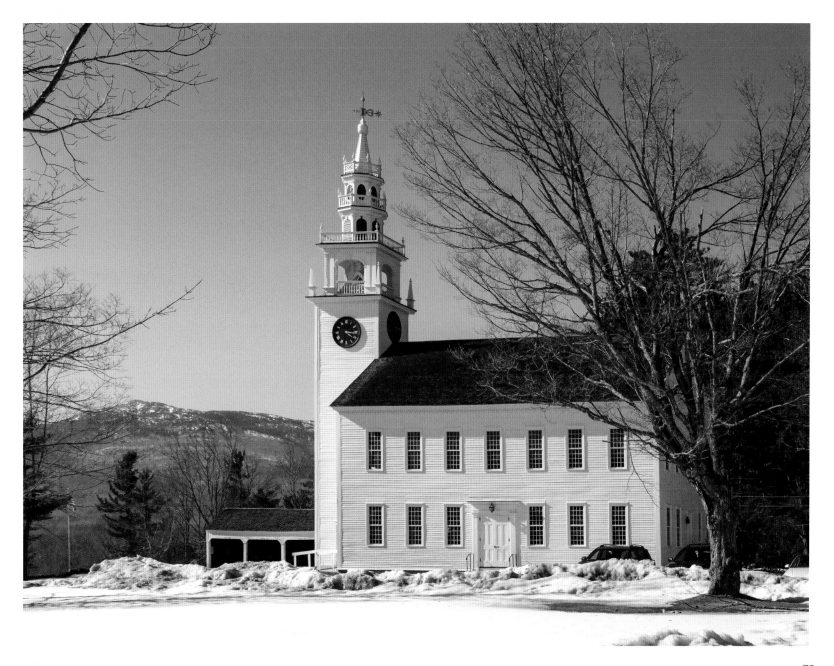

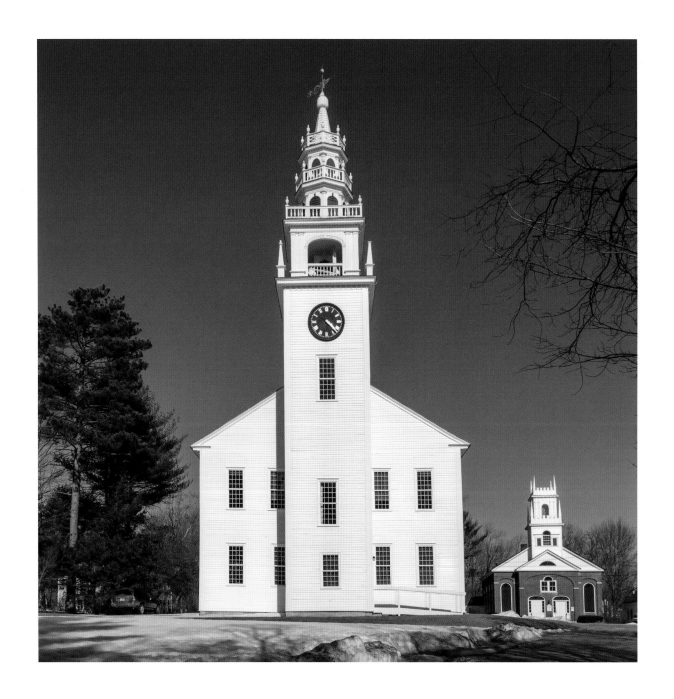

DREAM SHEDS
(Summer Cabins)

"In Finland, life is dictated by the seasons; summer holds the promise of leisure time and, in a sense, of liberation from the community—from school or work," write Jari and Sirkkaliisa Jetsonen. "People construct dreams for the summer—often a cottage built with their own hands."

Finnish summerhouses are small, one-story, and often modern. Usually the sauna is built first, followed over time by a series of cabins or rooms. They are arranged to shelter the inhabitants from the wind and to separate guests from the kitchen.

It may be the sauna that keeps the houses close to the earth, keeps them honest, suggest the Jetsonens. Each house is informal, even the modern ones. Each is built to drink in the most daylight, to get the most out of a fast-passing summer. They are summerhouses in the true sense of the word—to dwell there is to dwell in summer.

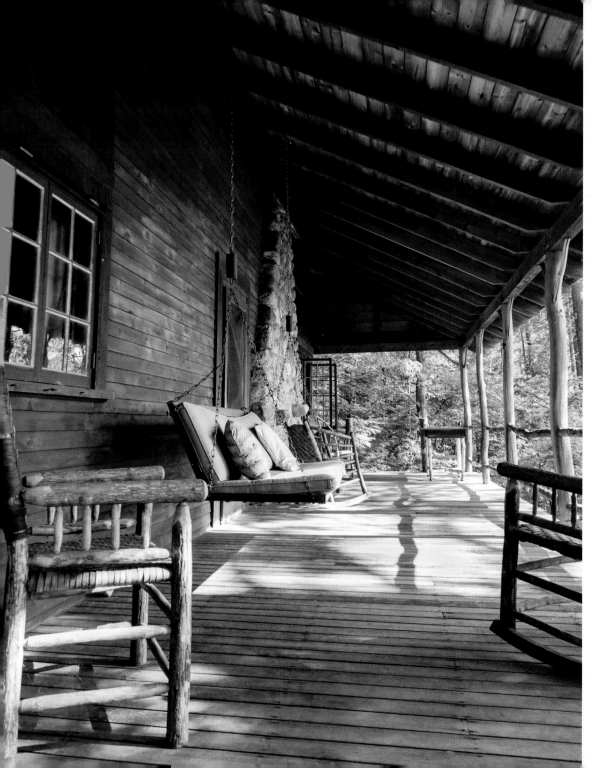

Over the years I have passed the time in a number of summer cabins. New Hampshire has many lakes and ponds, each with its own loyal protectors. Each lake and pond is some family's secret holy land, and they fear the day it might be overrun and overbuilt. The most satisfying cabins are the most un-house-like in their shambling informality. They have not been "improved" into a state of stultifying airlessness. They are imperfect and static. Summer after summer has been allowed to settle like dust. Odd gatherings of old furniture, yellowing nautical maps, hoofs and horns, found bones and shells all form a narrative, a memory map of past summers, a family history of grandparents, great-greats,

aunts, uncles, cousins, children, and close friends. The stop-time, deep-family time, eternal childhood summer of these cabins is alluring. This is your place, your people's place, now and forever.

These small cabins are a promise: summer waits. After the long winter, the story will resume.

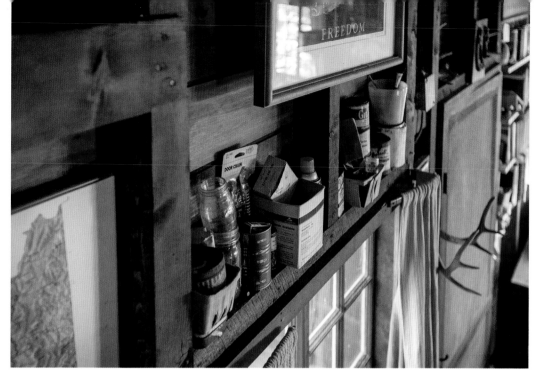

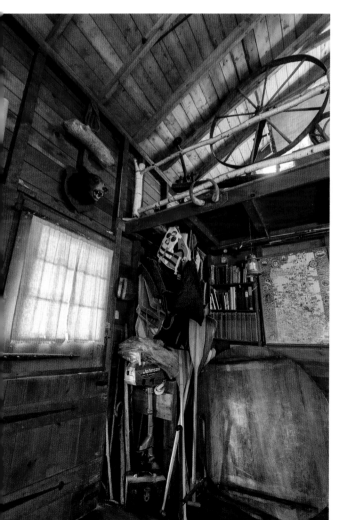

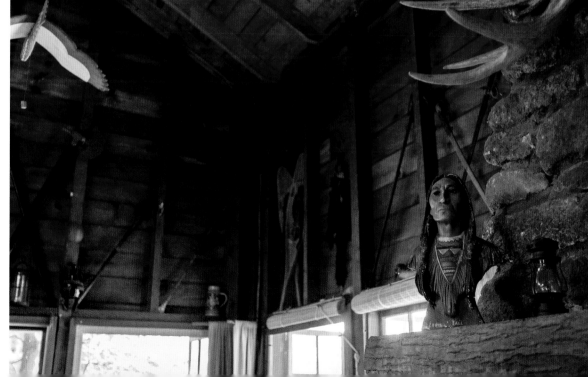

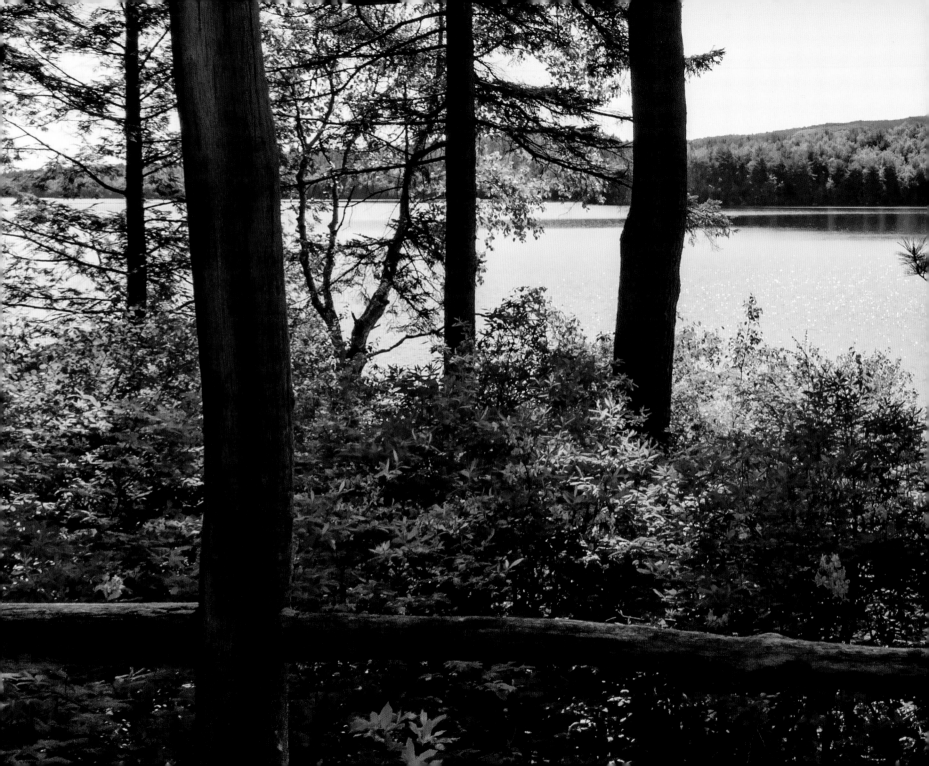

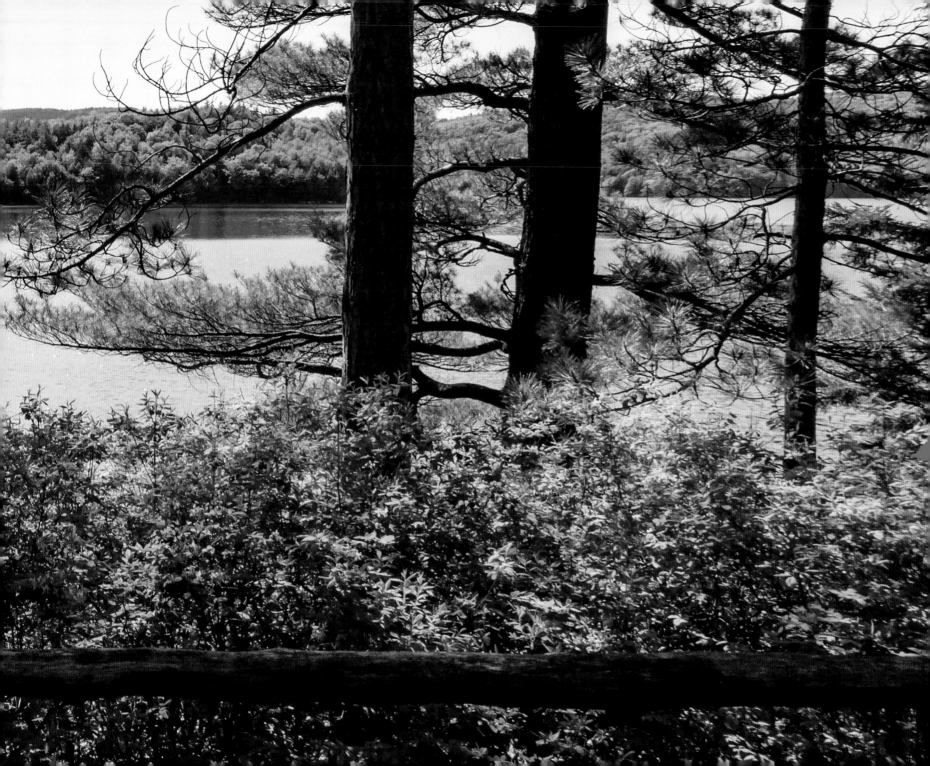

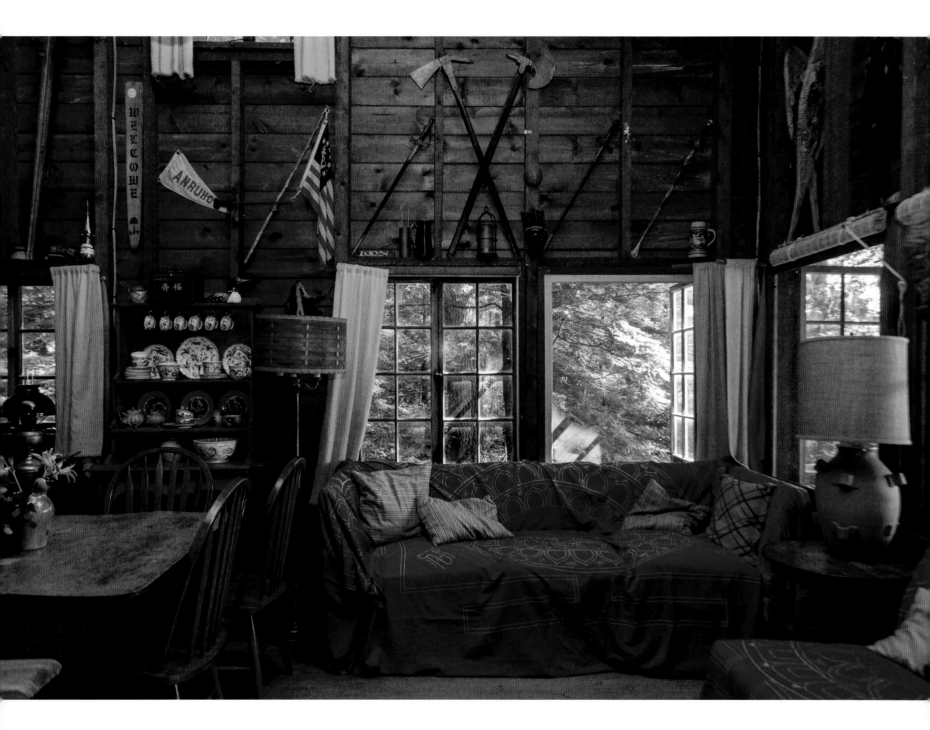

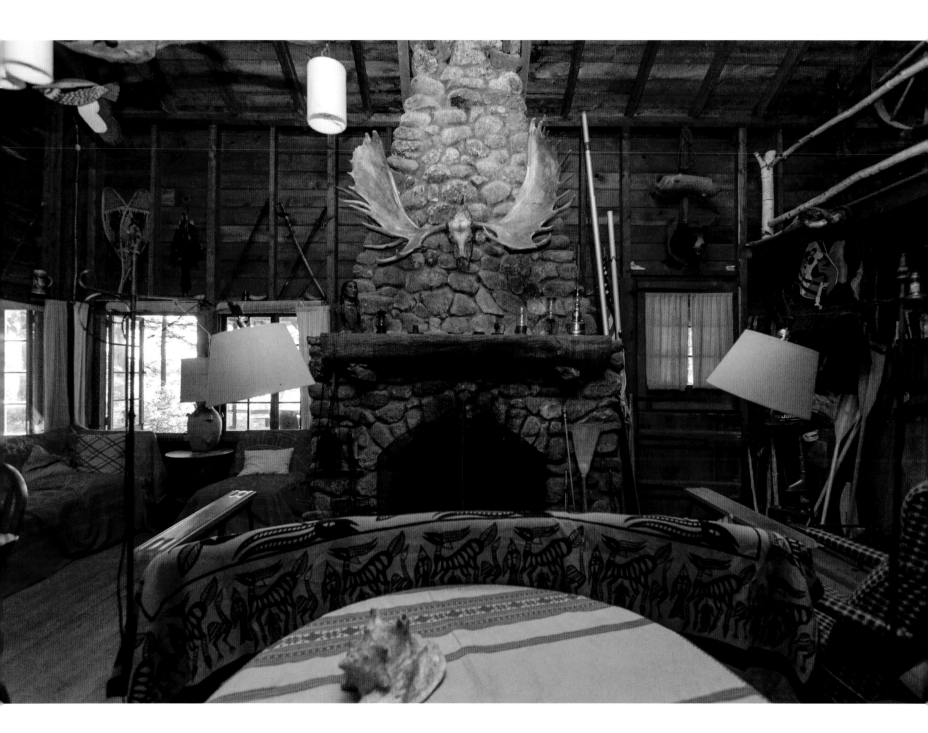

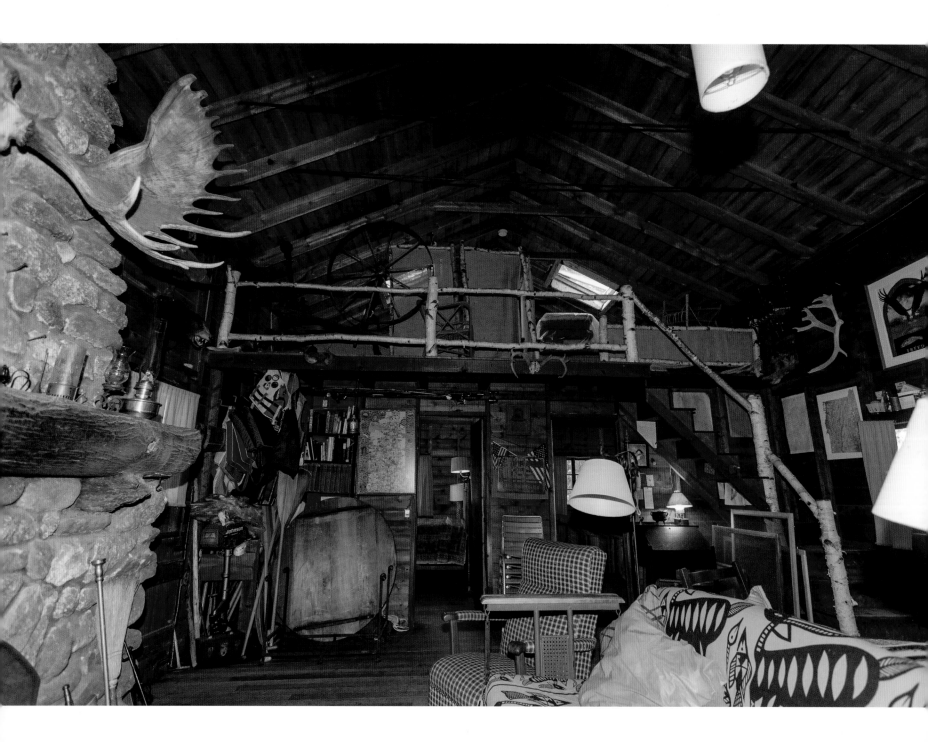

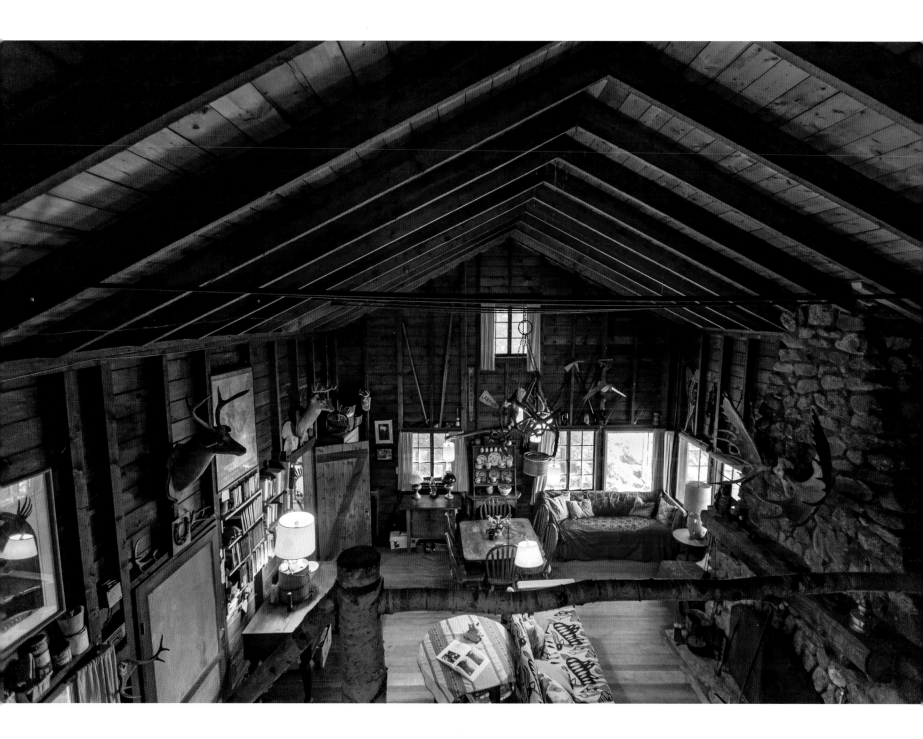

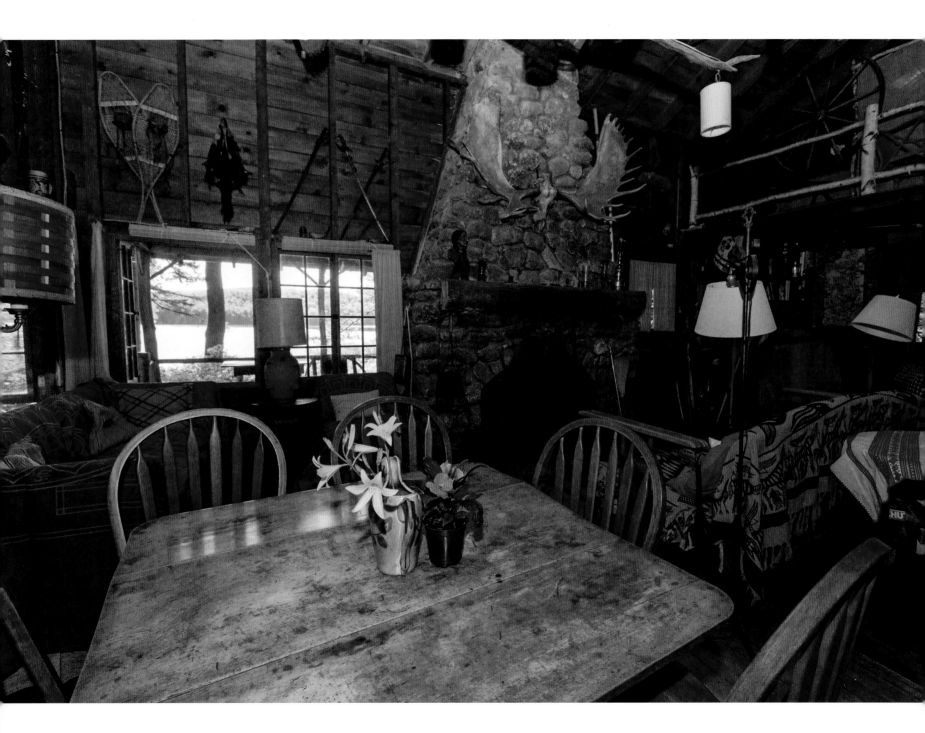

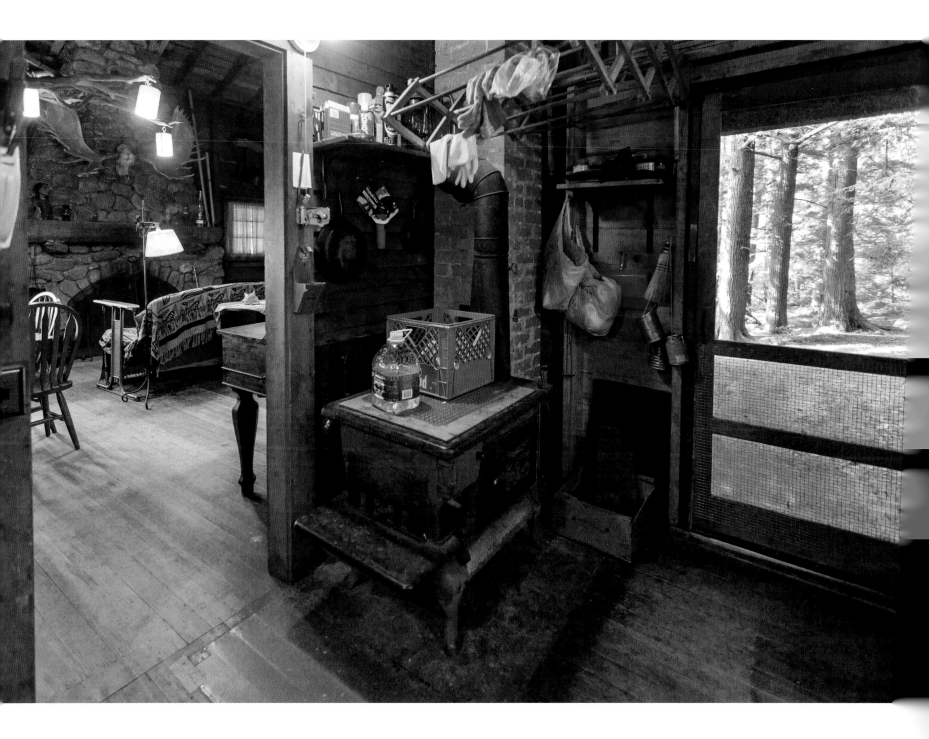

pillows
(+ 6 non-allergic
couch pillows can't sub
when an allergic guest comes)

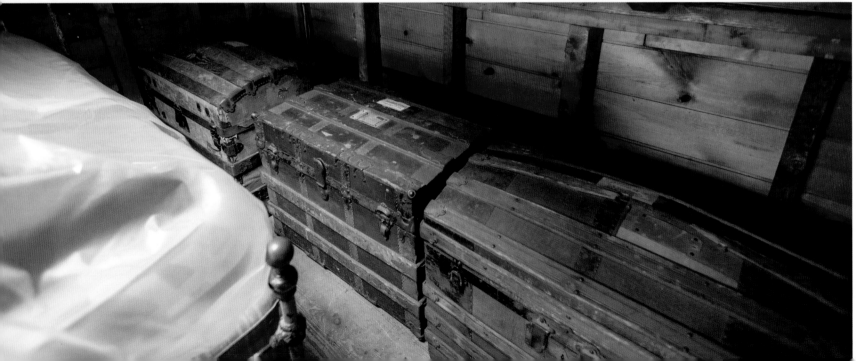

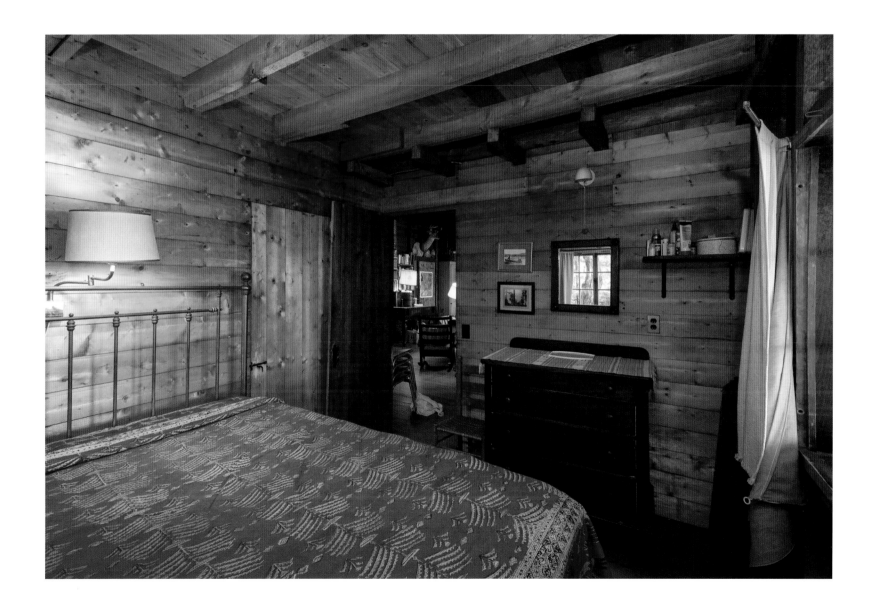

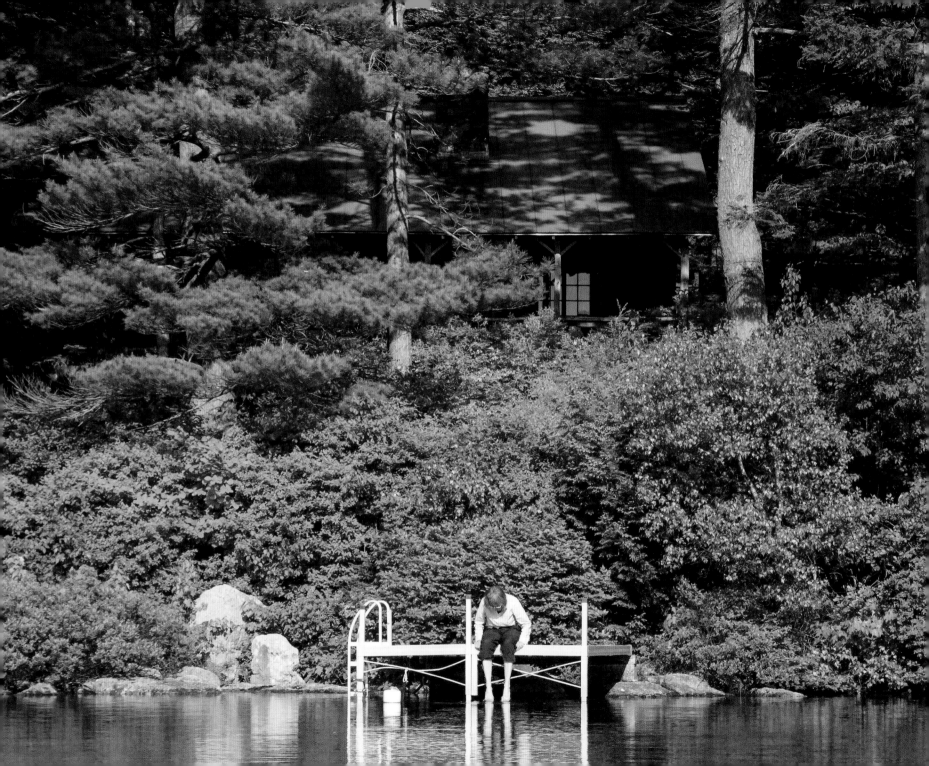

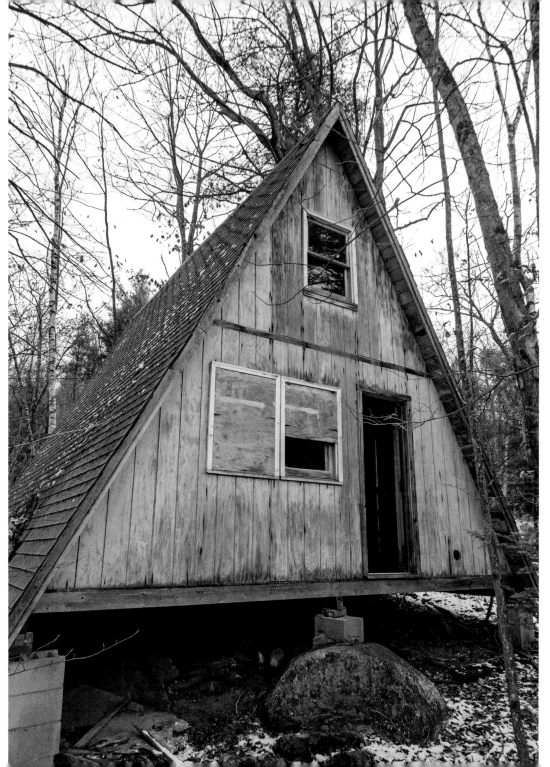

EVERYMAN'S SHED

The A-frame was "the quintessential postwar vacation retreat," wrote Chad Randl. The tent-shaped houses were everywhere, with their steeply pitched roofs forming the walls, and the all-glass gable ends facing a lake, beach, or ski slope. "The A-frame was the right shape at the right time. It was the era of the 'second everything,' when postwar prosperity made second televisions, second bathrooms, and second cars expected accoutrements of middle-class American life. Next, signs at the hardware store and ads in popular magazines declared, 'Every family needs two homes! . . . one for the workweek, one for pure pleasure,'" wrote Randl in his homage to the triangle that took over America.

The small cottages with cathedral pretensions—a six-hundred-square-foot shed with twenty-foot high ceilings—

were cheap and easy to build. Some cost no more than a new car. "For about $2000 you can whip up a small, beguiling shack from a jack-straw-heap of logs, boards, or plywood sheets delivered on your some-day doorstep—or as near it as a truck can go," said *Life* magazine in 1963. The aspiring builder could order a pre-cut kit to build his "leisure house," or build one from the "Care-Free Living" plan books published by the Homasote Company, or the plans in magazines like *Popular Mechanics*, *Woman's Day*, *House Beautiful*, and *Mechanix Illustrated*. They all promised that the weekend home handyman, and a few friends, could build an A-frame in a few days (or so). The foundation required only some concrete footings below the frost line. The identical triangles of the frame could be assembled on the ground, hoisted into place, and joined with lightweight plywood, Masonite, or Homasote panels. "Tricky gable roof framing is eliminated," said *Popular Science*. For those who left the building to others, developers filled resorts with A-frames, some quickly raised in just two days after purchase.

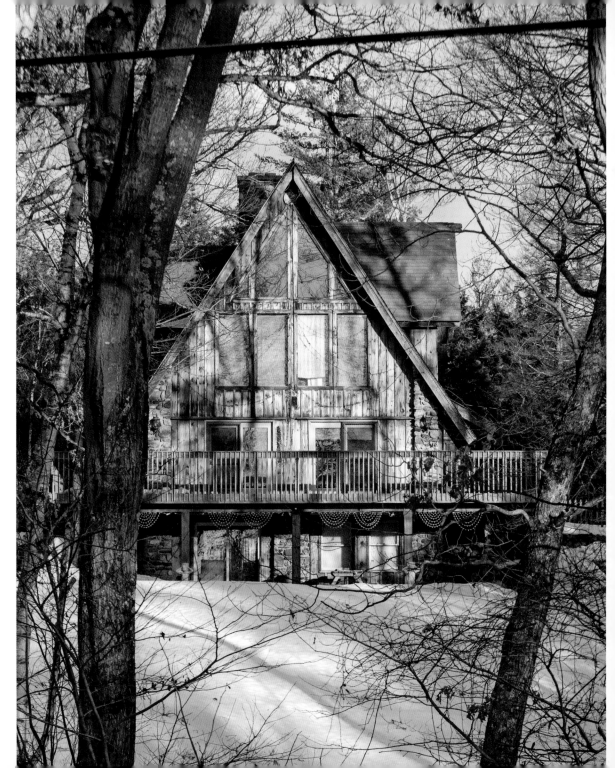

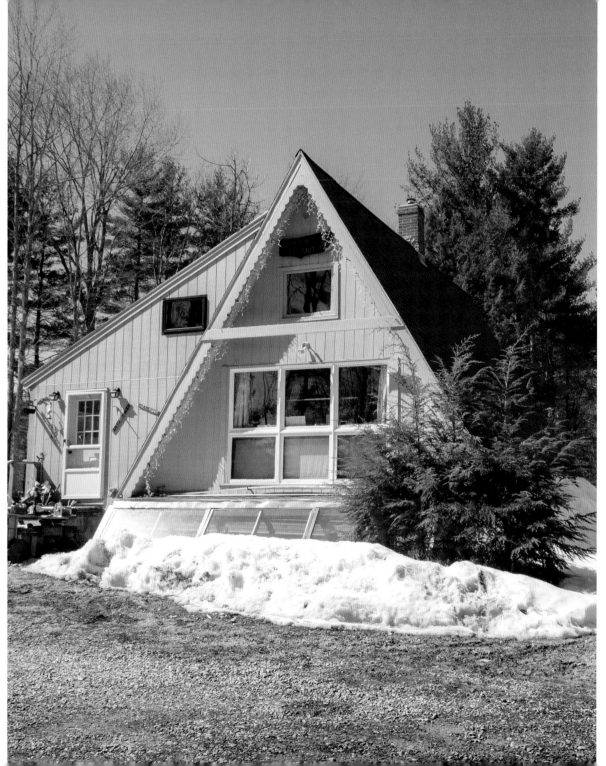

The A-frame was a Dream Shed for the middle class. "Plan now to use your off hours and vacation time to build one of these uncluttered little cottages, made better, easier and more economically with fir plywood," said the Douglas Fir Plywood Association vacation home plan book in 1958. "A little later you'll be swimming and boating with the kids, hunting, fishing or skiing, or just plain loafing in headquarters of your exact choice."

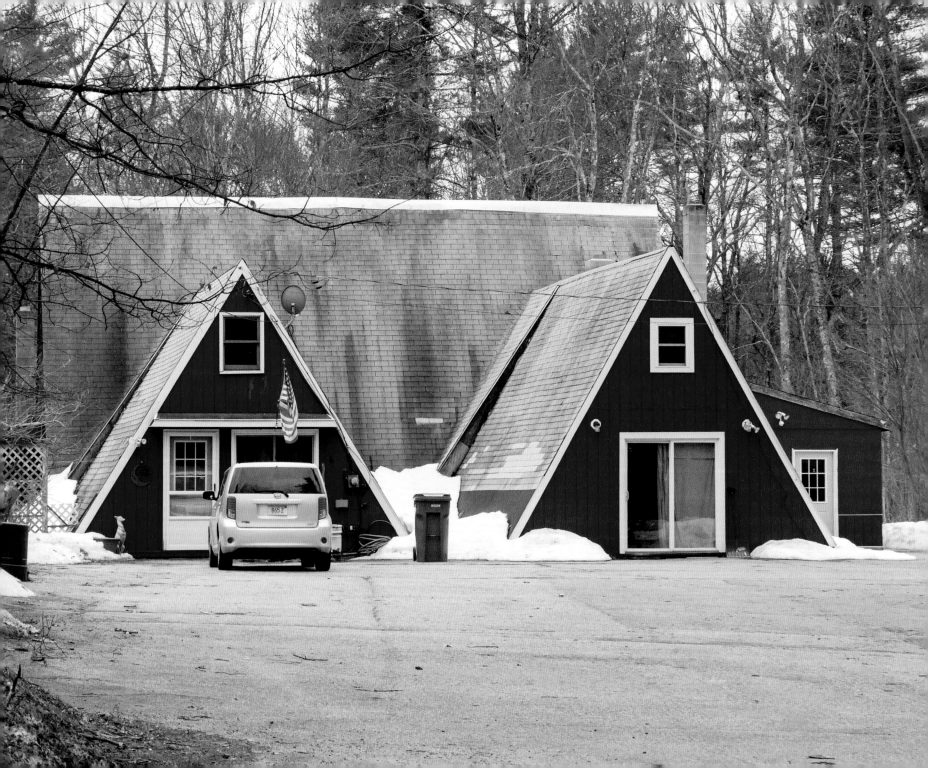

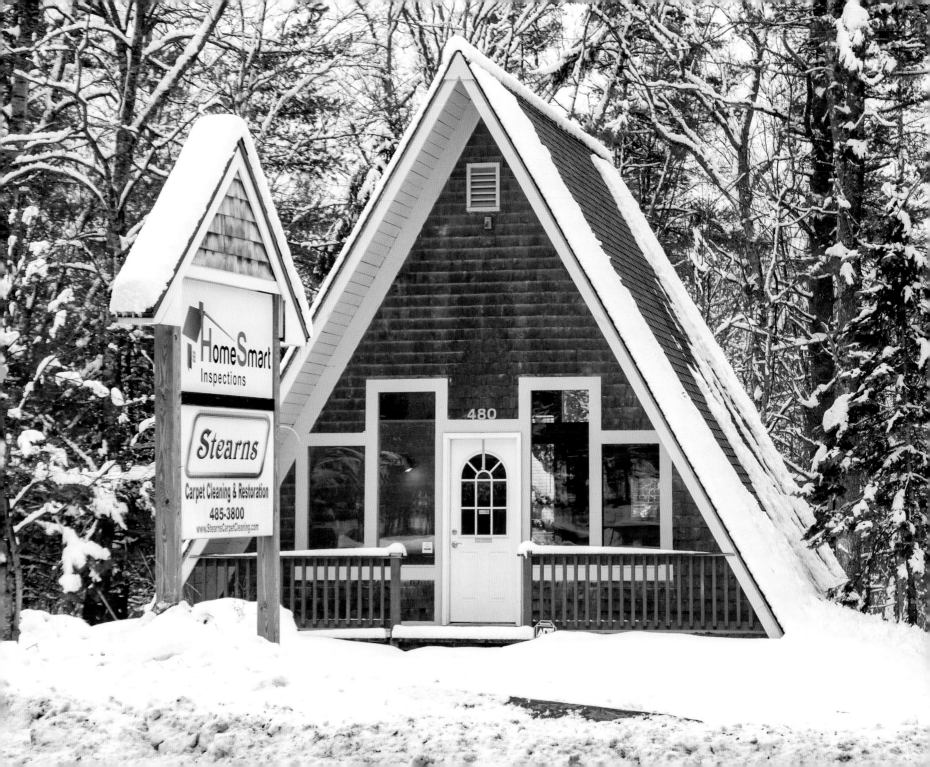

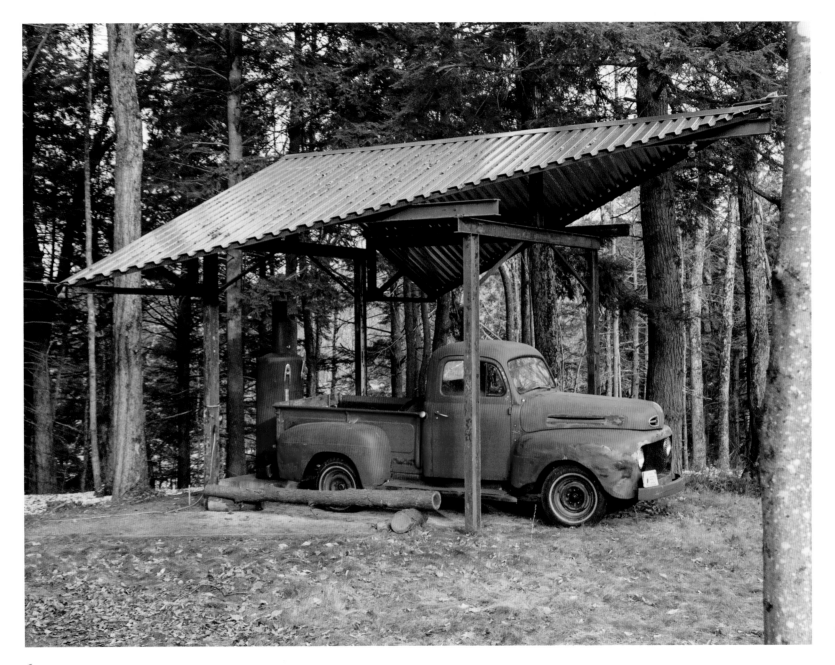

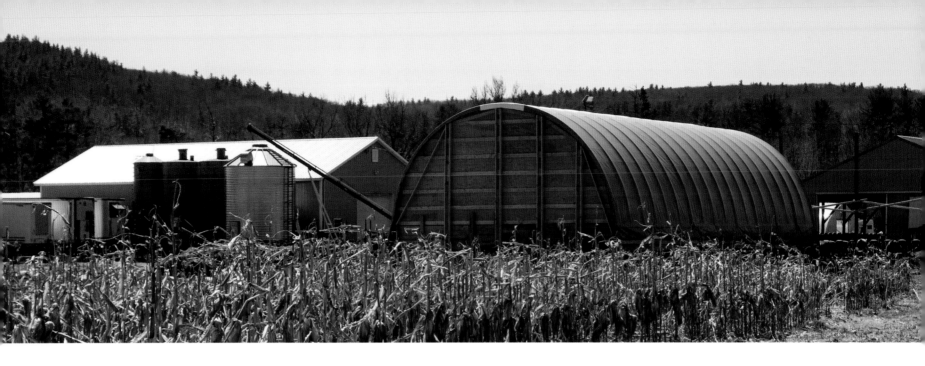

WAR SHEDS

The homeowner who was ready to spring for an A-frame kit in the 1950s and 1960s was often a veteran who may have slept and worked in another prefabricated shed, the metal Quonset Hut. Shaped like half of a can, the Quonset Hut, like the Jeep, became a symbol of America at war. It was "a kind of heroic icon," wrote Tom Vanderbilt, "a Coca-Cola of the landscape."

"The world's largest housing project" was born on the run. In 1941 the Navy contracted the George A. Fuller Company to design and produce temporary, movable shelters. The company's architects redesigned a British World War I all-metal shed, the Nissen hut. But the T-Rib Quonset was a little more hospitable, with Masonite interior walls, wood floors, and paper insulation. The basic structure was a sixteen-foot diameter steel arch frame that supported corrugated metal panels. As in the A-frame, there was great strength in carrying the roof right to the ground. (And like the A-frame, its interior was compromised by the lack of vertical walls.) Within two months the Rhode Island company was producing thousands of huts at Quonset Point.

Quonsets were flexible, serving as barracks, mess halls, offices, latrines, showers, hospitals, and bakeries. The Navy designed eighty-six different floor plans for the standard longhouse that was erected in lengths of twenty,

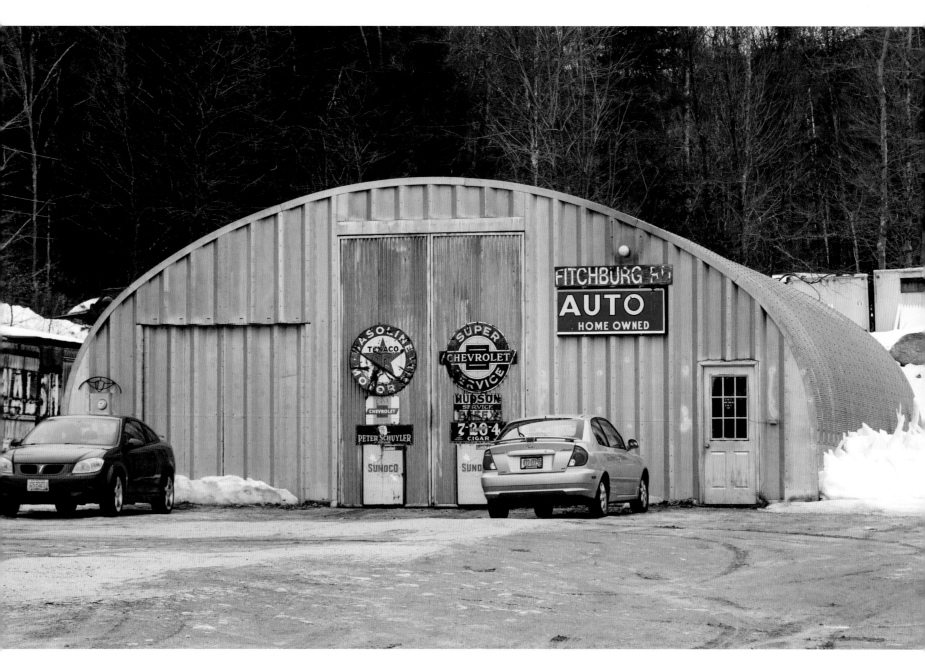

98

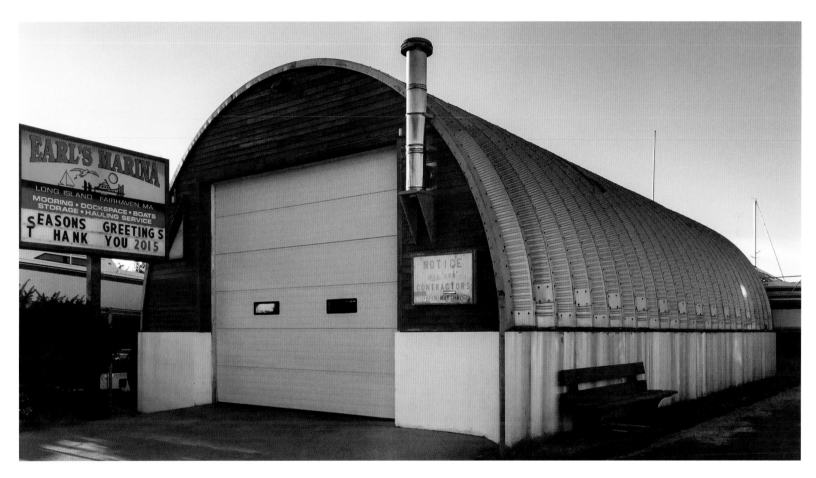

thirty-six, and forty-eight feet, and the much larger warehouses. A hut was shipped in ten crates—less shipping space than tents with wood floors and frames. It could be erected in one day by ten men. Quonsets served in the tropics, following the American advance across the Pacific, and in the arctic.

Between twenty thousand and thirty thousand were shipped to Alaska. In their first winter, the huts were tested by a raging storm in Iceland: "A night gale of hurricane proportion that wrecked shipping in the harbor, tossed crumpled PBYs [sea planes] on the beach like paper hats, and ripped the covering completely off of many British Nissen huts, left the Quonset huts practically undamaged," said the Fuller Company.

Wartime redesigns of the first T-Rib Quonset Hut created versions that were lighter and less expensive to produce, gave the hut some useful vertical walls, and reduced assembly time in the field

by substituting much of the nuts-and-bolts construction with the brute force of hammers and nails. Anyone, the thinking went, could drive a nail home. In all, with the various redesigns, some 153,000 Quonset Huts were launched into the world.

After the war, this temporary shed refused to retire. The returning vet might find himself living in a can once more due to the severe housing shortage, or taking classes in one at a university that was overrun with veterans returning to school on the GI Bill. One manufacturer, Stran-Steel, tried to convince consumers that the huts would make ideal homes. ("You are looking at a revolution in low-cost home design!" said one ad.) *House Beautiful*, admitting that a Quonset wasn't a dream house, dressed up the hut with white clapboards, a picture window, and a fireplace. Some vets, including former Seabees who had spent the war erecting the huts, became Quonset dealers. But there were plenty of war surplus Quonsets around. As the cans were sold off, they became grocery stores, restaurants, bars, movie houses, churches, hospitals, schools, music

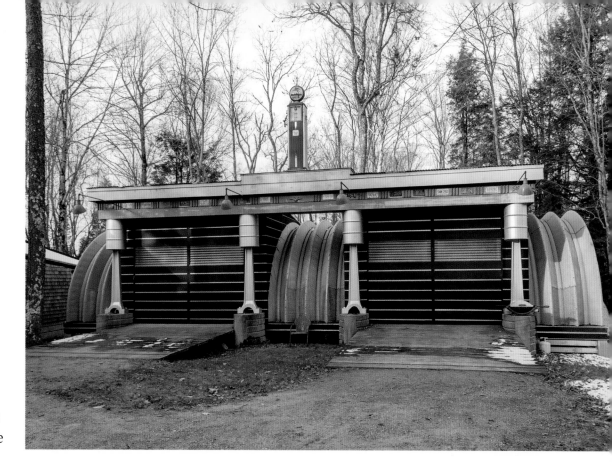

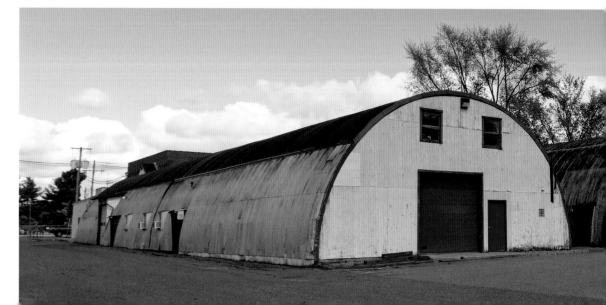

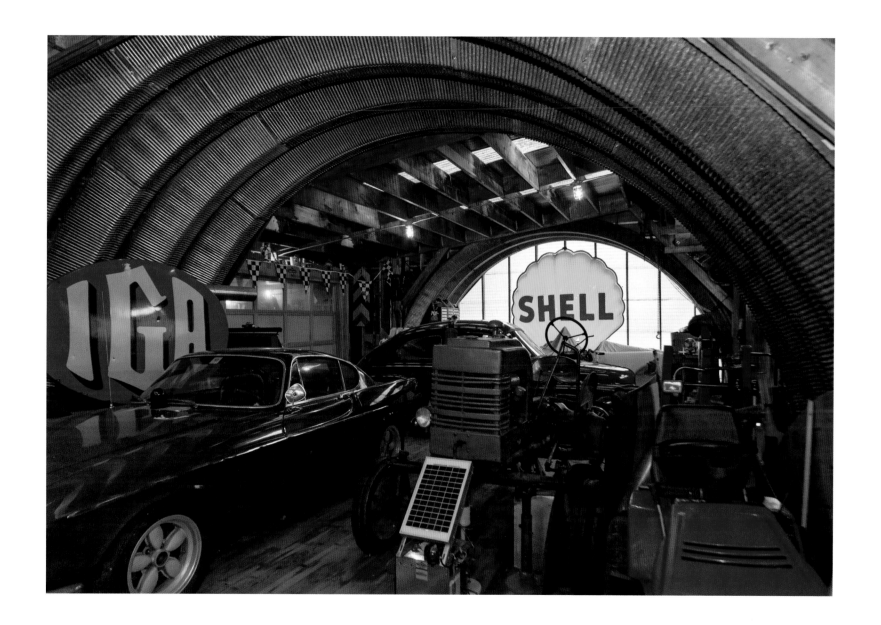

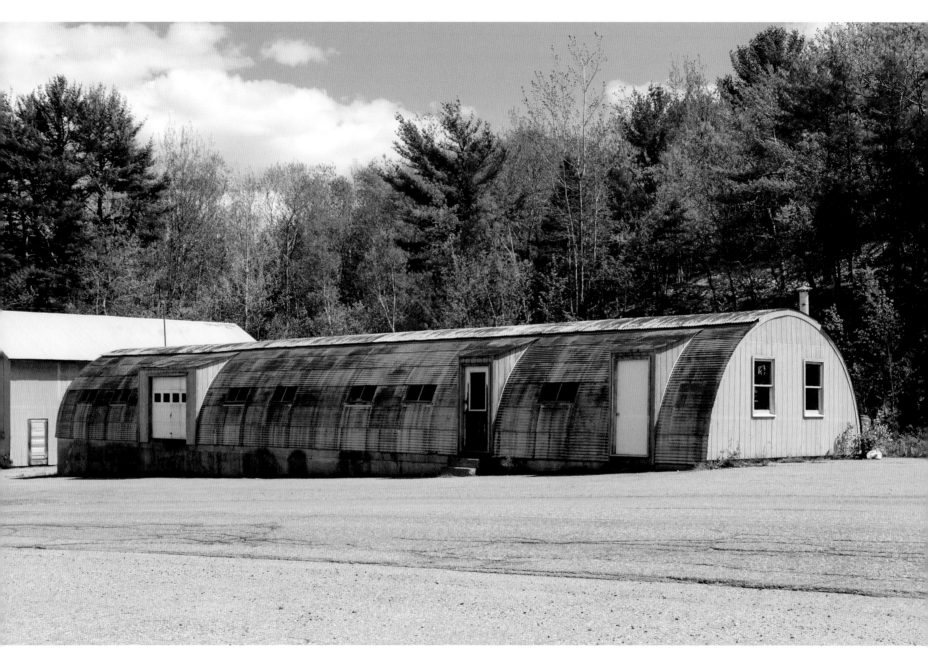

studios, and hay barns. Stran-Steel counted 257 different uses.

On Seward Peninsula, Alaska, which had a plentiful supply, the arching metal ribs made good fish racks. "Everybody in the family can reach some of the racks. Kids can hang up the salmon at the lower end. It's a good system," said Cathleen Doyle. "And if you take out walls [at each end] then you get an ideal way for the air to move through and dry the salmon. And, easy to close it off and smoke it out, too."

The Quonset Hut has inspired a new generation of designers looking to create prefabricated, modular housing. Shipping containers have become the new building blocks of lower-cost housing. There are seventeen million of the sturdy, all-metal containers, most in two standard sizes: eight feet tall, eight feet wide, and either twenty or forty feet long. In Amsterdam they have been stacked into an apartment block to house one thousand students. In Odessa, Ukraine, the stacked containers form

the largest market in Europe, housing sixteen thousand vendors on 170 acres. In the United States, due to our trade imbalance, there were at one time seven hundred thousand empty containers piling up at the docks, some available for as little as $1,200. They are being converted for housing, with windows, decks, and spray-on insulation, and, to come full circle, as ISBUs (Intermodal Steel Building Units), movable metal housing for the military.

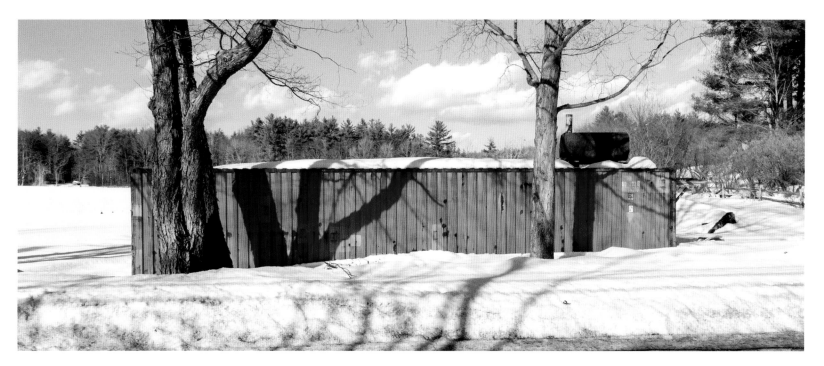

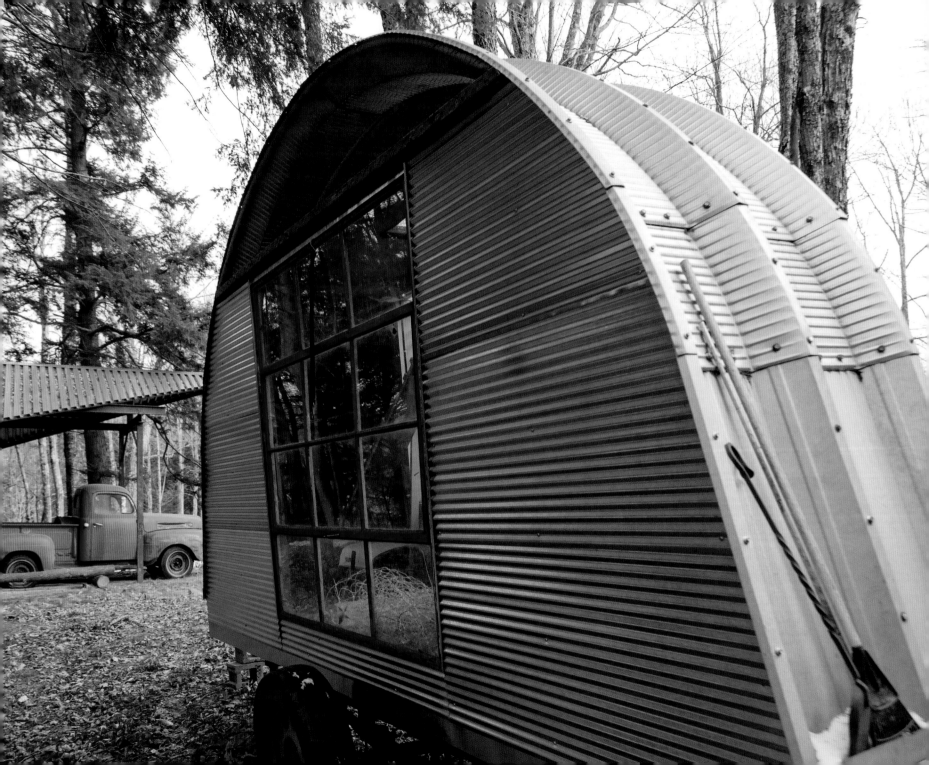

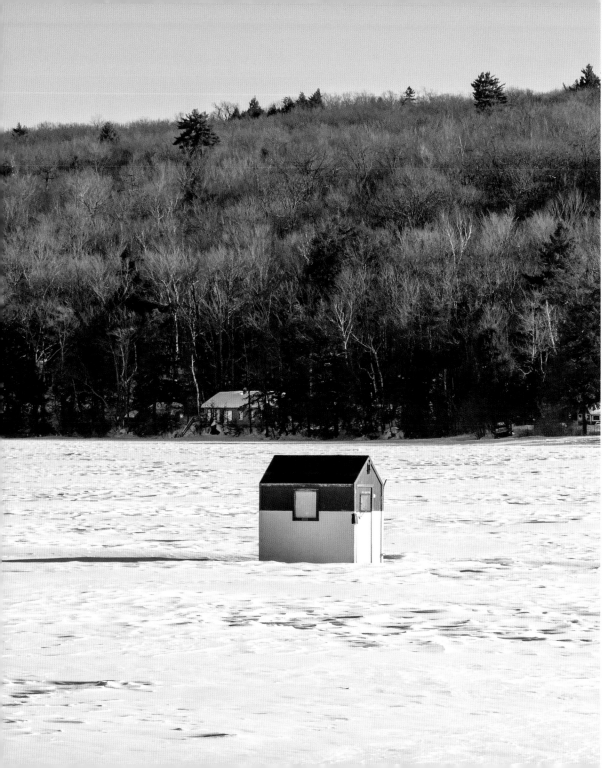

BOB HOUSES

When winter begins to close in on me, when I feel as if I were wearing a groove indoors, I head out to a nearby lake to talk with the men ice fishing. (It's mostly a guy thing.) It's a relief to get outdoors, to drink in the horizon, to look straight across the expanse of flat ice for miles. I set out on snowshoe or ski or foot, depending on the conditions, to visit the small settlements of bob houses, the sheds that the ice fishermen pull out on the ice. On this lake they are mostly small, with just enough room for a bench to catch a catnap, a small woodstove, a hole or two in the floor so you can bore right into the ice and fish, and a window so you can see your "tip-ups"—the flags that signal you have something on one of your other lines. "It's a man house," said my friend Eric Aldrich, an outdoorsman. "You want one big enough to sleep in." (That is, in case you're in trouble at home, which he emphasized he wasn't— not at the moment.)

Bob houses are built mostly of plywood, often of scrap, and painted,

if they are, with what's on hand. This is strictly "what's on hand" construction. No one runs their table saw overtime confecting a little Parthenon. You don't want to get too fancy; it adds weight. A bob house has to be portable; it has to fit in a pickup truck bed or on a trailer. Lighter is better. Simplicity is achieved by subtraction.

None of them are beautiful, but on the ice they seem like they belong. Out of season, out by the woodpile or by the pile of things-that-could-be-useful-one-day, they seem crude, like a plywood privy. But on the ice their roughness is a match to the below-zero winds that get moving on the lake.

We call them bob houses in New

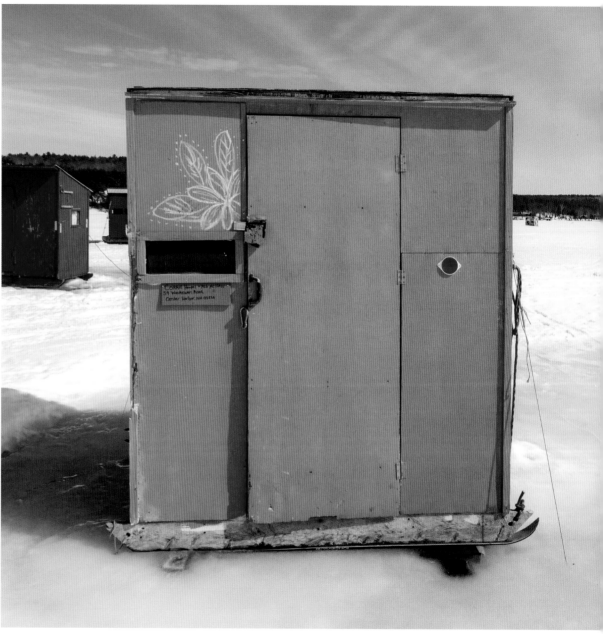

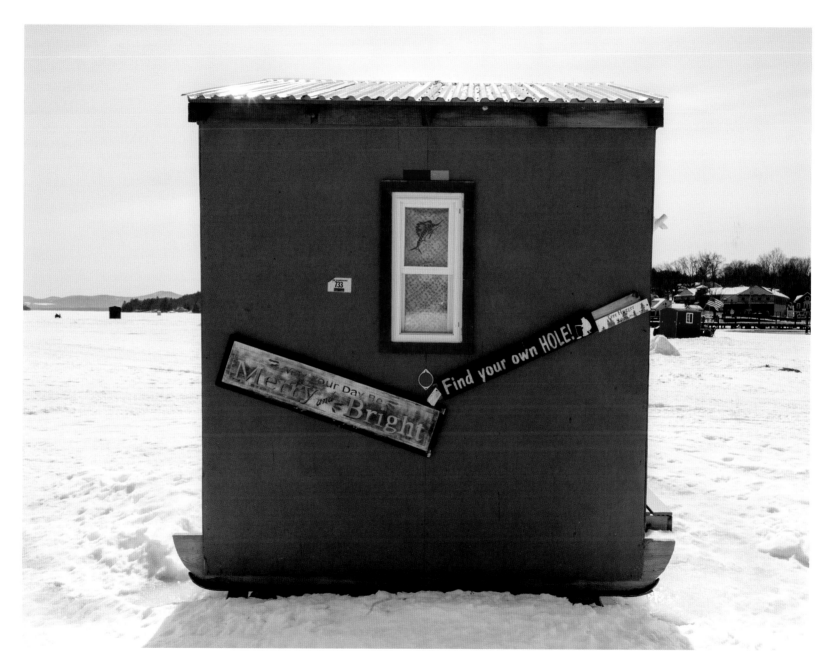

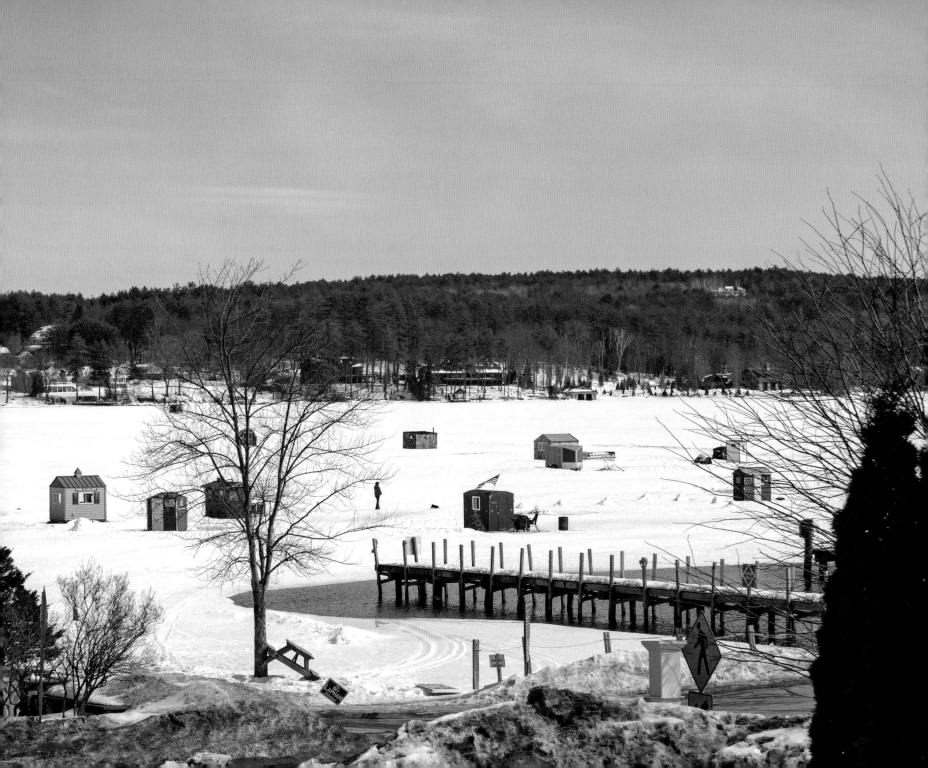

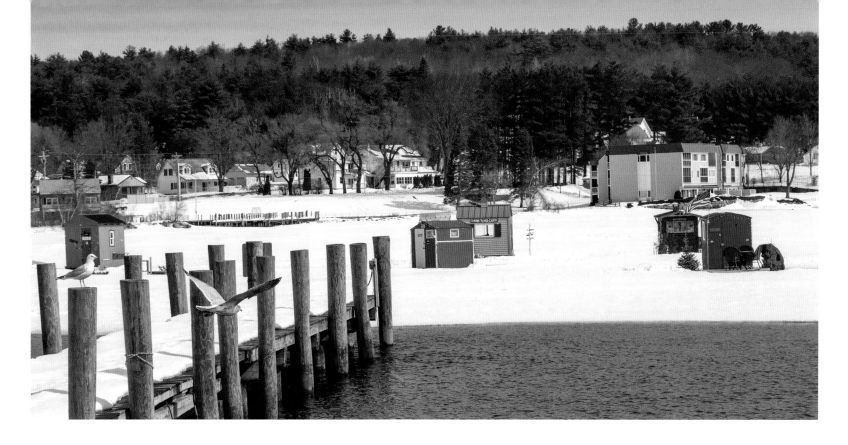

England. (So named for the bobbing of a fish line through an open hole in the ice.) Out in the Midwest they favor ice house, fish house, or ice shanty, but shanty has that wrong-side-of-the-tracks, Hooverville connotation.

Fishing seems to be a little beside the point (except for a famous fishing derby). The number of tip-ups you can have is limited, and fish are lethargic in winter. On some lakes you can fish all winter and not catch a thing. "You can be out there all winter and not see a flag go up. All winter," said Aldrich. "And some doofus gets out there at 11 a.m., sets out a tip-up, and he gets a twenty-inch lake trout right off the bat."

On New Hampshire's big lake, Winnipesaukee, home of the famous ice-fishing derby, some bob houses have gone beyond "what's-on-hand" construction. Some have generators, propane heaters, camping toilets, and satellite television. Some are finished with clapboards and even have drapes in the window. Some guys just set up their camping trailers. Years ago there was a village out on the ice that even had its own post office with mail delivered right to your bob house.

Other big lakes have also seen the supersizing of bob houses. On Mille Lacs Lake in Minnesota there may be five thousand ice shanties, some of which have bloated to dry-land excess: cathedral ceilings, custom kitchen cabinets, sound

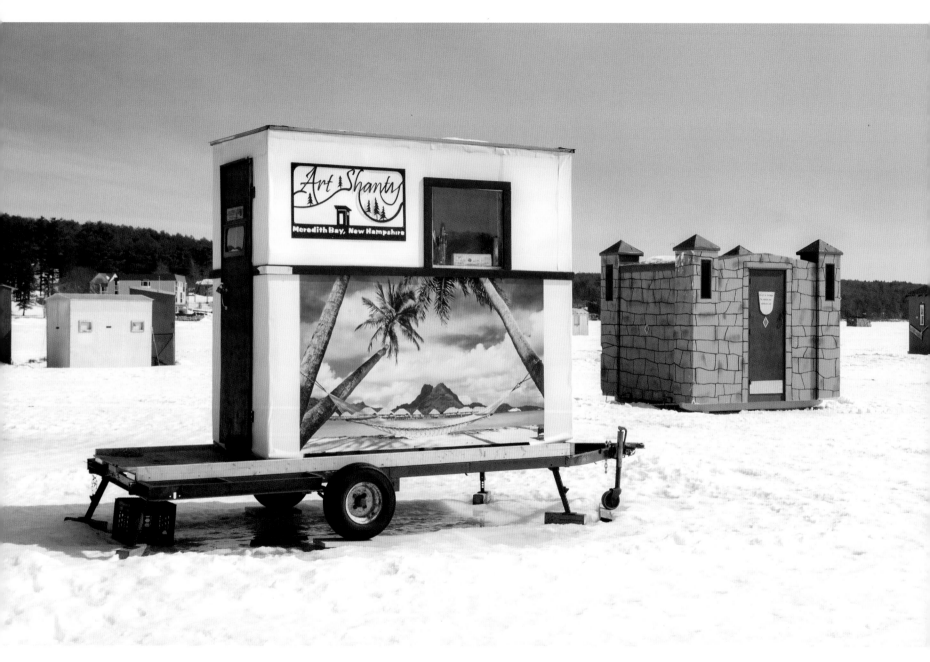

systems, DVD players, satellite television, underwater cameras to watch fish, "auto jiggers" that tend the fishing line, one house with Brazilian cherry inlaid floors, and another with a stainless-steel urinal (a finishing touch that would have escaped Martha Stewart).

Aldrich, who worked for the state's Fish and Game Department, once spent a few days visiting bob houses on Winnipesaukee. The oddest one he saw was this big white plastic dome with a door cut in the side. What the heck was that? The big plastic tank belonged to a septic field designer. While everyone else was struggling to get their bob house on the ice, he just turned his dome on its side and rolled it out. It was perfect. A septic yurt.

On Aldrich's tour he saw some "shaky stuff," he said. "Some guys with teeth and some without teeth." A few guys from the city moved out of their apartments for the winter. "It's free lakefront," he said.

Bob houses may be the last free housing in America. No one inspects them; no one will tell you that you have to build them to meet "code." New

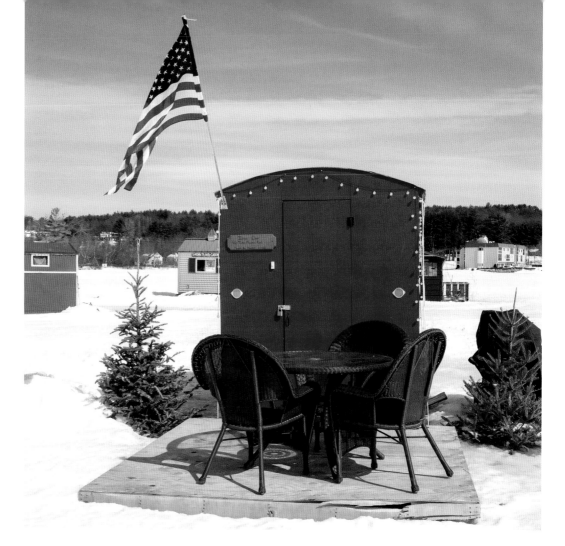

Hampshire's rules are few: put your name and address on the outside and some reflectors so a snowmobile won't crash into it at night, and get it off the ice by April Fool's Day.

All the ice fishermen I've ever talked to are happy to be out there, sitting in a meager shed on the ice. Why come to the lake when it's freezing out? I once asked an ice fisherman. He was wearing a dirty tan one-piece coverall. He had a red face from sun and wind, and probably drink.

"Good time to be he-ah," he said. "Mosquitoes aren't a baw-tha."

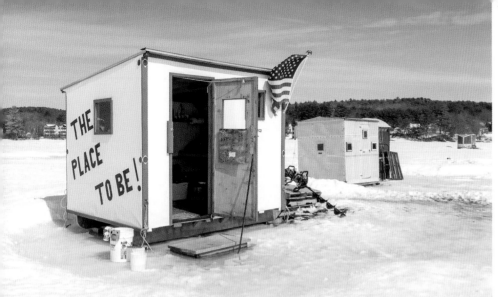

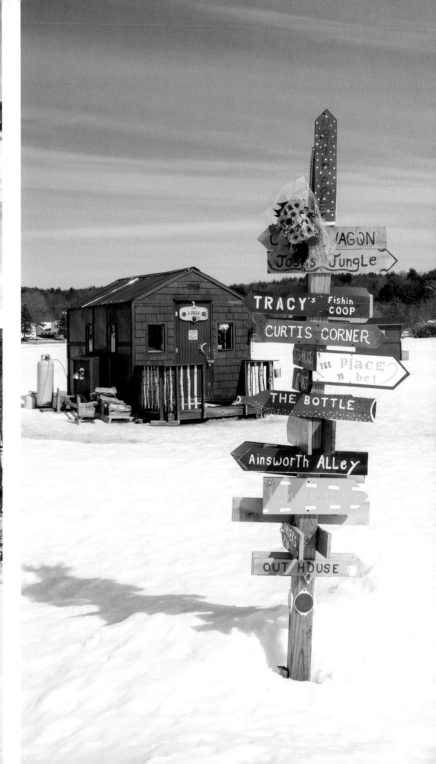

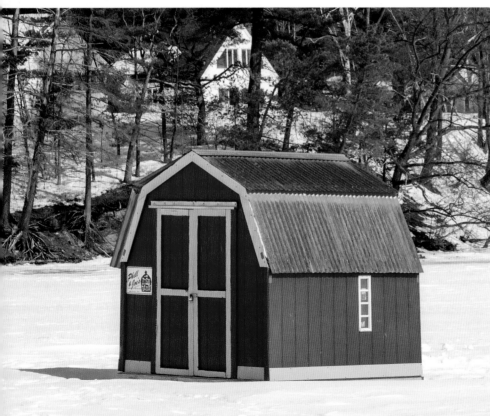

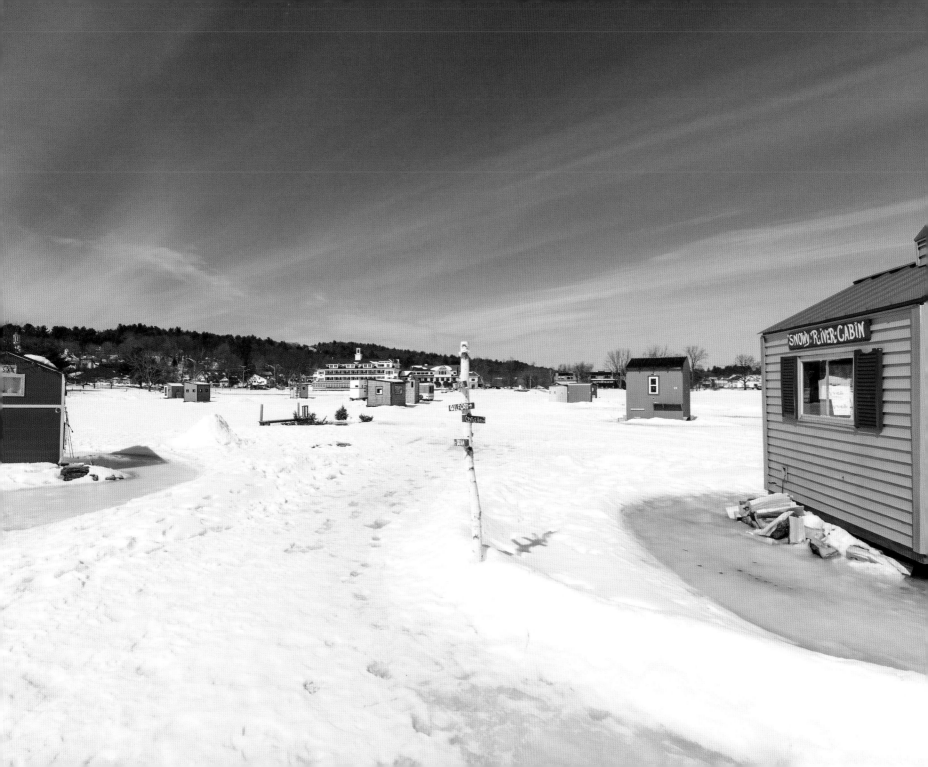

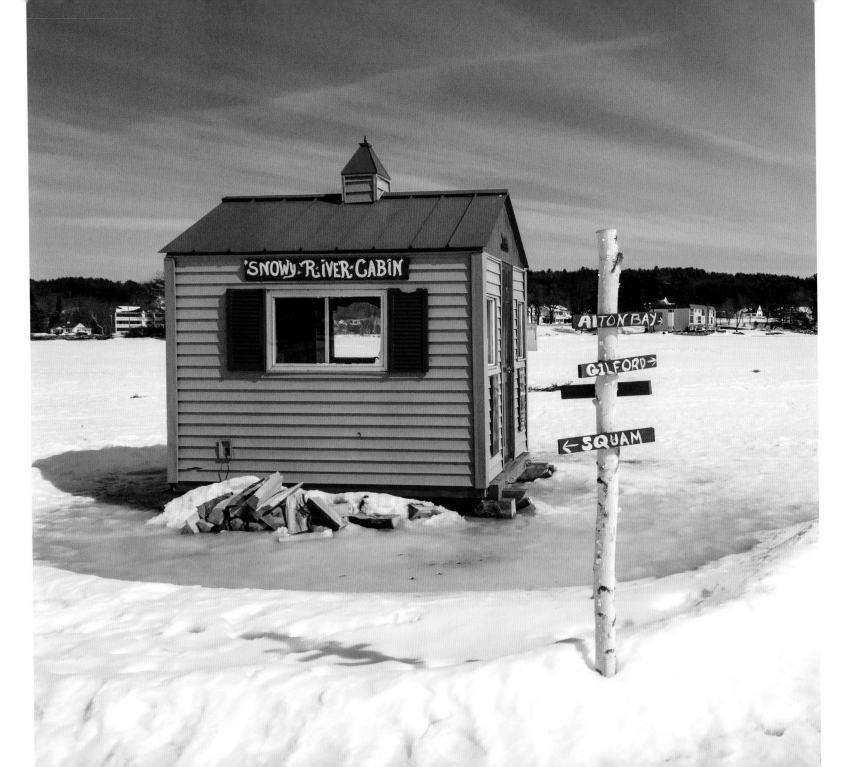

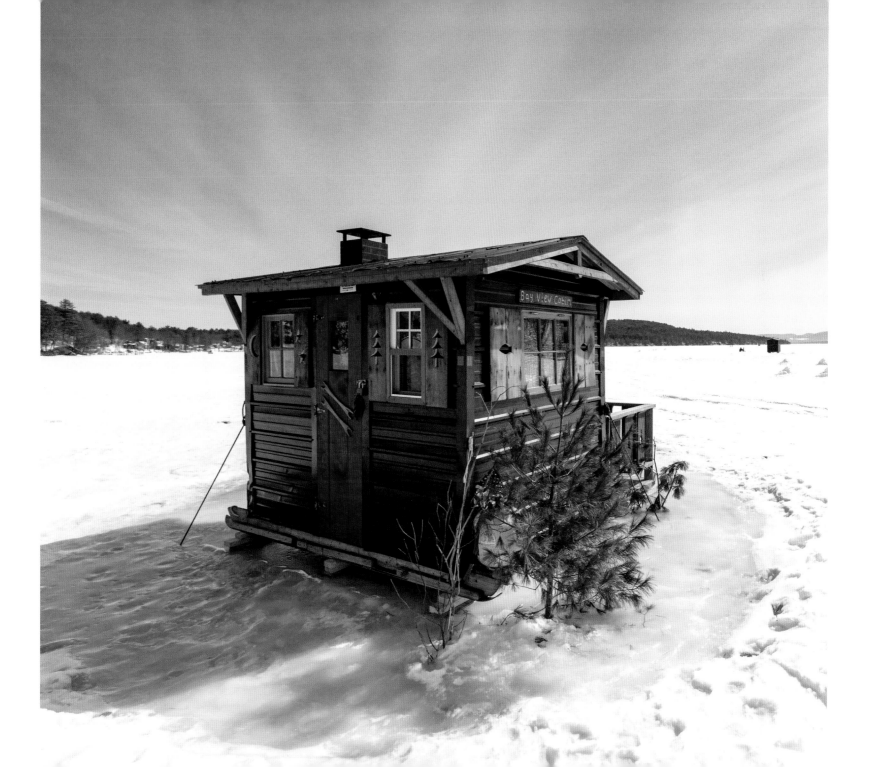

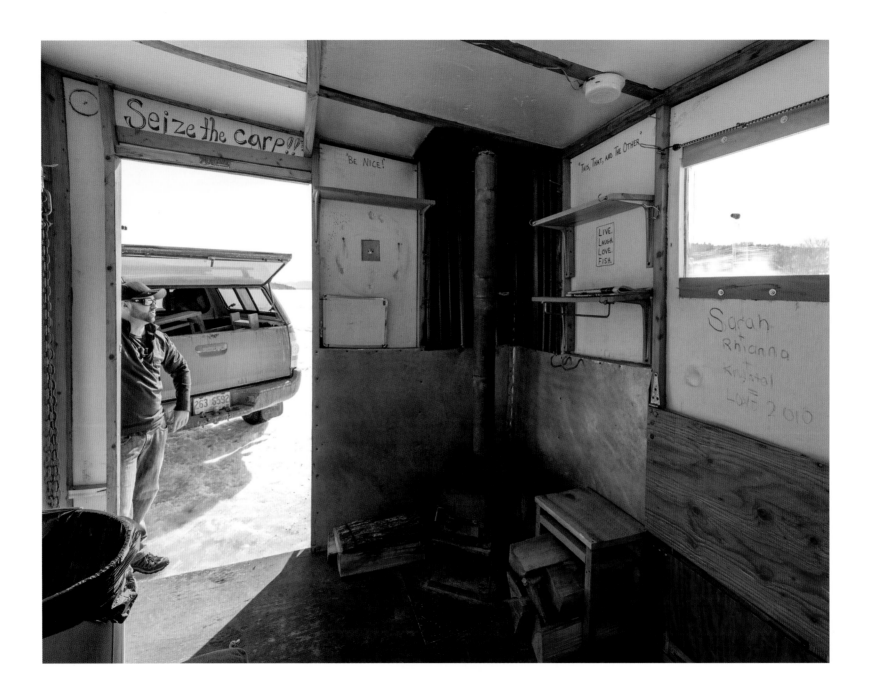

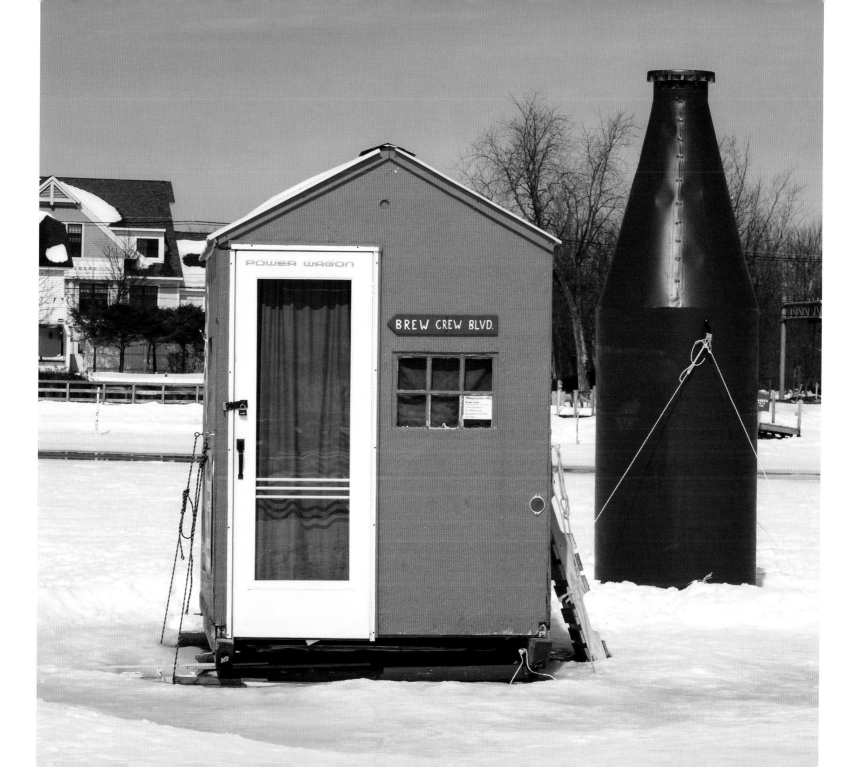

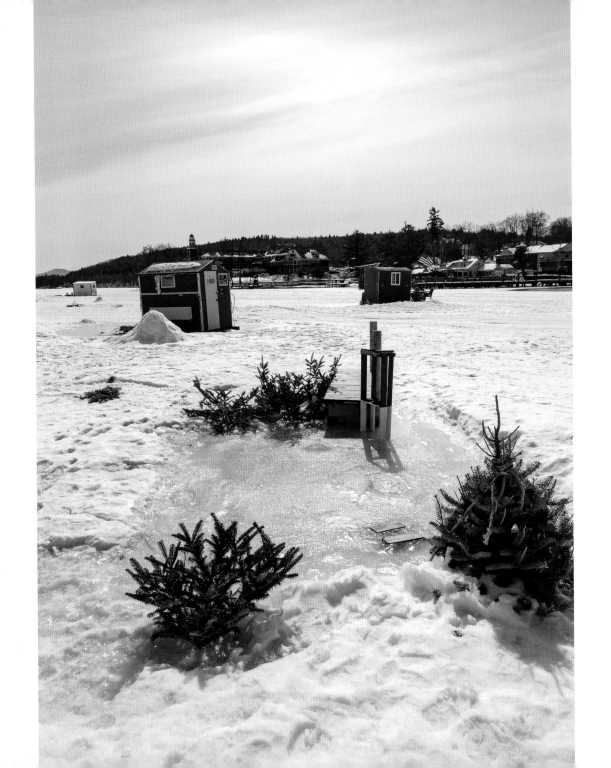

BREAD TRUCK

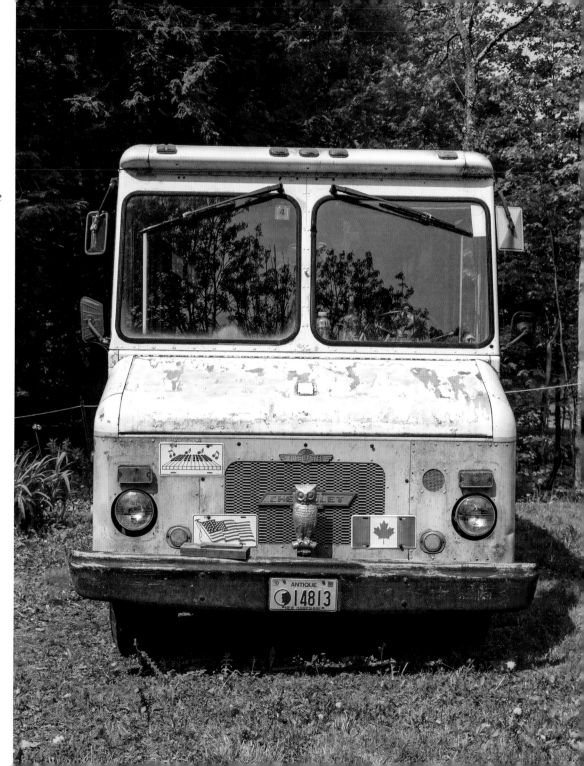

"Hermie Newcome lived in a bread truck on the edge of Bear Swamp."

He had a bunk up front where the seats used to be so in the morning he could wake up and look out the windshield at the day.

He had a small woodstove in the back, a table and chairs, and "some crates for cupboards," wrote Vermont poet David Budbill in "The Chainsaw Dance."

It was always neat in there.
It was a good place and cozy.
Hermie didn't need anything big as a bus.

Before the bread truck, Hermie lived in a shack with "his woman, Florence." But Hermie "flew into a rage, which he did about twice a week" and burned down his shack:

"Burn! Goddamnit!
Burn! you wuthless place.
You never was no goddamn good!"

He and Florence moved on to a shack by the cemetery.

Hermie liked it there,
said it was the first place he ever lived
where he had decent neighbors.

Someone went by one Saturday night and saw Hermie and Florence "dancing with the chainsaw going in the middle of the floor." Hermie adjusted the carburetor so that it ran rough, and "would sputter, bounce with a rhythm worthy of a good musician." But he burned that shack, too, and Florence left him.

Then he moved alone into the bread truck in
the swamp.
Hermie spent his life looking for the perfect place.
That's what all those fires were about.
And in the end he found that place.
The bread truck wouldn't burn.

Hermie inhabited his craziness. He was at home. Was he askew, or was the world askew, or both? Yeah, probably both.

As I read the poem, Hermie is clear-eyed and crazy. Spot-on and off-kilter. He's living truthfully—by the crooked measure of his madness. "To thine own self be true" is Shakespeare's famous advice. But what if that truth is madness?

For Hermie the bread truck was a Dream Shed.

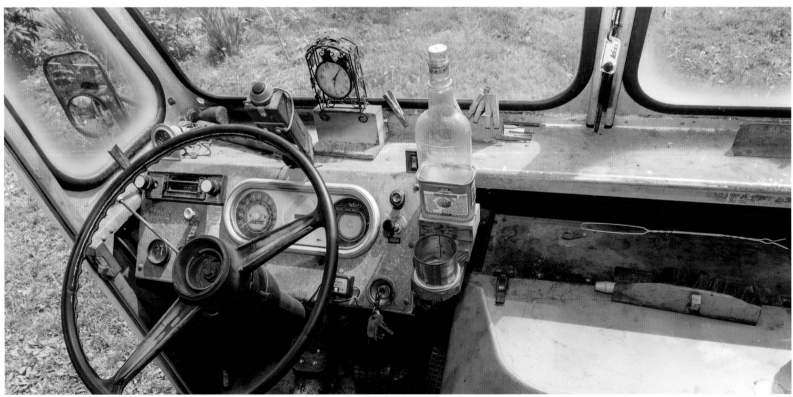

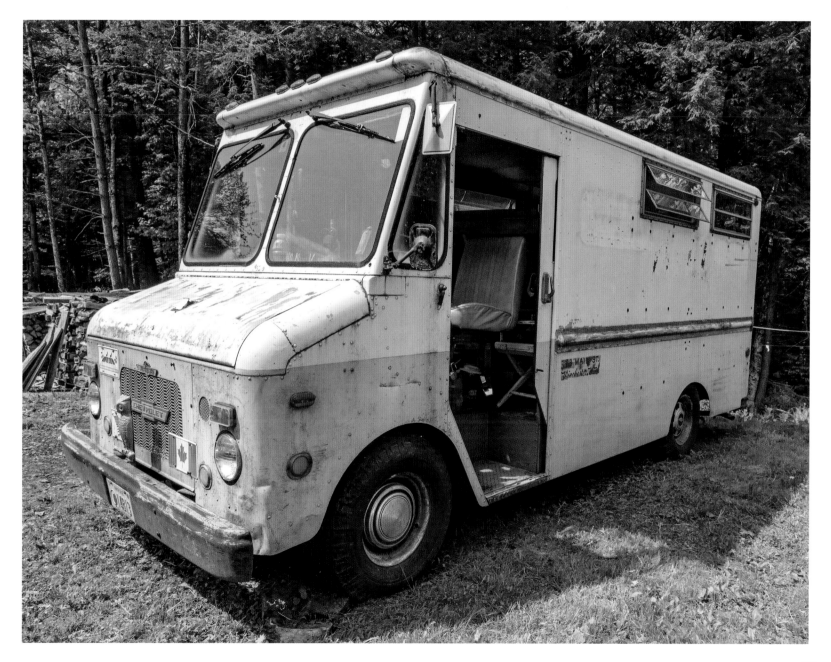

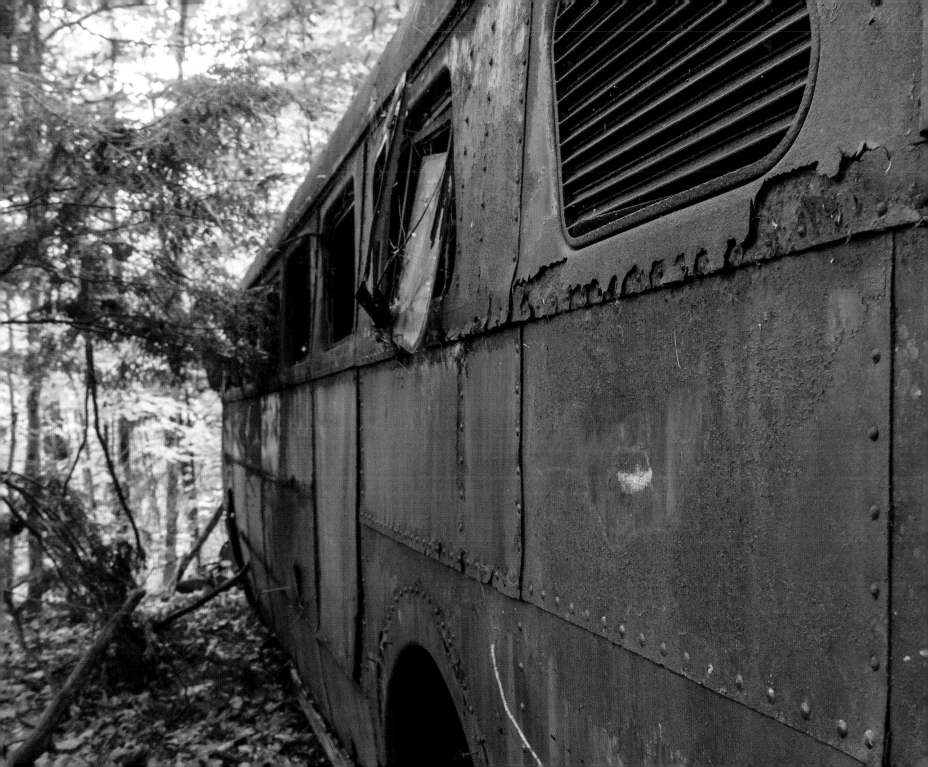

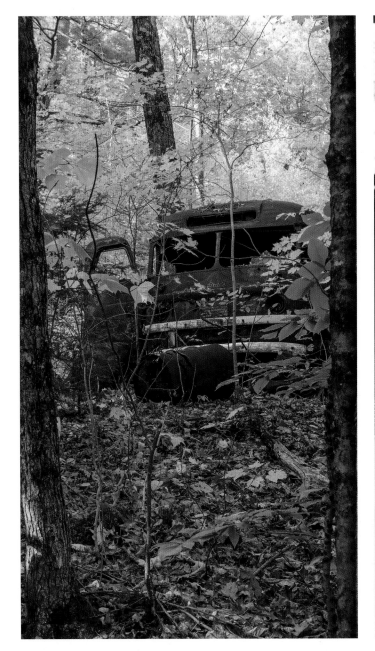

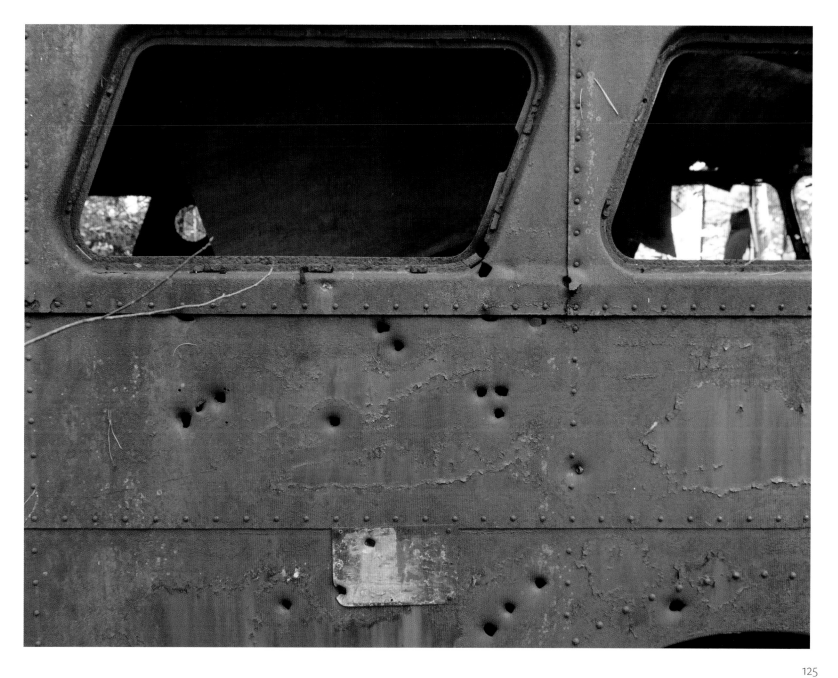

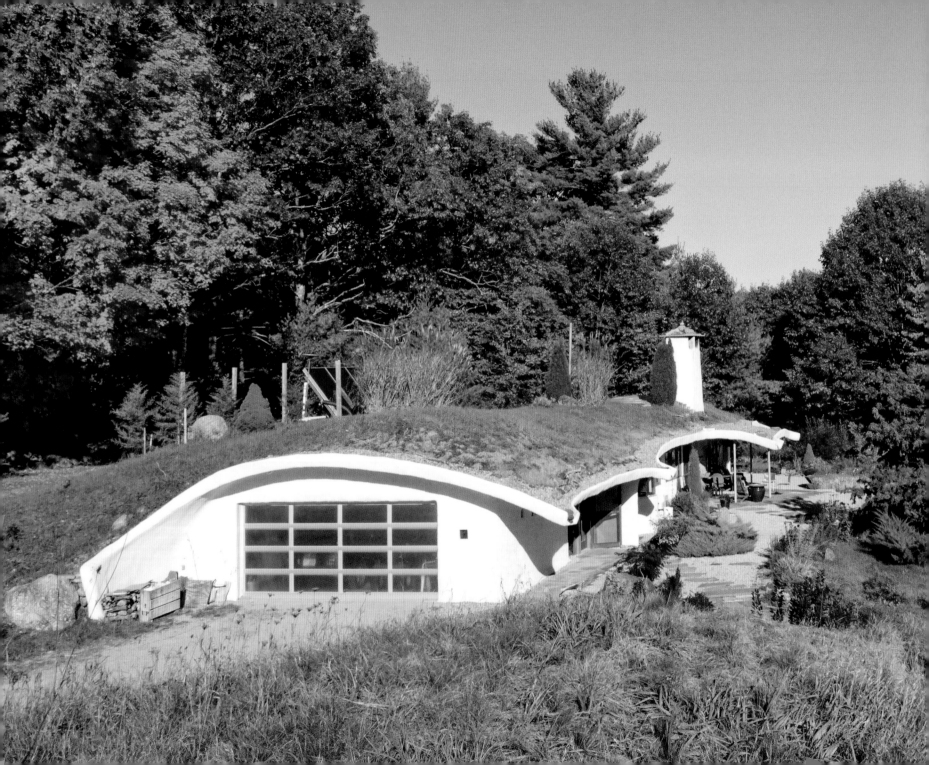

SUBTERRANEAN DREAMSPACE

I f you drive through the curving lanes of suburbia, everything you see is tucked in. It's a landscape with "hospital corners." But you can't see all the basement workshops, model railroad layouts, home handyman-built bar/ entertainment, all-in-one rooms.

A few neighbors might work on cars in the driveway, but this is a weekend-only event. No one gives up their driveway to a continuing hulk-in-progress (or they will invoke their neighbors' ire).

Any unfinished space can be a dreamspace. It's the place people fill with their plans—that will be the guest room, the kids' hangout, the place where we'll host parties. It will be a playroom

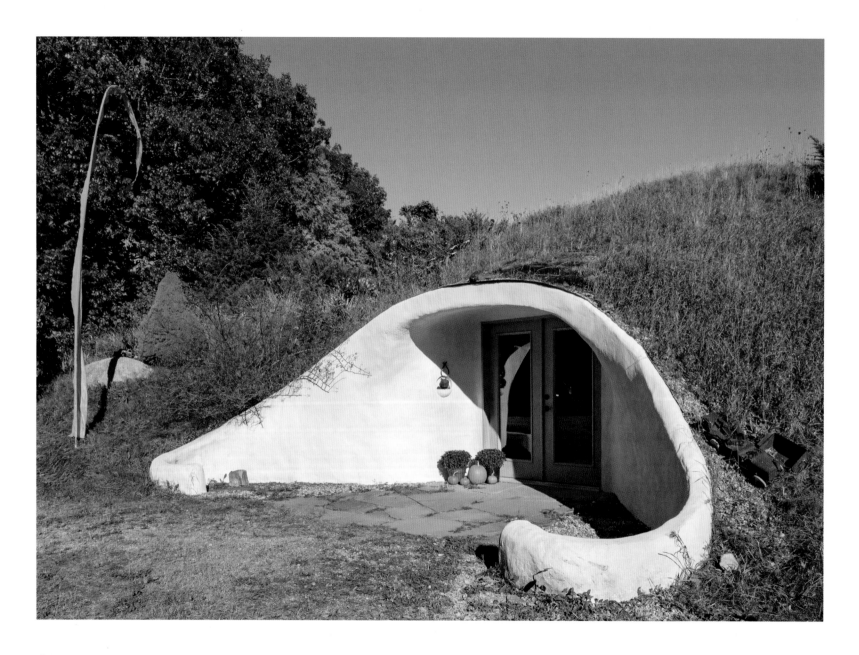

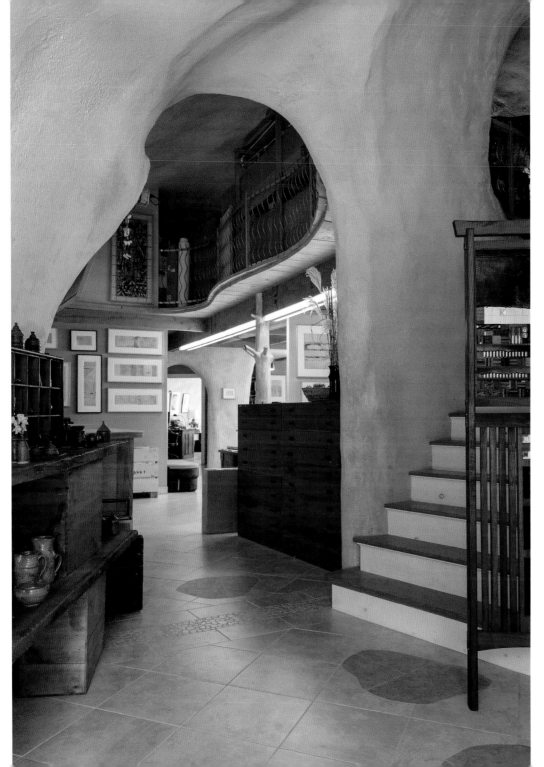

now, a family room later, and then my study. All that can fit in a few hundred square feet of a damp cement basement.

Unfinished spaces are where houses flex. In the past, big New England houses went from sheltering families of a dozen or more in one era to a nuclear family in the next. Big old houses were divided into apartments and then reunited.

Houses, like people, live in many ages. Even suburban houses can bend and flex.

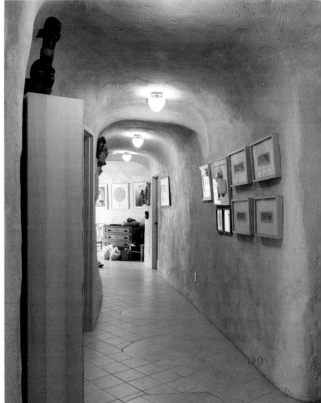

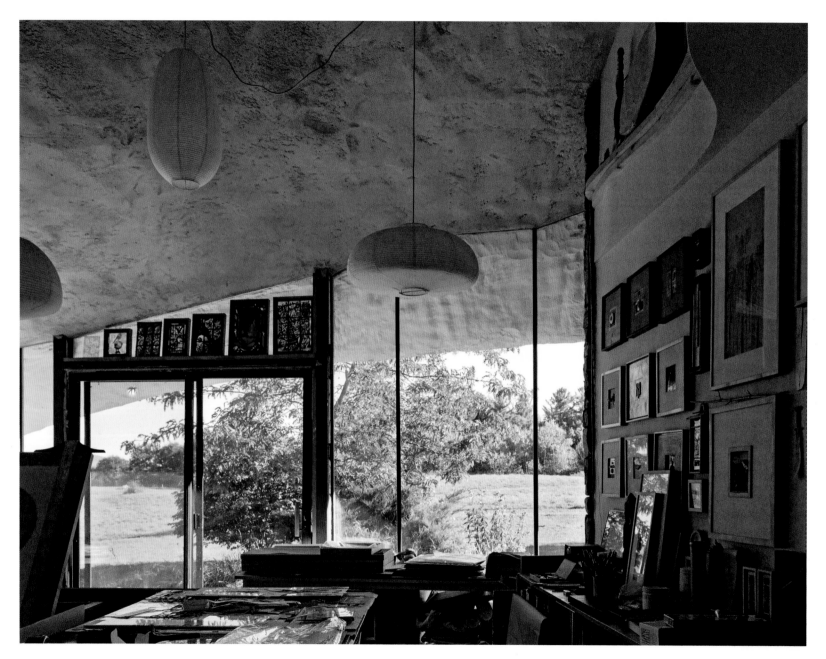

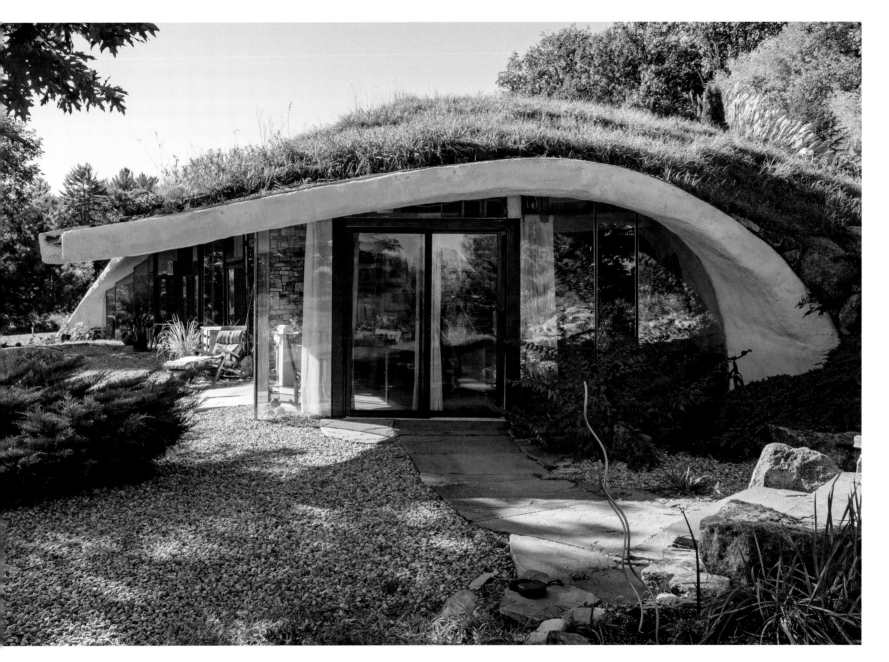

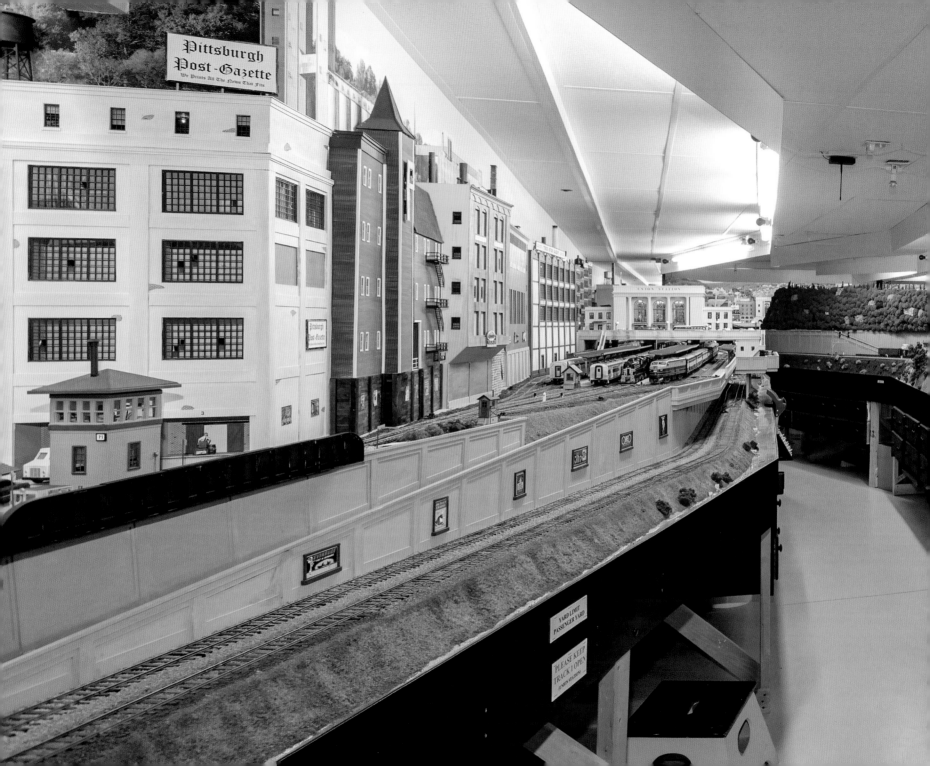

ARMSTRONGS'S
24-HR RAILVIEW
CAFE

John sez: "Try our fabulous Monterey Allen Java!"

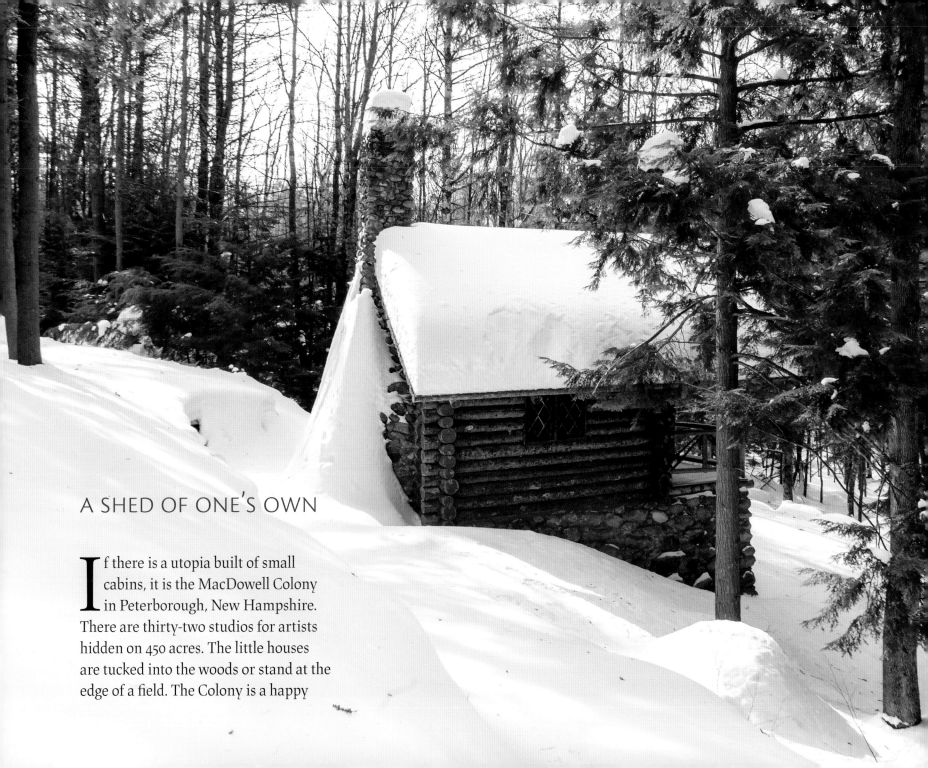

A SHED OF ONE'S OWN

If there is a utopia built of small cabins, it is the MacDowell Colony in Peterborough, New Hampshire. There are thirty-two studios for artists hidden on 450 acres. The little houses are tucked into the woods or stand at the edge of a field. The Colony is a happy

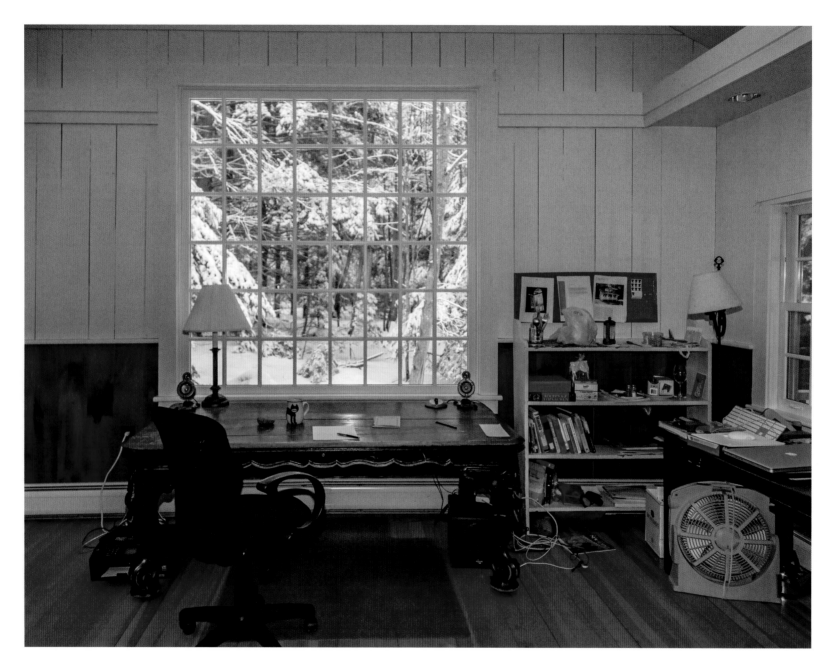

contradiction—a neighborhood of hermits, group solitude. Walking down a country road, a dirt lane winding through the forest, and coming upon a cabin is reminiscent of a fairy tale—but which one? Hansel and Gretel? Little Red Riding Hood? Cinderella? Many fairy tales take place in a kind of re-membered European landscape of dark forest enveloping a little cottage. And all fairy tales seesaw between enchantment and entrapment. Most "Colonists," as they are called, are enchanted; a few, up from the cities, are spooked by the dark and the green, silenced by the quiet.

Each cabin is a distinctive, diminu-tive house, a short essay about dwelling: a room, porch, bathroom, fireplace. There are cabins impersonating a Clas-sical temple and a Swiss votive chapel, cabins that have come down with a touch of Tudor or German cottage fever, cabins in clapboard, shingles, stucco, granite block, stone, brick, logs, and white-pine bark, but simplicity prevails. Most were built before the 1930s in a sort of North Country Craftsman style, a sturdy boots-on, outdoorsy, rough-and-ready spirit that is just right. (It implies that a birch

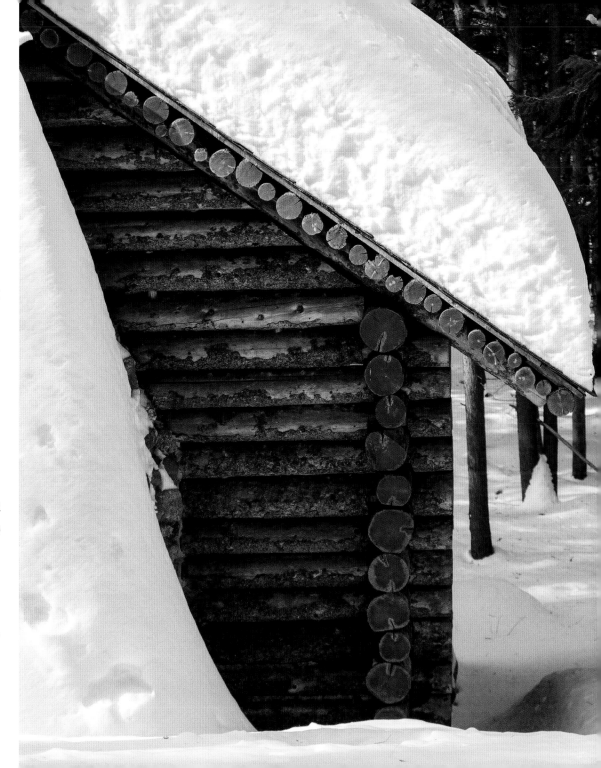

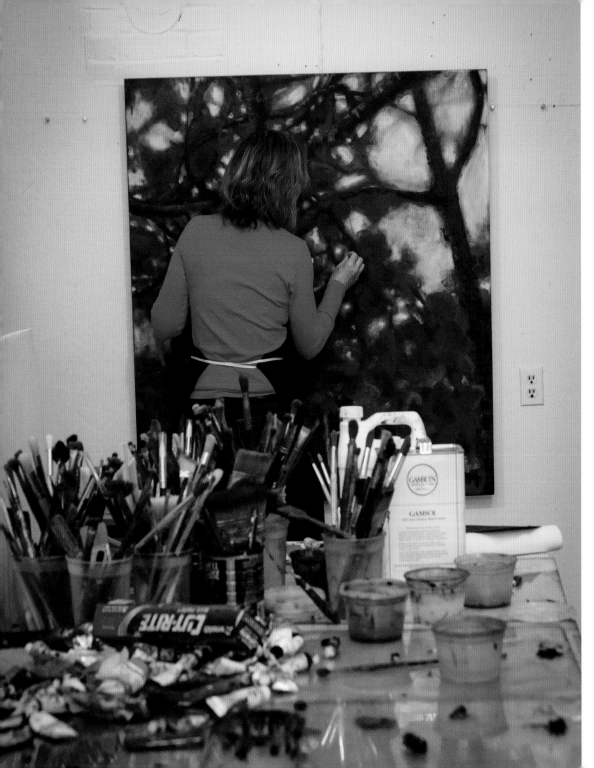

bark canoe is nearby, ready to take you trout fishing.) Marian MacDowell, who founded the Colony in 1907, called her collection of studios "little boxes."

The Colonists are grateful for the gift of "a room of one's own," in Virginia Woolf's phrase, for the time to think, to dream, to create. They speak of finding a "world within a world," "a deep well," "pure time." There are no interruptions from breakfast to dinner. A lunch basket is quietly deposited at their door. They are amazed at the amount of work they can get done, and they are proud to add their name to those of the other artists who have worked in that studio and signed one of the studio's small wooden "Tombstones."

"It's like one of Plato's universals," poet Howard Moss said. "The ideal place to work, to rest, to concentrate, to think, to be." Privacy is the last luxury.

It's ideal, except, of course, when it's not—when the novel or concerto or film or sculpture is going poorly. Then they are not enchanted by this fairy tale of artists in the woods. Then the wolf is at the door. And "MacDowell can be Hell," wrote novelist Peter Cameron.

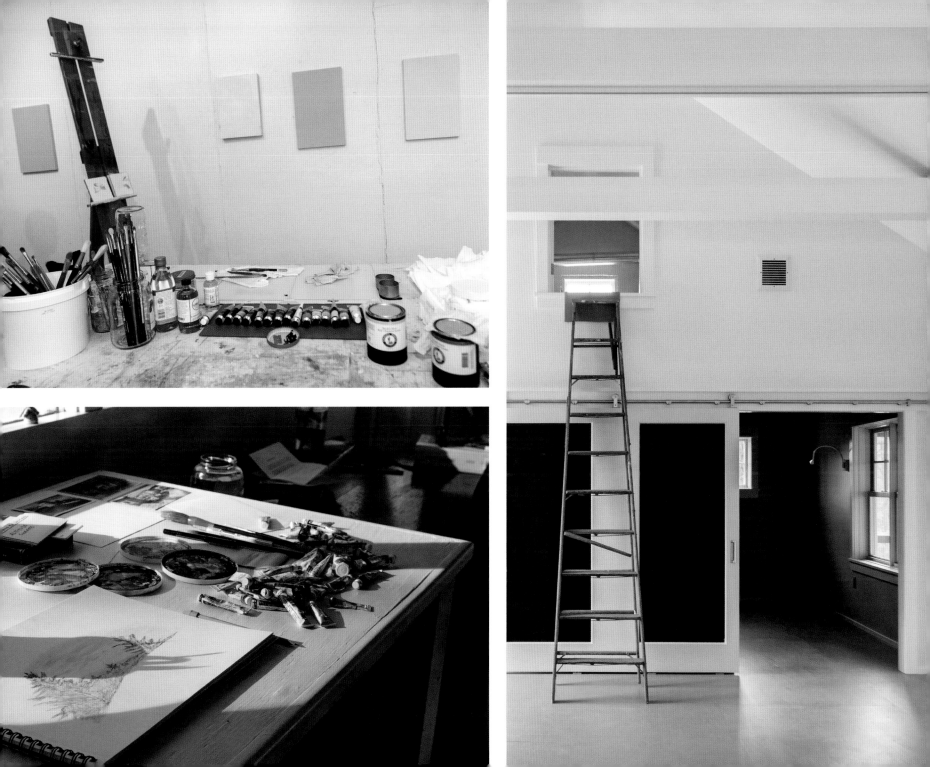

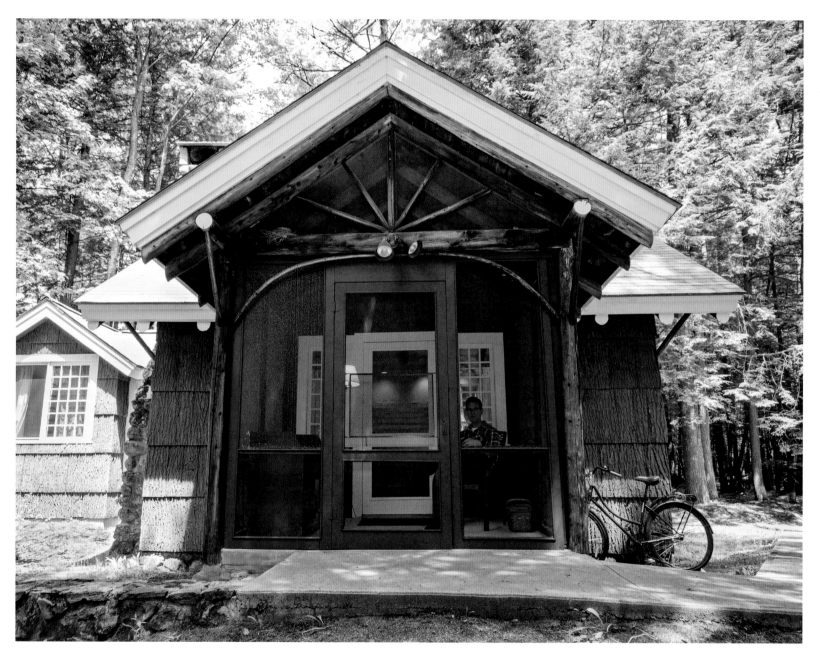

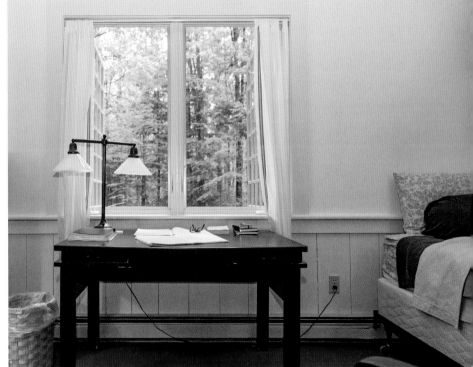

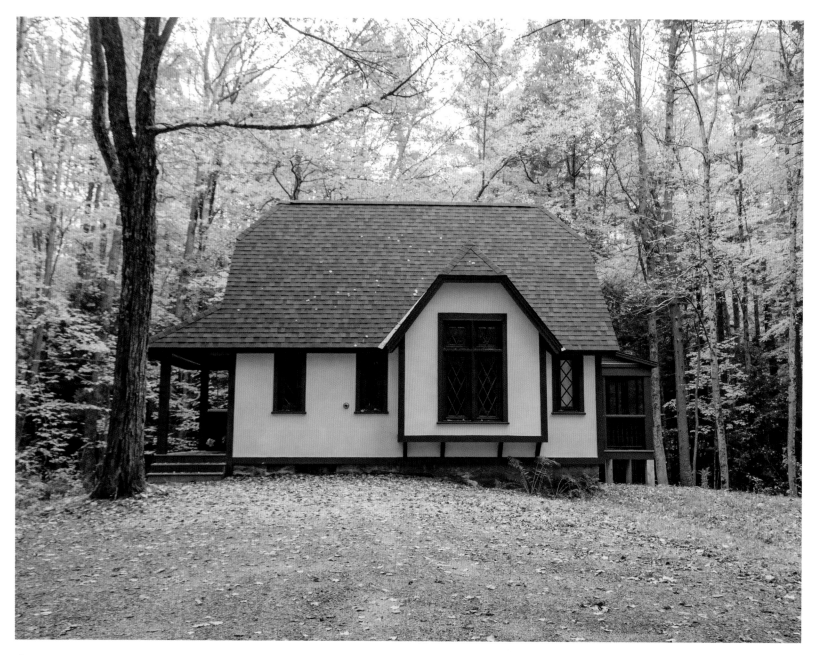

"For an artist, there are few fates worse than being stuck in a cabin in the woods with a putrefying canvas, or manuscript, or idea. There are only so many walks (and naps) you can take, books you can read, only so many times you can check for mail or messages—you must keep returning to the small lonely room that seems to contain your inept mediocrity. And knowing that the woods are alive with the sounds of artists creating, creating, creating is enough to drive you mad. . . .

"It can get a bit creepy, late at night, looking at the names on those wooden plaques bearing former Colony Fellows' names, some disappearing beneath the bruise of time," writes Cameron. "So much of art is futile—unappreciated or unacknowledged, forgotten or unseen. But, oh—to be given a place to be alive in and create art, a place in the woods, a fireplace, a screened porch, a window, a birch tree iridescent in a stand of pines, a field of snow."

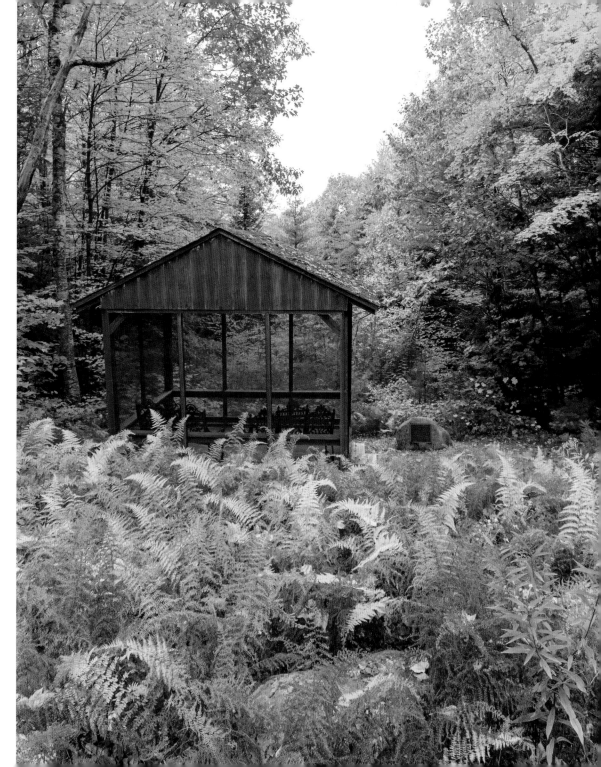

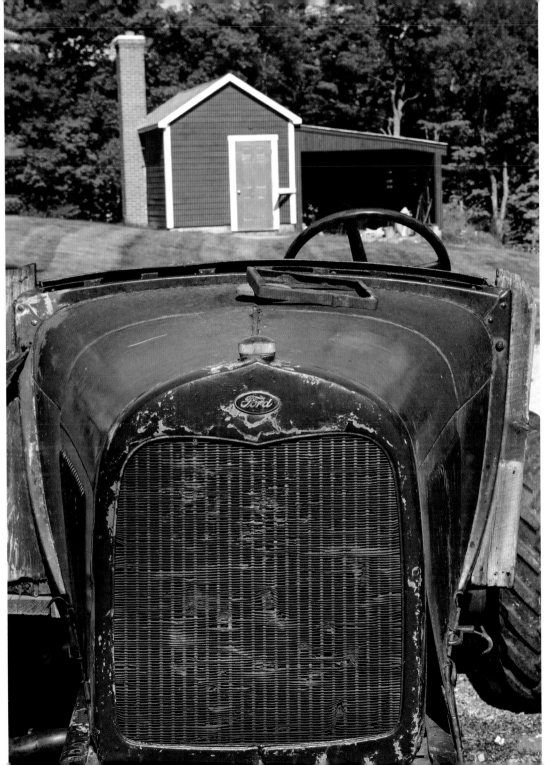

SAUNAS

Saturday night was sauna night when Ralph Kangas was growing up. Around one in the afternoon, his father would say, "Ralphy, time to lug the water and get the wood in—get the sauna going." His Finnish grandfather had built their sauna the old way, with a wood fire and water hauled in by the bucket.

Everyone in their community of Finns got their saunas going on Saturday. His family, like other Finnish families in town, had come to New Ipswich, a small New Hampshire town on the Massachusetts border, in the early twentieth century, taking up farms that the Yankees had abandoned. Most of them settled in a part of town that was soon called Finn Country. On Saturdays they danced polkas at the "Cracker Box" to the Lampi family's accordion, and they visited family and friends for a sauna (which is properly pronounced *sow*—as in pig—*na*).

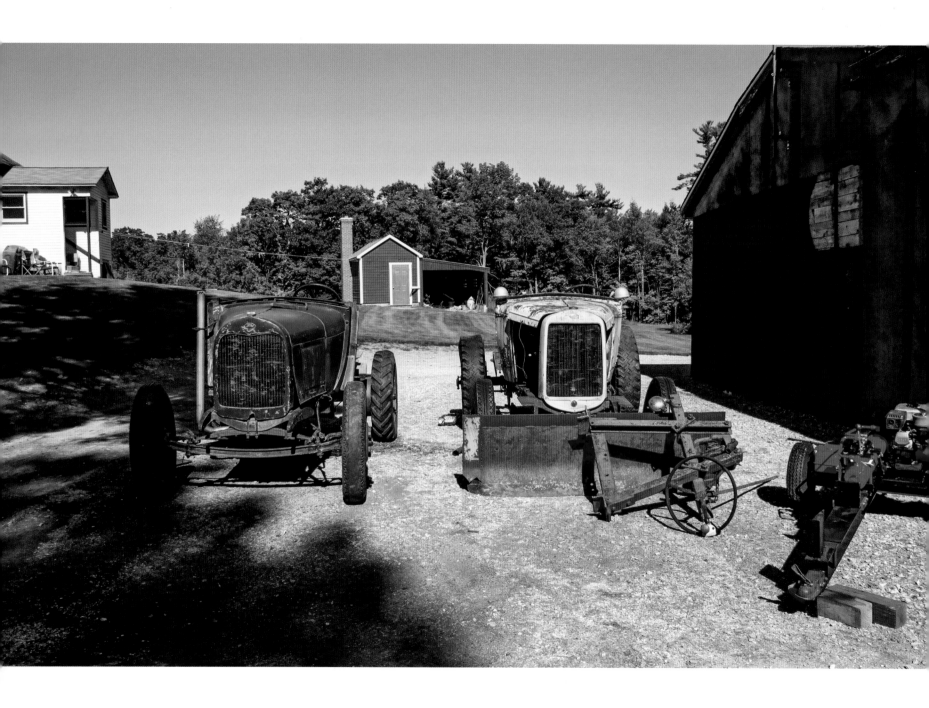

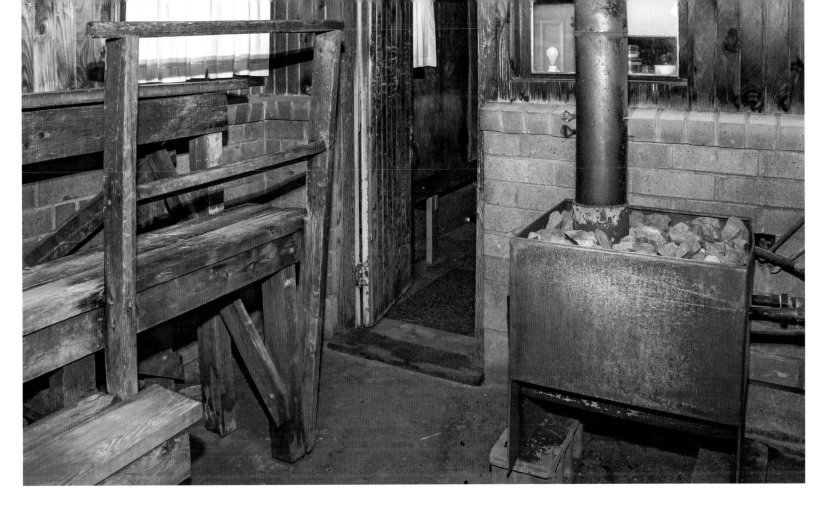

"It was always open to your closest friends. You didn't call. There was never a Saturday night without a sauna," said Kangas. Afterward, in his family, the adults sat around talking over coffee and *nisu*, Finnish coffee bread. "There wasn't much to watch on TV, just test patterns a lot. People just sat around and shot the breeze." Other Finnish families in town mixed in a Yankee custom, a frank and bean supper.

"All the Finn farmers had saunas." None of the Yankees, who lived in the center of town, had them. In his class at school, at least half of the twenty-five kids had saunas at home. "It was the only way you could keep clean because there was no shower," he said.

The old farmhouses did not have indoor bathrooms until the mid-to-late 1950s. (A hand pump in the kitchen sink brought water into the house.) Most of the people Kangas knew had outhouses. Theirs was in the back shed—the shed linking the barn to the house. His father added an indoor bathroom with a shower in 1956. Before that they washed three times a

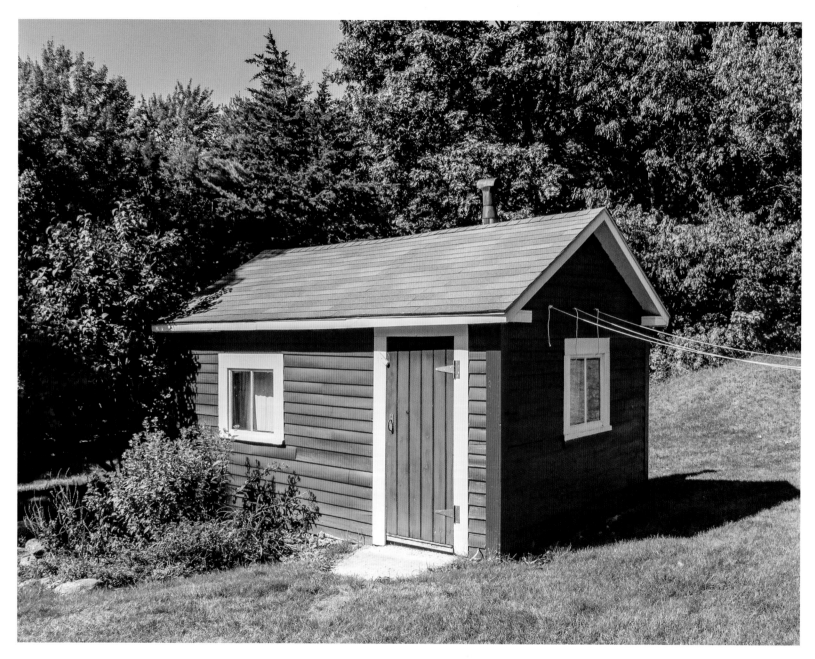

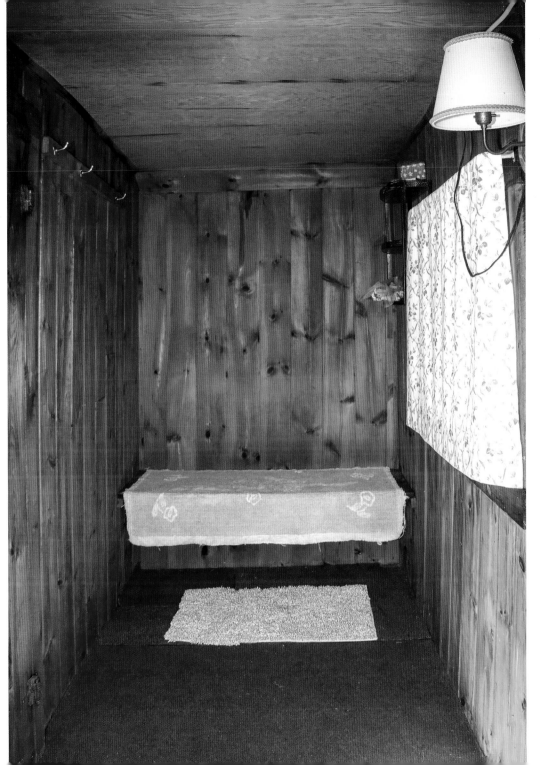

week, once in a galvanized metal tub and twice in the sauna, Saturday and Wednesday nights, which was not a time for visiting. To wash in the sauna, they mixed two buckets of water, a cold water bucket on the floor and a hot water bucket heating on the stove.

His grandfather built a series of saunas on their farm. The first was in the back shed, the next was behind the barn on a knoll (but that was damaged by the great hurricane of 1938), and finally the one that the family still uses, just behind the house.

Construction was simple: two-by-fours, no insulation, and a poured cement floor, which was sloped toward a drain. This was all do-it-yourself work. There were no sauna contractors, no cement trucks. They got a cement mixer, or just used a "mud tub," and poured the slab themselves. To wire the sauna for a light, they hung a wire from the barn to the side of the sauna. "There were no building inspectors and permits. You just built it. You didn't go to the selectmen to get permission—no tax on it."

The sauna shed was the size of a one-car garage, "if you drove the car in

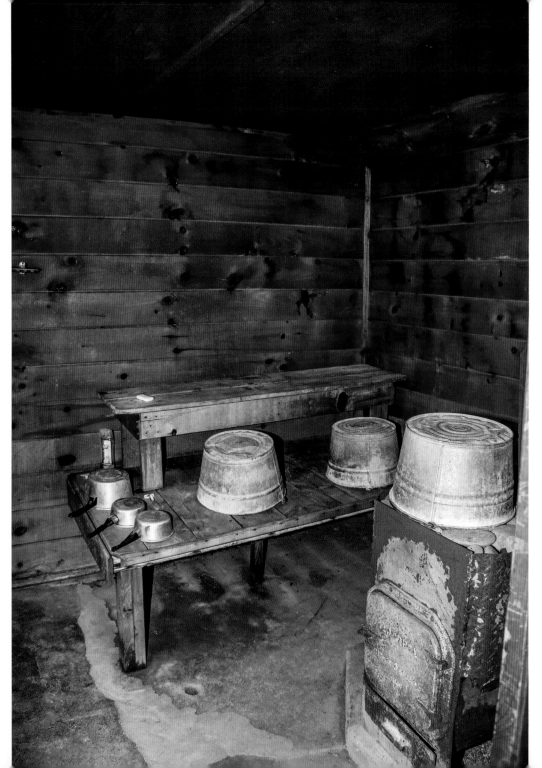

the gable end." That's the way most of them were built in town. There were two rooms—a changing room with a small window, and the sauna room itself, with an upper and lower bench (the higher up you sit, the hotter it is) and a woodstove attached to an outside cement-block chimney. The walls were tongue-and-groove knotty pine. "The pine pitch blistered out and gave it a nice smell." No one used cedar like they do today. The one flourish his grandfather, a good carpenter, allowed himself, was a "pigeon stool"—the molding that follows the slope of the gable returns a short way across the front, as it does in Greek Revival houses, to suggest a formal temple-like pediment.

In front, the Finns planted flowers, usually hollyhocks, said Kangas, and a lilac or two, which would thrive on the ashes from a woodstove. "The Finns love lilacs," he said.

The woodstove was the heart of the sauna. A sauna woodstove has an open box on top to hold stones. Kangas's father used smooth, round stones from the beach. "They were just better. You never saw a rough stone." A bucket of

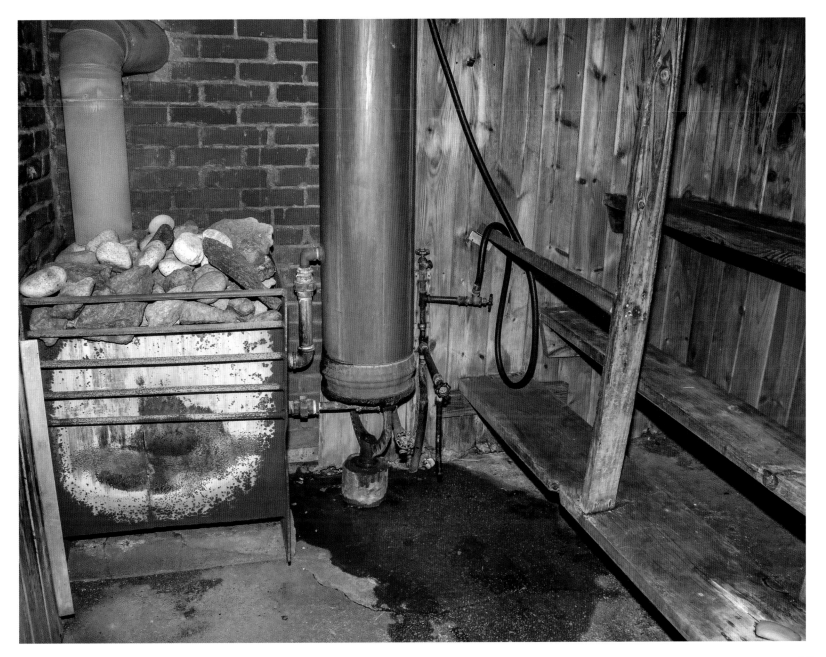

water poured over the stones provides the steam. "It's a dry heat at first and then the water goes on the stove, and all of a sudden that blistering humid air just grabs on your skin and, wow, you could feel it." The sauna would heat up to between 140 and 180 degrees—heat and humidity that will do in most beginners, he said. In winter Kangas would sprint up to the top of the field and jump in a snowbank. "Even if it was ten degrees out, it was like a summer's day." No one he knows continued the Old World practice of switching themselves with a bundle of leafy birch twigs.

Today almost all the sauna sheds are gone. Kangas can count only maybe ten old sauna sheds when he drives around town. They were lost to fires—on Saturdays the fire engines were always going out—and to rot—there was no pressure-treated lumber back then—and they were lost to changing times.

Saunas have moved indoors. They have electric stoves that heat up quickly after a twist of the timer. Many are built from kits, set up in basements or garages or the house itself. They're like furniture, said one Finnish sauna

salesman. You can take your sauna with you when you move.

To someone raised with a wood-fired sauna, it's a diminished experience. "I've been in electric heat at the health club I go to. Not the same. Everything's fake on it," he said. Pouring water over the fake rocks doesn't jolt you with that "blistering humidity."

When the sauna moved indoors, some of the sociability was lost, too; some of the heat went out of visiting. "It's a sad thing. People don't go out to other people's houses as much," Kangas said. "Everyone is locked up in their TV/computer world."

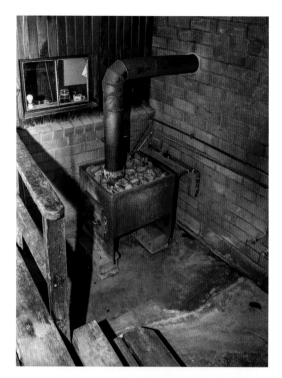

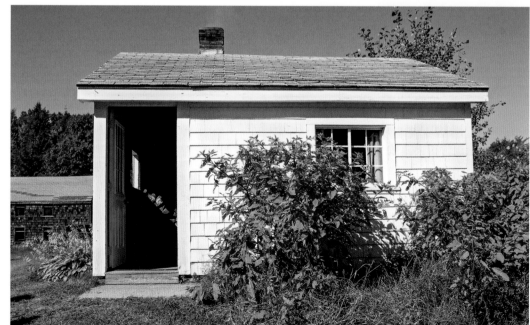

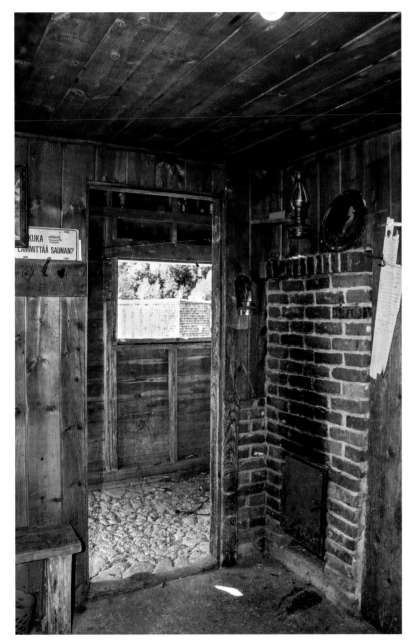

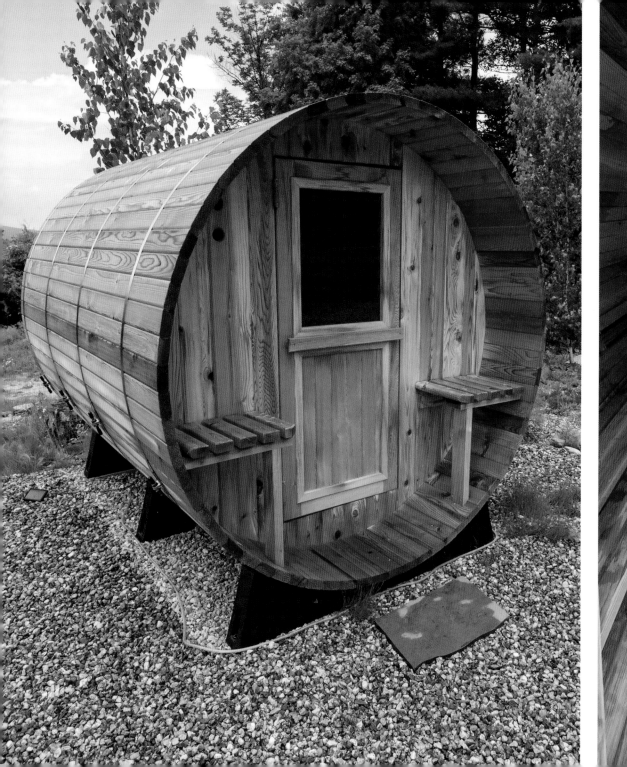
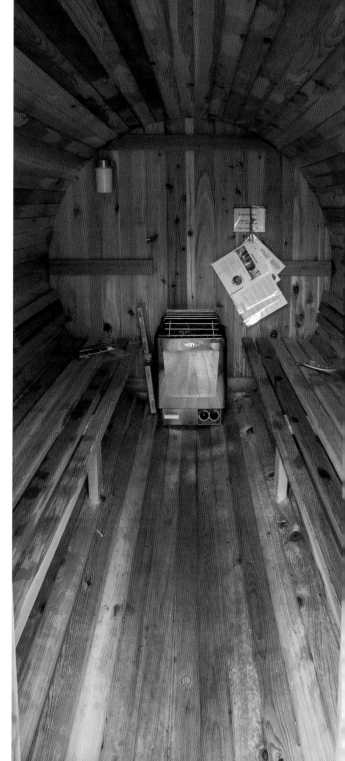

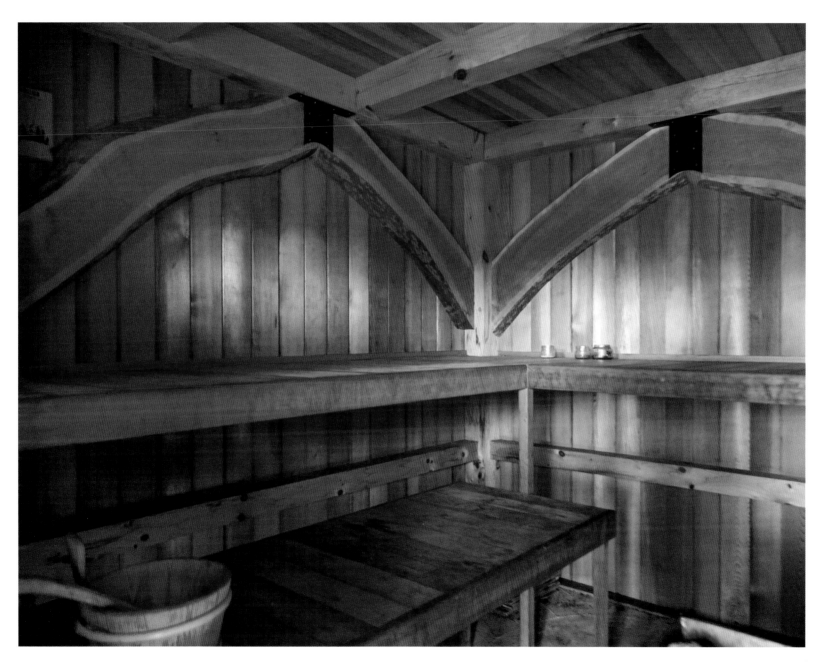

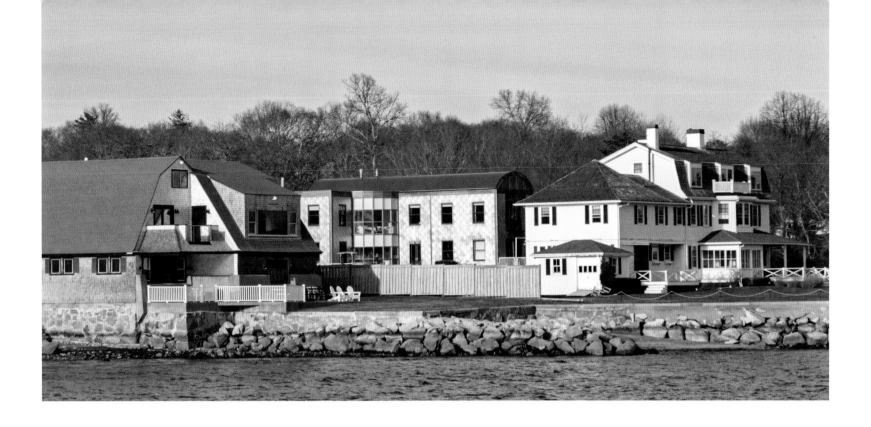

ANTI-SHED II

The Austrian architect was enjoying his visit to a lakeside mountain village "where everything breathes beauty and peace" when he came across a new building. "What's this then? A false note disturbs the peace. Like an unnecessary screech: among the peasant's houses which were not made by them but by god [his lower case],

there is a villa. The work of a good architect, or a bad one? I don't know. I know only that peace and beauty have fled," Adolf Loos wrote in 1909. "Why is it that every architect, whether he is good or bad, harms the lakeside?

"The peasant does not. Nor does the engineer, who builds a railway to the lake, or plows deep furrows in its

bright surface. They create in another way. The peasant has pegged out a patch of green meadow on which the new house is to stand, and dug a trough for the foundations. If there is clay in the neighborhood, then there will be a brick kiln to supply bricks; if there isn't, the stone round the edge of the lake will do equally well. And while the mason

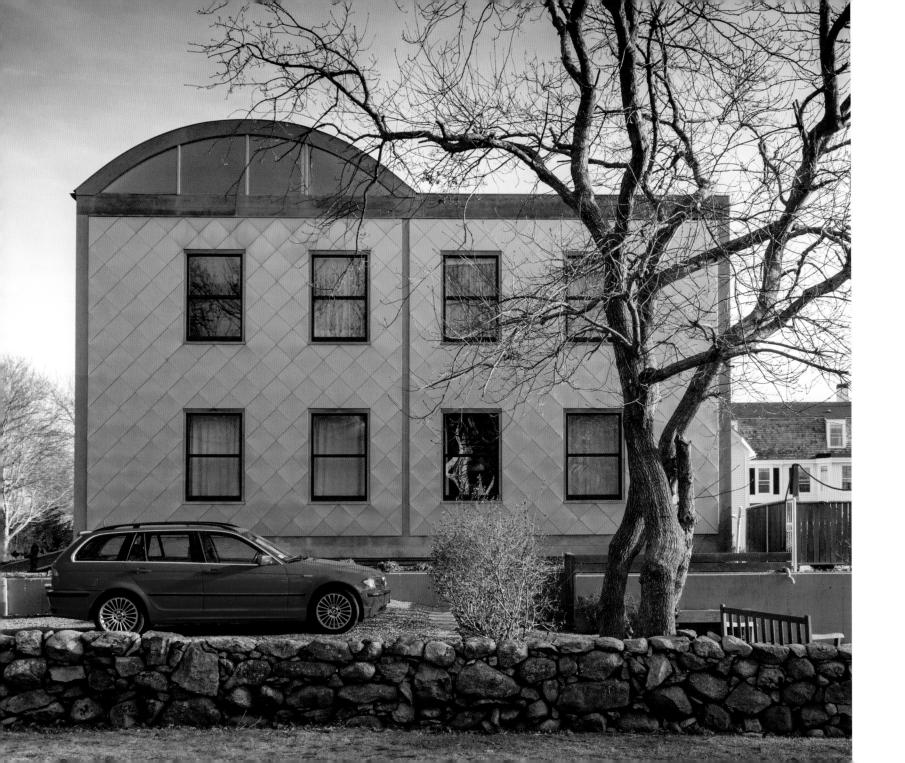

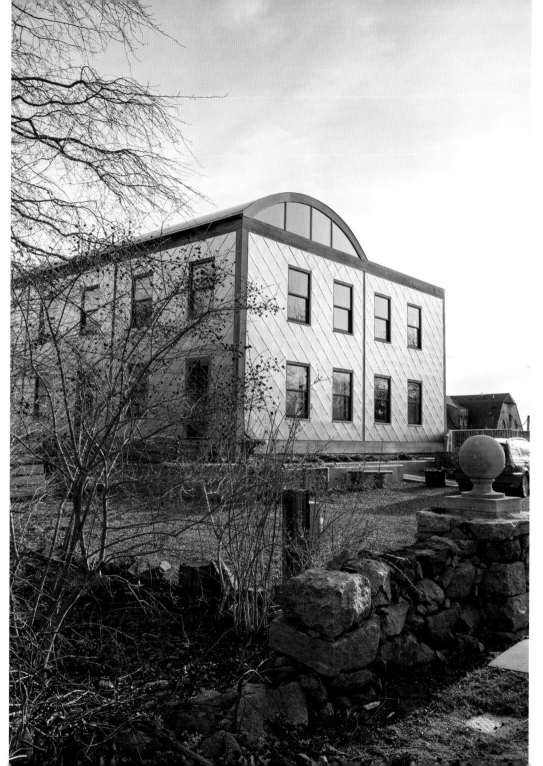

lays brick on brick, stone on stone, the carpenter has set up his rig. He is making the roof. Will it be a beautiful roof or an ugly roof? He doesn't know. A roof.

"The peasant wanted to build a house for himself, his kin and his cattle, and he has succeeded. As his neighbor and his ancestor succeeded. As the animal succeeds, guided by its instincts. Is the house beautiful? Yes, just as beautiful as the rose and the thistle, the horse and the cow. I therefore ask again, why does the architect, be he a good or a bad one, harm the lakeside? Because the architect, like practically every townsman, has no culture. He lacks the security of the peasant, who does have a culture. . . . I call culture that harmony between the inner and outer man which alone guarantees sensible thinking and acting. . . ."

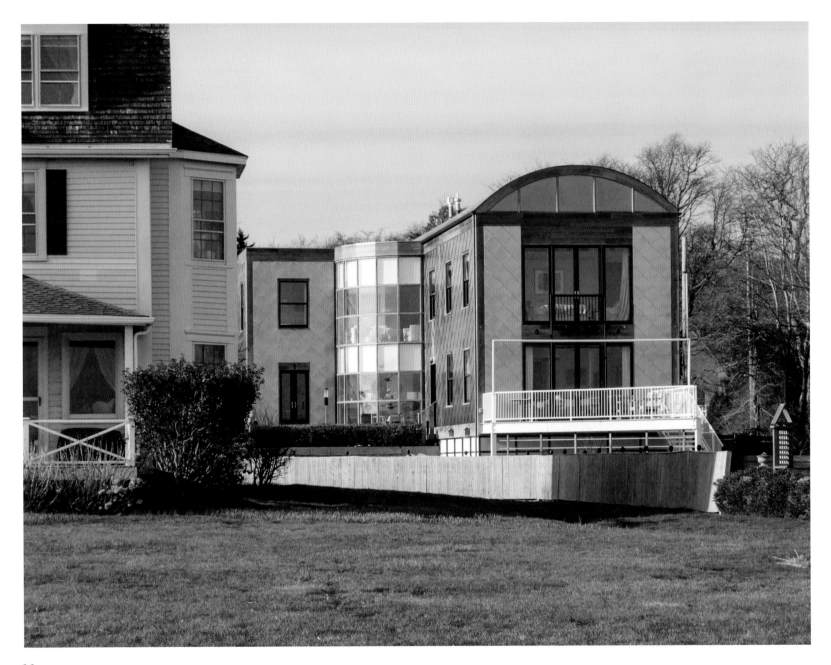

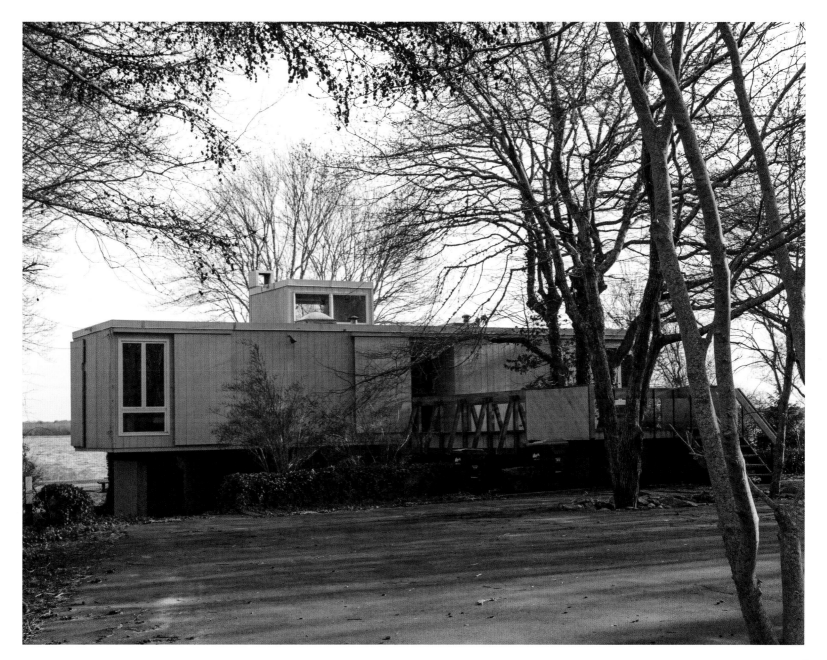

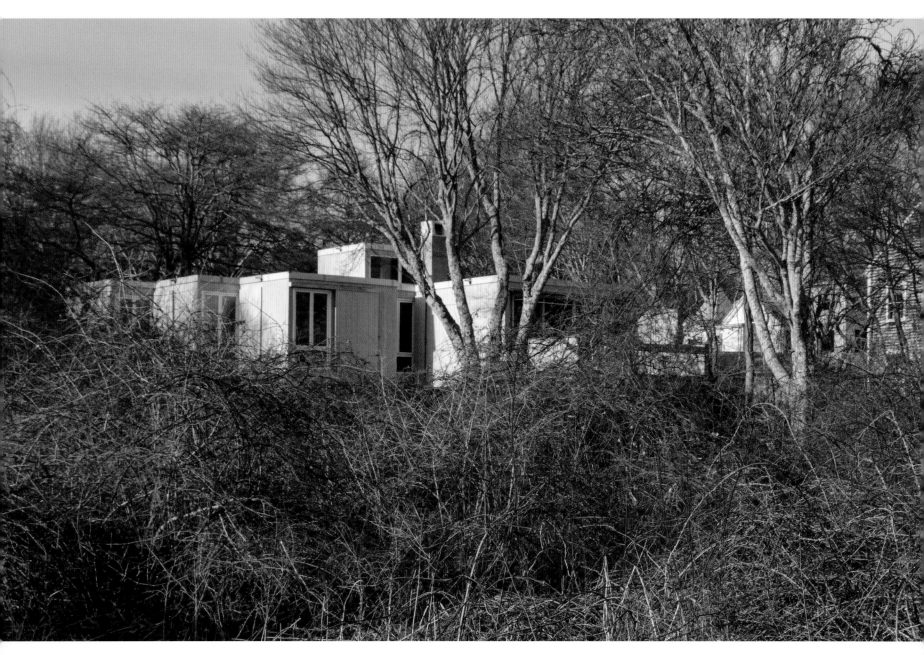

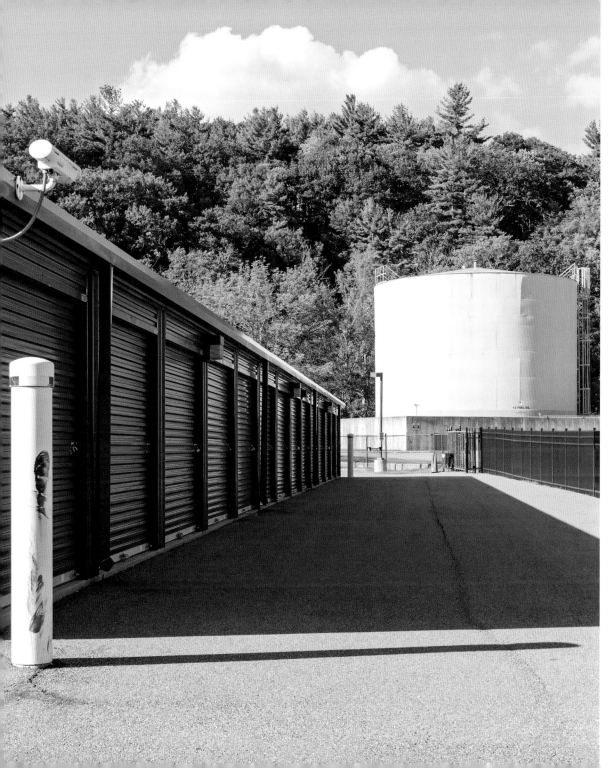

STORAGE SHEDS

They have become a defining char-
acteristic of the roadside, wedged
in among the malls and fast food
franchises, barrack-like rows of buildings
with small garage doors, surrounded by a
fence. A gated enclave for excess stuff.

There are 2.3 billion square feet of
"self-storage" space in America, or more
than seven square feet for every, man,
woman, and child in the country. It's now
"physically possible that every American
could stand—all at the same time—under
the total canopy of self-storage roofing,"
boasts the Self Storage Association. There
are about fifty-one thousand storage
facilities in the country—more than four
times the number of McDonalds. The
storage shed may be our most common
shed, worthy of a commemorative stamp.
One in ten households rents a unit.

Surveying these mute buildings, a
friend's child was curious about what
they were. After they were identified, he
asked, "So—some people have a house
just for stuff—but some people don't have
a house?"

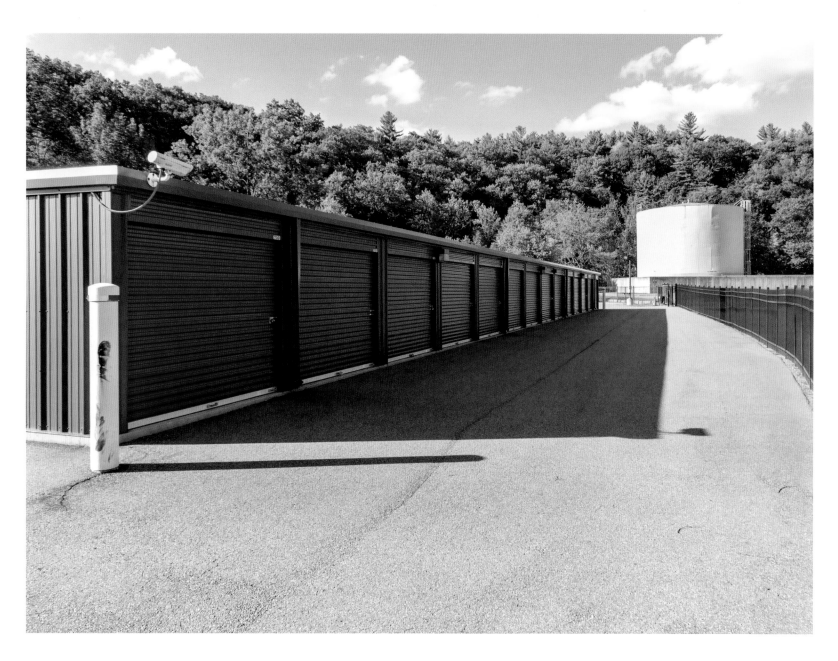

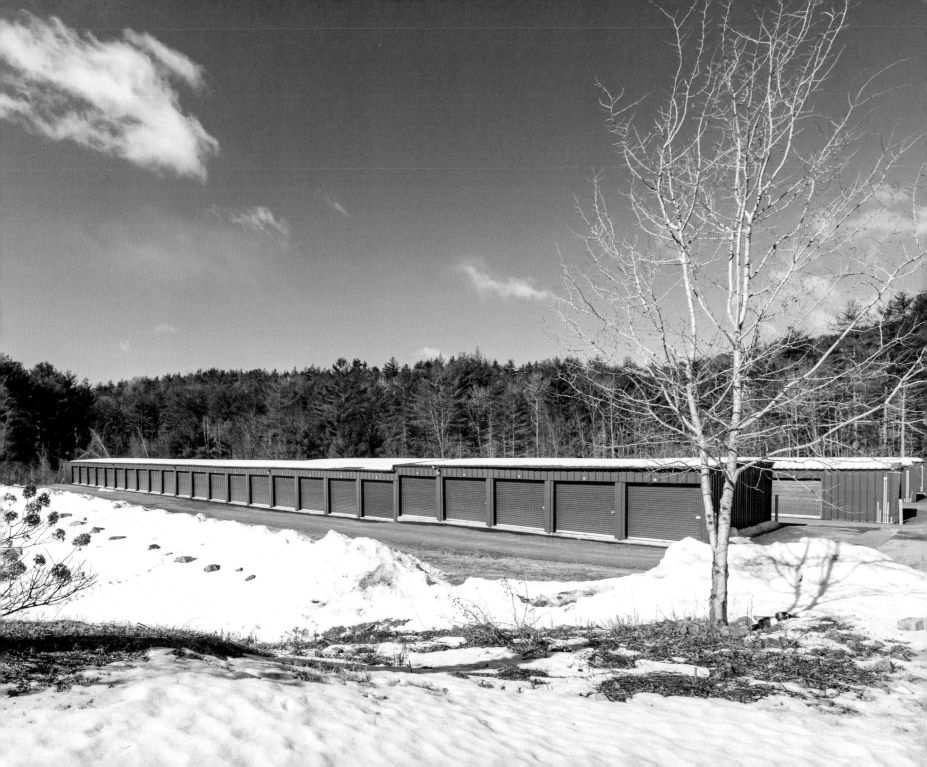

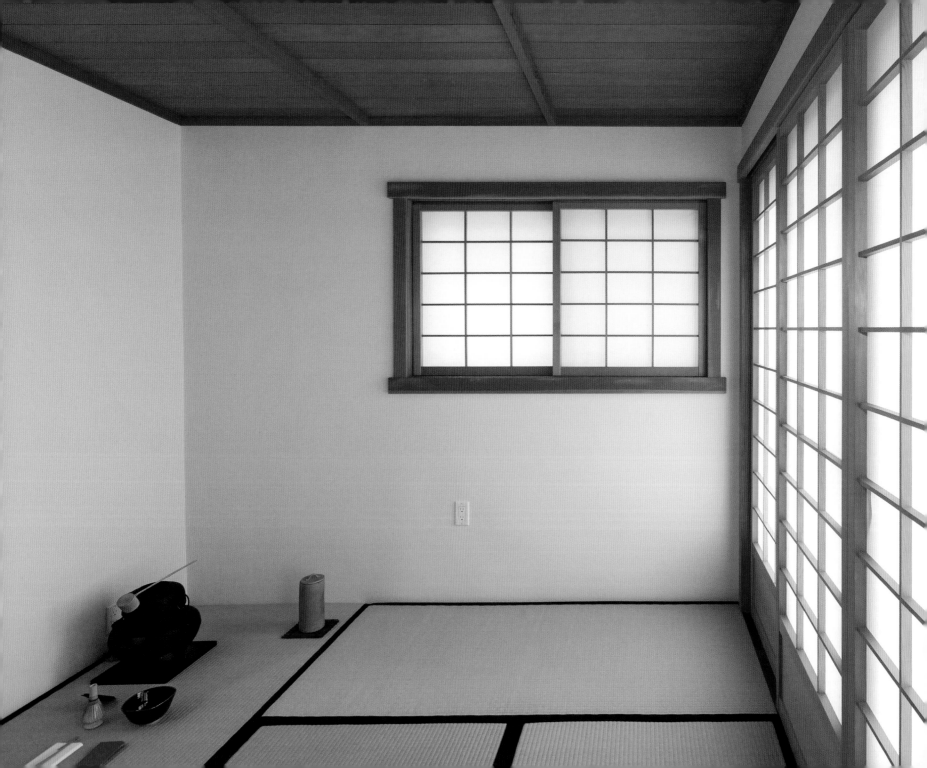

TEAHOUSES

We don't have teahouses in America. Teahouses are anti-storage sheds. We have one and not the other. The small garden teahouse was introduced to many in the West by *The Book of Tea*. Written in 1906 by a Japanese art scholar who was a curator at Boston's Museum of Fine Arts, it stands out as one of the earlier reports of Japanese traditions. *The Book of Tea* is a record of artful simplicity; it is about carefully selecting a few things, about deliberateness. It is, of course, the opposite of clutter and noise, two constants in our lives and homes.

The author, Kakuzo Okakura, proceeds by beguiling contradictory epigrams—"Teaism is the art of concealing beauty that you may discover it." He tells us how the tea ceremony was lost and found and changed over the centuries of different dynasties, invasions, and restorations. "We find a Ming commentator at loss to recall the shape of the tea whisk mentioned in one of the Sung classics," he wrote about the aftermath of the thirteenth-century Mongol invasion of China that interrupted the evolution of the tea ceremony.

Tea spread through China with Buddhism. Zen monks took up tea, sharing "a bowl before the image of Bodhi Dharma. . . . It was this Zen ritual which finally developed into the tea ceremony of Japan in the fifteenth century." The great Japanese tea master Rikyu perfected the ritual in the late sixteenth century, defining the four principles of the Way of Tea as harmony, respect, purity, and tranquility.

"Tea with us became more than an idealization of the form of drinking; it is a religion of the art of life," wrote Okakura, "a sacred function at which the host and guest joined to produce for that occasion the utmost beatitude of the mundane." The tea ceremony "shows comfort in simplicity rather than in the complex and costly; it is moral geometry, inasmuch as it defines our

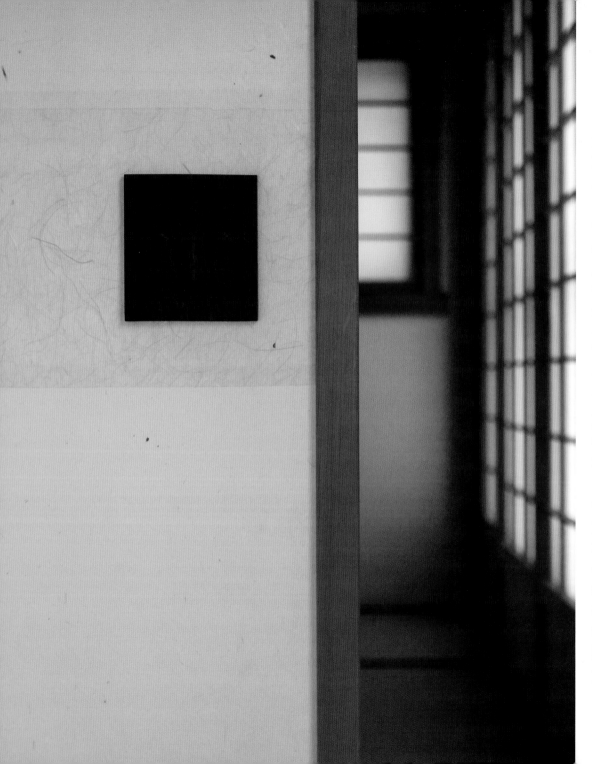

sense of proportion to the universe."

Okakura, who wrote *The Book of Tea* in English, calls this "Teaism." Its roots are in Taoism and in Zen, which, he said, recognized "the mundane as of equal importance with the spiritual." "The whole ideal of Teaism is a result of this Zen conception of greatness in the smallest incidents of life." From Zen, an awareness of life's evanescence entered the tea ceremony. The body is but "a hut in the wilderness," grasses tied together, he wrote. Release the binds and the body returns to "original waste." "In the tea room fugitiveness is suggested in the thatched roof, frailty in the slender pillars, lightness in the bamboo support, apparent carelessness in the use of commonplace materials."

The teahouse is "an ephemeral structure built to house a poetic impulse." Smaller than the smallest Japanese houses, it is crafted with "immense care and precision" by carpenters who are "a distinct and highly honored class among artisans." It is "consecrated to the worship of the Imperfect, purposely leaving something unfinished for the play of the imagination to complete."

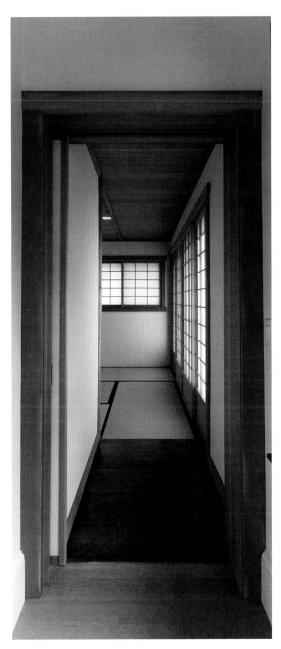

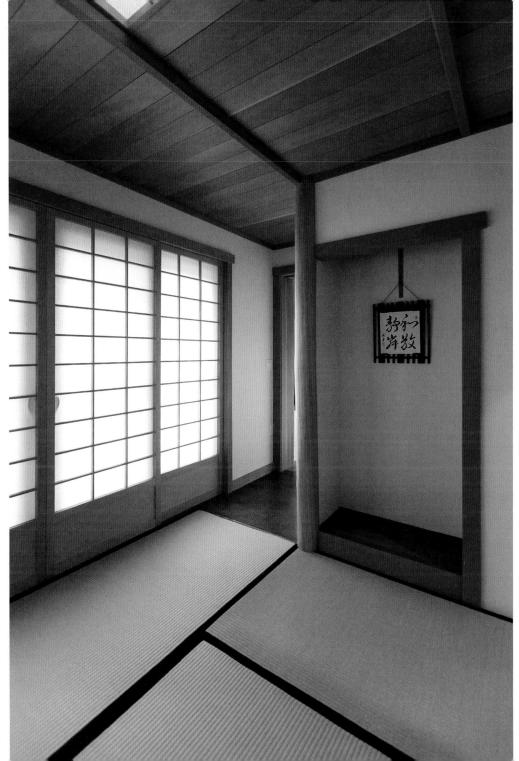

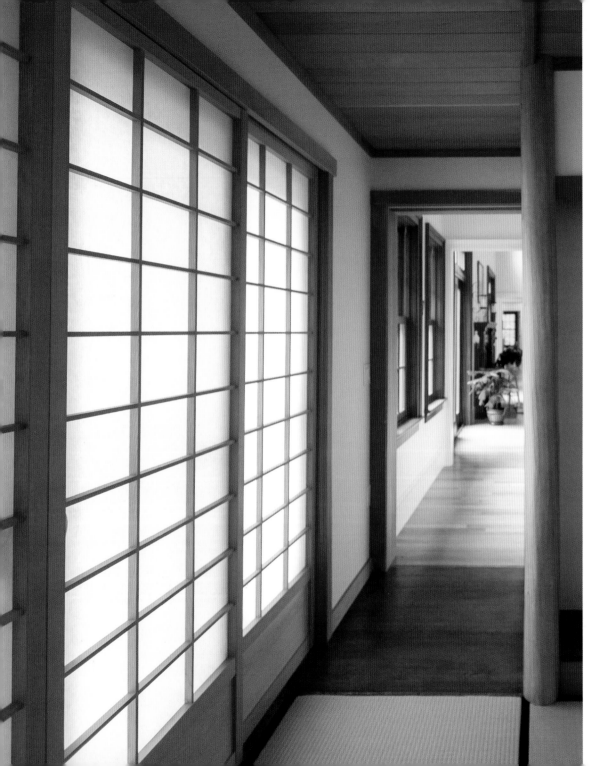

Each teahouse has a small tea room, an anteroom where the tea utensils are washed and arranged before they are brought in, and a shelter at a distance down a garden path, where guests wait until they are summoned. The path is meant to shake off the daily world and put the guests at ease. "One who has trodden this garden path cannot fail to remember how his spirit, as he walked in the twilight of evergreens over the regular irregularities of the stepping stones, beneath which lay dried pine needles, and passed beside the moss-covered granite lanterns, became uplifted above ordinary thoughts."

Showing their humility, guests enter the teahouse by crawling through a low doorway, not more than three feet high. The colors are muted, the light subdued. The tea is on the boil and there is a flower arrangement or one art object. One thing at a time. The guests quietly wait for the tea, attend to each detail. Time is slowed; attention is paid. Here and now is given its due respect.

"The host will not enter the room until all the guests have seated themselves and quiet reigns with nothing to break the silence save the note of the boiling water in the iron kettle. The kettle sings

well, for pieces of iron are so arranged in the bottom as to produce a peculiar melody in which one may hear the echoes of a cataract muffled by clouds, of a distant sea breaking among the rocks, a rainstorm sweeping through a bamboo forest, or of the soughing of pines on some faraway hill."

Flower arranging is an adjunct art. Great respect is paid to cut flowers; only a few are displayed at a time. Sometimes a monument is erected in memory of the flowers, Okakura said. "Entering a tea-room in late winter, you may see a slender spray of wild cherries in combination with a budding camellia; it is an echo of departing winter coupled with the prophecy of spring. Again, if you go into a noon-tea on some irritatingly hot summer day, you may discover in the darkened coolness . . . a single lily in a hanging vase; dripping with dew, it seems to smile at the foolishness of life." The tea master orders his life by the high standards of the teahouse. He maintains serenity. "Until one has made himself beautiful he has no right to approach beauty," said Okakura. "Thus the tea master strove to be something more than the artist—art itself." He lives by Rikyu's four principles of harmony, respect, purity, and tranquility.

The Way of Tea is simple, said Rikyu.

First you heat the water,
Then you make the tea.
Then you drink it properly.
That is all you need to know.

We will be on a path to a happier life when we begin to trade in storage sheds for small garden teahouses.

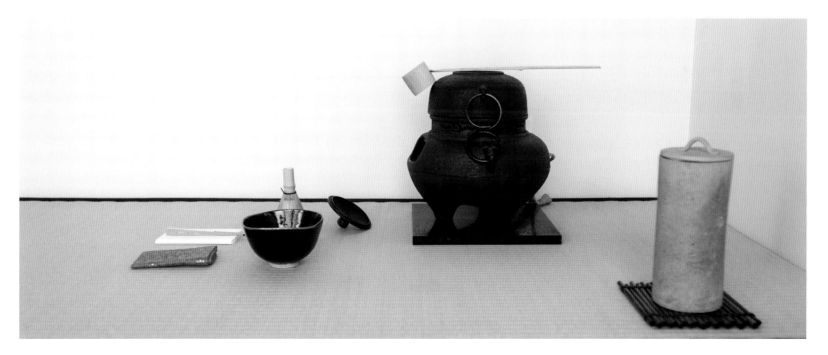

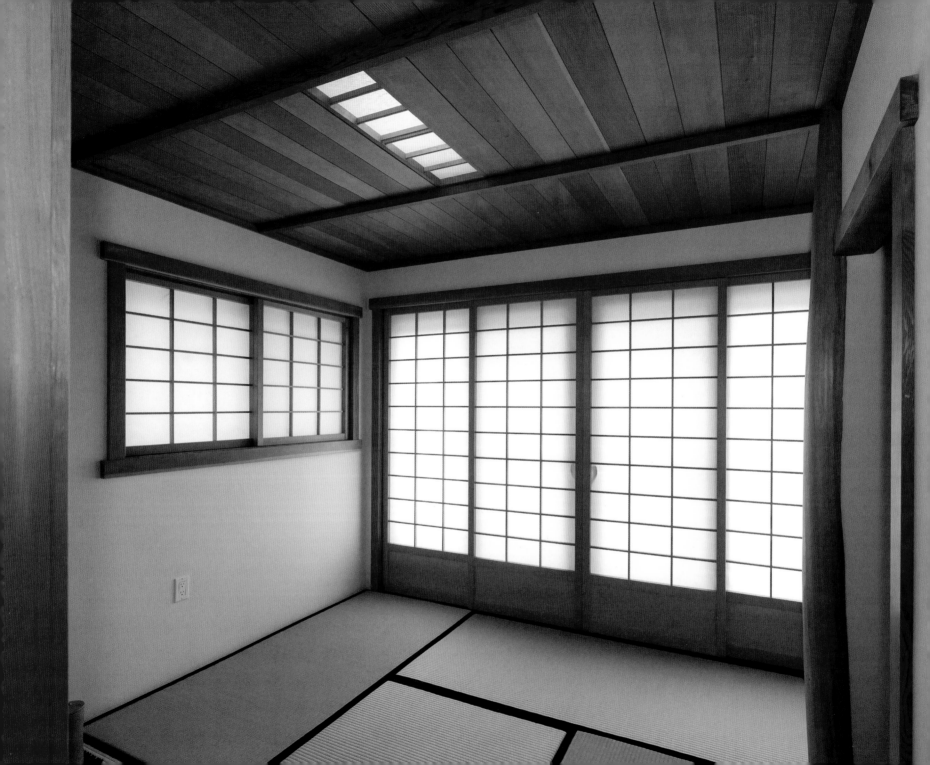

THE EXALTED ORDINARY—
A PEASANT'S BOWL

An old peasant's bowl isn't a shed, but it has the ordinary qualities that make a shed ordinary—it may be lopsided, badly finished, easily overlooked; the kind of thing that might be left behind at the end of a garage sale.

In Korea in the sixteenth century, a bowl was made and shipped to Japan, one piece of crockery among hundreds unloaded on the dock. No one knows who made it. There were thousands upon thousands of bowls like this once: unseen in their daily use, broken at some point, discarded, forgotten. The person who saw it—who was he?—saw something special in it: the bowl was ordinary, perfectly ordinary.

In time this bowl was declared a "meibutsu," Japanese for masterpiece, literally "thing with a name." This anonymous bowl was given the name of its owner, Takeda Kizaemon, an Osaka merchant. Today, the Kizaemon Bowl, chipped and repaired, dirty from centuries of use, is honored by the Japanese

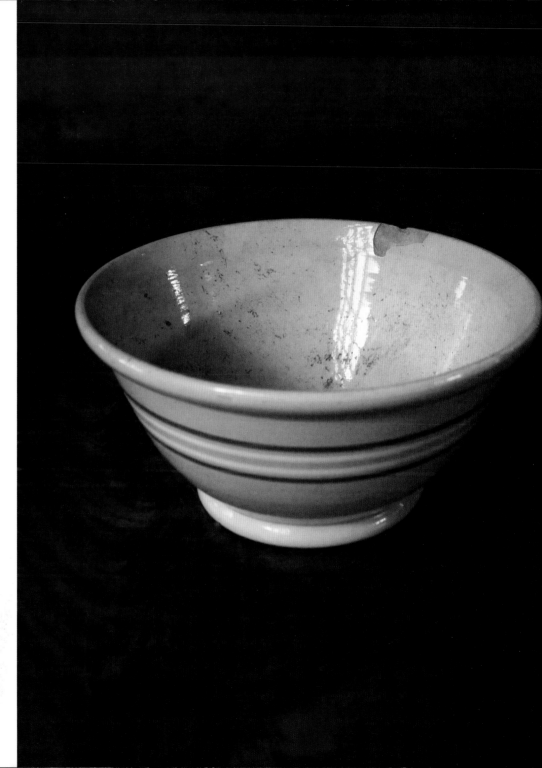

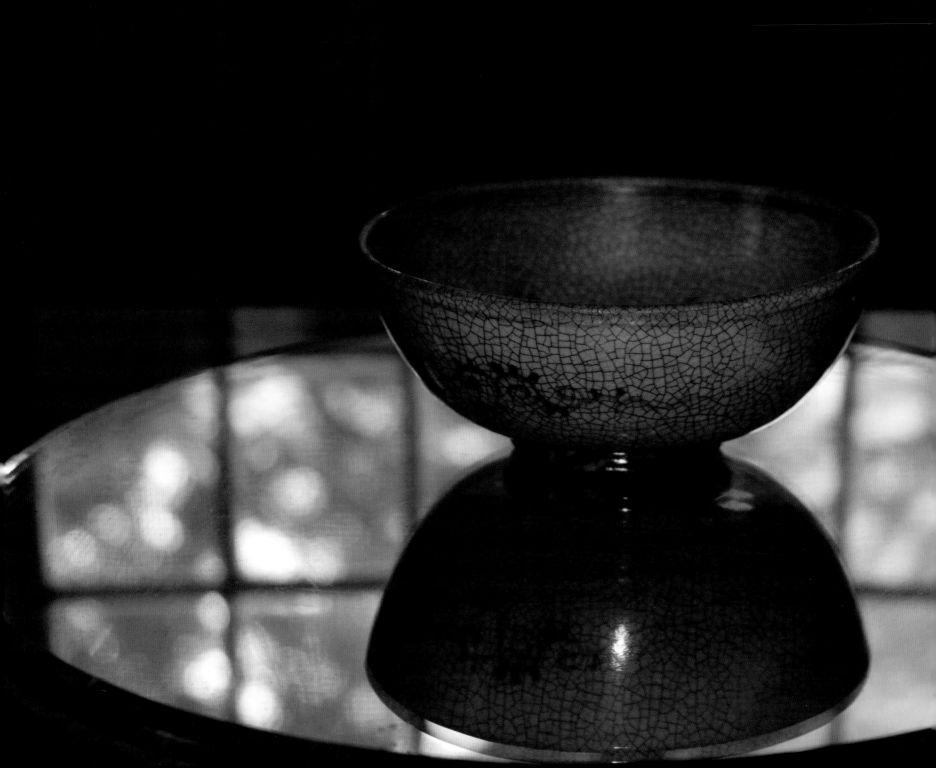

government as a national treasure and is considered to be the finest tea bowl in the world, the essence of the Way of Tea.

When it was discovered on the dock, there was not much pottery being made in Japan. Shipments from Korea and Southeast Asia were eagerly awaited by a small band of a few hundred enthusiasts: nobles, monks, temple officials, warriors, doctors, and wealthy merchants. "These men knew one another, met regularly for tea, and competed intensely on issues of taste and ownership of utensils," wrote Louise Cort, a curator of ceramics at the Smithsonian Institution. They developed a language of appreciation, a way of seeing these ordinary bowls. They classified the Kizaemon and other bowls of this shape as an "Ido" bowl, because looking into the deep bowl as they drank tea from it was like looking into an ido, a well.

In particular they admired the Kizaemon's failed firing, the way the glaze had "crawled," pulling away from the clay in "beadlike globules." They called this "plum-blossom bark" after the shark skin used in sword fittings.

"The appearance of the coarse and abundant crawling is interesting beyond my powers to express," said one admirer.

The Kizaemon was treasured, passed on through the centuries, and used in tea ceremonies. It was "a duty of ownership" to cultivate "the patina of use and age," wrote Cort. The true nature of a thing can be known only by using it. "In properly venerated Ido bowls, brown tea tannin has been allowed to sink into the cracks and pits of the glaze. Oil from caressing hands has given a luster to the surface. Rough edges have been worn down . . . breaks and repairs are openly acknowledged," wrote Cort.

And like some treasures, it gathered a legend of extracting a high price for possessing beauty. A number of owners were cursed with "a plague of boils" and death.

Very few people got to see these honored Ido bowls. "The tea masters guarded their treasures with religious secrecy," said Okakura. "Rarely was the object exposed to view, and then only to the initiated." The Kizaemon was enshrined in boxes within boxes, five in

all. It was bedded in wool and wrapped in purple silk.

Soetsu Yanagi, the founder of the Japanese folk craft movement, wanted to see the Kizaemon. He had seen only the fuzzy black-and-white photos that were available in the early years of the twentieth century. Yanagi used his connections to gain an audience. Finally, when the day arrived, he was ushered in and stood by as box after box was removed and the silk unwrapped.

"I had expected to see that 'essence of Tea,' the seeing eye of Tea masters . . . the embodiment in miniature of beauty, of the love of beauty," wrote Yanagi. "When I saw it, my heart fell. A good Teabowl, yes, but how ordinary! So simple, no more ordinary thing could be imagined. . . . It is just a Korean food bowl, a bowl moreover, that a poor man would use everyday—commonest crockery."

It was carelessly made—"the work had been fast; the turning was rough, done with dirty hands; the throwing slipshod"; the firing in a wretched kiln was haphazard. "No one invested the thing with any dreams," said Yanagi.

But, he said, this is "as it should be." He saw the essence of the bowl. "More than anything else, this pot is healthy. Made for a purpose, made to do work. Sold to be used in everyday life. If it were fragile, it would not serve its purpose. By its very nature, it must be robust. . . . Only a commonplace practicality can guarantee health in something made."

He saw the Ido bowls as the tea masters saw them. "The tea masters liked the fine netting of crackle on Ido bowls for the warm, fresh friendliness it gives. They found a charm when the glaze skipped in firing, and when a 'landscape' formed in the pattern of mended cracks. . . . [T]hey developed a high appreciation for the internal volume and curves of bowls; they looked to see how green tea settles into them.

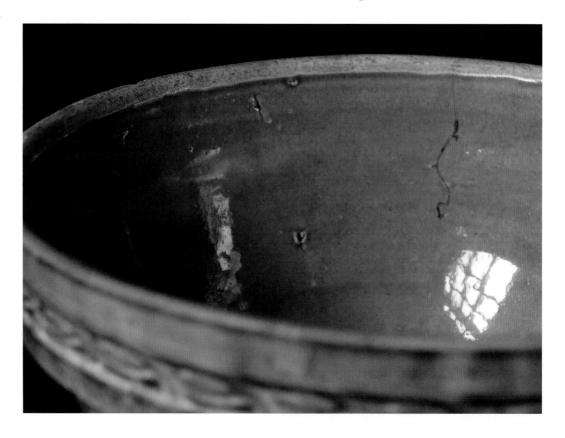

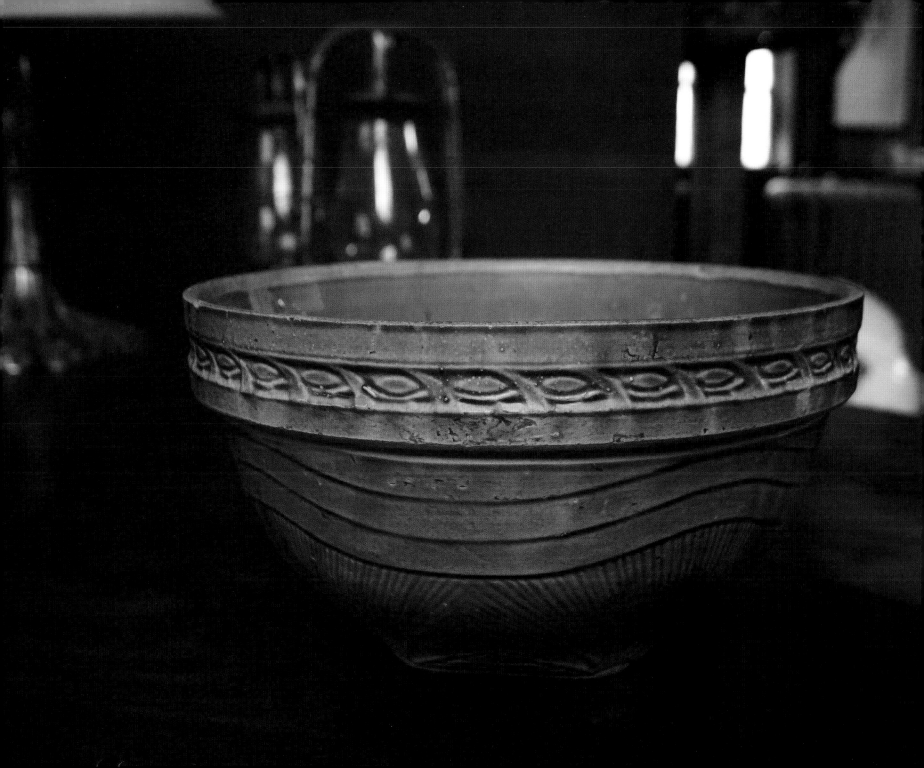

They were particular how the rims of bowls feel to the lips and how the endless ring is varied. They embraced the shape and kissed the thickness. And they knew what heart's ease there was in a gentle deformity."

Yanagi was grateful to them because "they saw things directly." "From my heart I am thankful for those discriminating eyes," he said. "The early tea masters apprehended the profundity of normal things. . . . If what the masters had marveled at had been something merely unusual, they would have been nothing exceptional. Anyone could have done that. But the masters' eyes were more penetrating. They did not see the extraordinary in the extraordinary. Therein lies their merit. They did not draw their cherished treasures out of the valuable, the expensive, the luxurious, the elaborate or the exceptional. They selected them from the plain, the natural, the homely, the simple, and the normal. They explored the uneventful, normal world for the most unusual beauty. Can anything be more uncommon than to see the uncommon in the commonplace?

"Most of us today have grown so commonplace that we cannot see the extraordinary save in the exceptional." But Yanagi was hopeful. He believed that we could become connoisseurs of the commonplace. "In actuality we today have more opportunities of seeing, of finding crafts of this order than the old tea masters had. Were they to be amongst us once more, their tears would fall with delight, and they would be collecting newly seen things of Tea and adapting them for a new Way of Tea for all people."

Seeing and handling the Kizaemon Bowl convinced him that this revival was possible. "I shall strive to find the way for such things to be made again," he vowed. He had been inspired by his visit. This "commonest crockery" was beautiful, he said. "Why should beauty emerge from the world of the ordinary? The answer is, ultimately, because that world is natural. In Zen there is a saying that at the far end of the road lies effortless peace. What more can be desired? So, too, peaceful beauty. The beauty of the Kizaemon Ido bowl is that of strifeless peace."

The Kizaemon Bowl left Japan for the first time in 1991. It was exhibited in a sprawling blockbuster show at the National Gallery of Art in Washington, D.C., lost among the hundreds of objects from Europe, Africa, the Americas, and Asia. Curator Cort came upon it unexpectedly and revisited it many times. "On more than one occasion I found myself defending this lopsided, cracked and scarred brown bowl against the skeptical comments of unimpressed viewers."

The bowl was smaller than she had expected and cut off from the Way of Tea. It had suffered. "It was dried out and lusterless after its ordeal in the brightly-lit case. Upon its return to Kyoto, I was reassured, it would be soaked in water to revive it."

WHAT MAKES A GOOD SHED? SOME CONCLUDING PRINCIPLES FOR SHED MAKING

1. Sheds are flexible and fragile. They live in this paradox: they are strong enough to bend. If they break, they can be fixed with common knowledge and common tools. A shed is a simple form, easily rebuilt.

2. They are temporary and yet they last. (The paradox continued.)

3. They evolve and devolve as needed. They can take the accretion of style—a steeple, a gable, a dormer, fish-scale shingles, and shrug them off. Steeples have been a part of meetinghouses for about two hundred years, and yet in their essence the meetinghouse is unchanged.

4. They are part shelter and part tool. We change them to fit the job at hand.

5. They are permeable. Each shed is partly shelter and partly open to the day, each to a different degree. The measure of enclosure changes; the mix of darkness and light, warmth and coolness, dampness and dryness. This quality of indoor/outdoorness is one that we have trouble understanding. Sheds, and old houses in particular, suffer when people try to shut down this permeability.

The best sheds are like summer cabins and lake houses. They are just enough shelter—more summer than cabin, more lake than house. They are alive to the season.

6. They can bear, at least, one metaphor. Sheds are like our lives—not the grandest building or the most graceful. Sheds are ordinary—and in that they are exalted.

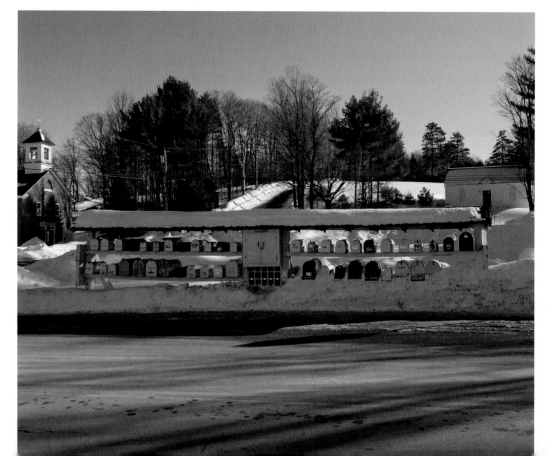

ACKNOWLEDGMENTS

Sheds are ordinary buildings, and as such are often overlooked. Photographer Jo Eldredge Morrissey and the book's designer and photo editor Henry James have an affinity for these old buildings. In their hands, these old sheds are stars.

We thank the many people who let us visit or pointed us up the road or deep into the woods to go see a good building. For acting as gracious hosts and guides, we thank Wendy and Mark Beaubien, Herm Botzow, Francelia Clark, David and Julie Coponen, Don Ganley,

David Keurulainen, the late Ralph Kangas, The MacDowell Colony, Jon and Kikuko Mills, Tom and Mary Meyers, Dan Scully, Paul Tuller, Donald Wyman, and Gordon Webber.

Thanks also to Sarah Bauhan, Mary Ann Faughnan, and the crew at Bauhan Publishing.

And finally we are indebted to the late Christina Ward, the literary agent who first suggested that the Sheds chapter of *Dwelling in Possibility* could stand on its own as a short, illustrated book.

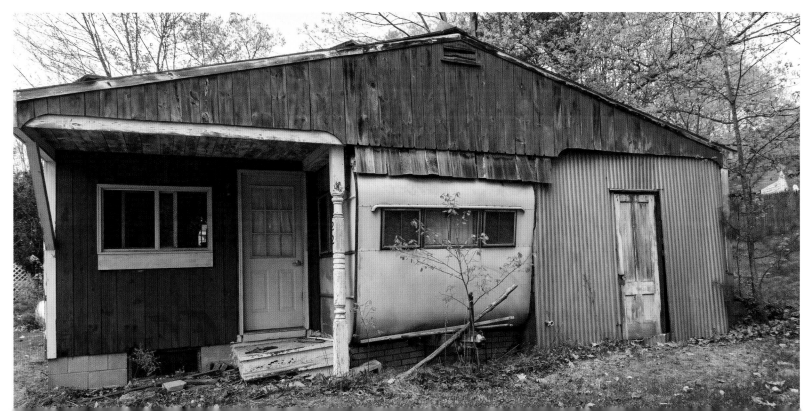

PLACE INDEX

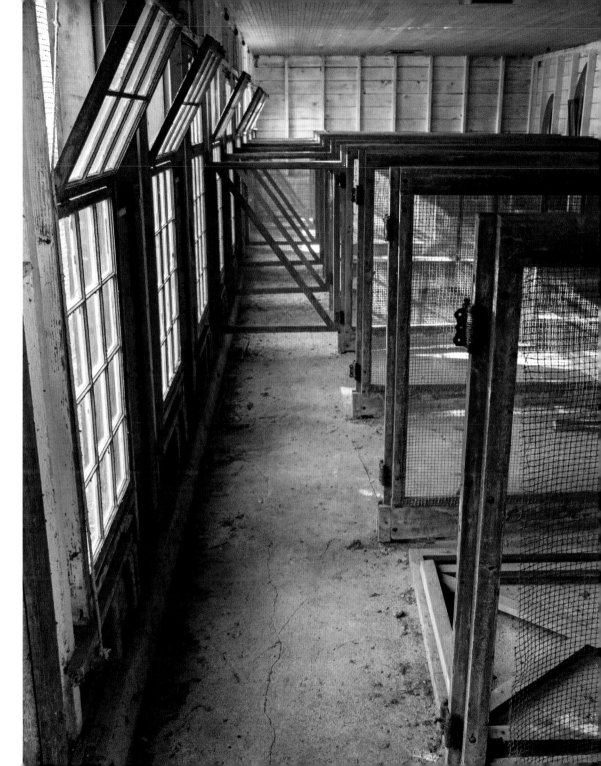

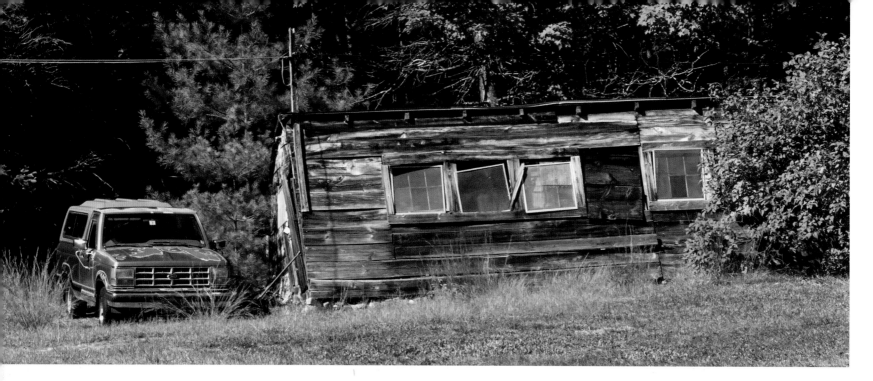

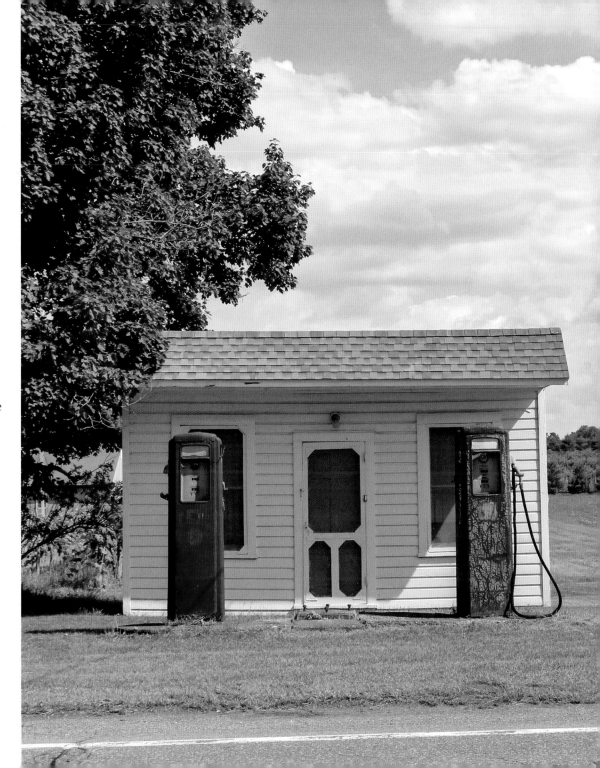

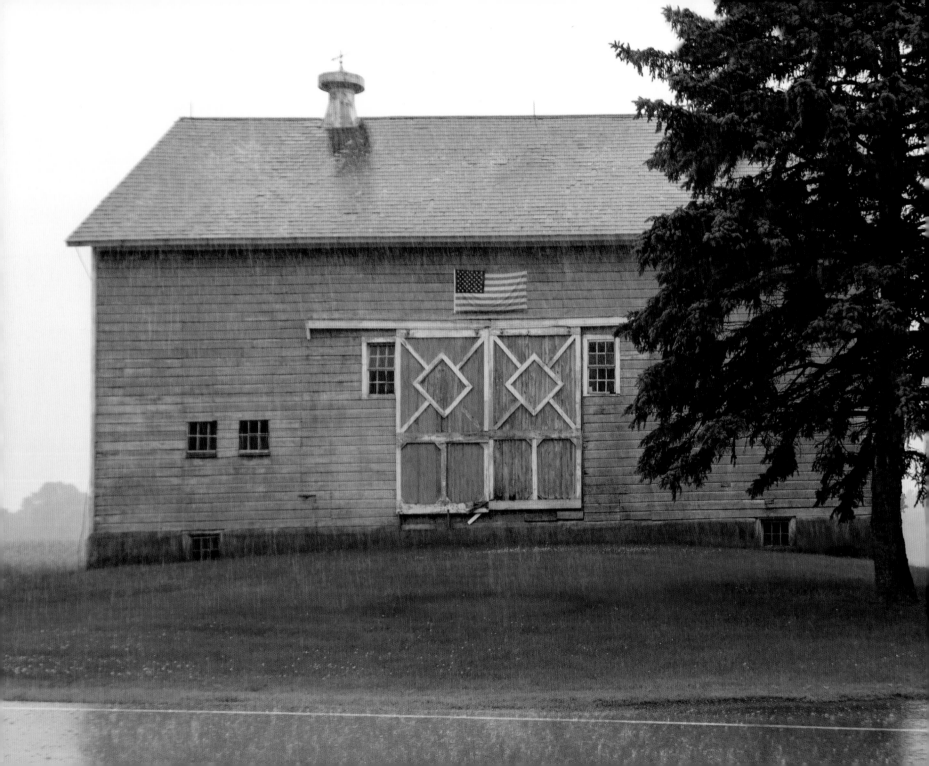